Sony® α DSLR-A100 Digital Field Guide

David D. Busch

BICENTENNIAL
1807
WILEY
2007
BICENTENNIAL

Wiley Publishing, Inc.

Sony® α DSLR-A100 Digital Field Guide

Published by
Wiley Publishing, Inc.
111 River Street
Hoboken, N.J. 07030
www.wiley.com

Published simultaneously in Canada

ISBN: 978-0-470-12656-1

Manufactured in the United States of America

10 9 8 7 6 5 4 3 2 1

1K/RW/QS/QX/IN

For general information on our other products and services or to obtain technical support, please contact our Customer Care Department within the U.S. at (800) 762-2974, outside the U.S. at (317) 572-3993 or fax (317) 572-4002.

Wiley also publishes its books in a variety of electronic formats. Some content that appears in print may not be available in electronic books.

Library of Congress Control Number: 2006939464

WILEY

About the Author

David D. Busch has been a roving photojournalist for more than 20 years, illustrating his books, magazine articles, and newspaper reports with award-winning images. He's operated his own commercial studio, suffocated in formal dress while shooting weddings-for-hire, and shot sports for a daily newspaper and an Upstate New York college. His photos have been published in magazines as diverse as *Scientific American* and *Petersen's PhotoGraphic*, and his articles have appeared in *Popular Photography & Imaging, The Rangefinder, The Professional Photographer*, and hundreds of other publications. He's currently reviewing digital cameras for CNet.

When About.com named its top five books on Beginning Digital Photography, occupying the first two slots were Busch's *Digital Photography All-in-One Desk Reference For Dummies,* and *Mastering Digital Photography.* His 90-plus other books published since 1983 include best-sellers like *Digital SLR Cameras and Photography For Dummies* and *Digital Photography For Dummies Quick Reference.*

Busch earned top category honors in the Computer Press Awards the first two years they were given (for *Sorry About The Explosion* and *Secrets of MacWrite, MacPaint and MacDraw*) and later served as Master of Ceremonies for the awards.

Credits

Product Development Supervisor
Courtney Allen

Project Editor
Cricket Krengel

Technical Editor
Michael D. Sullivan

Copy Editor
Lauren Kennedy

Editorial Manager
Robyn B. Siesky

Vice President & Group Executive Publisher
Richard Swadley

Vice President & Publisher
Barry Pruett

Business Manager
Amy Knies

Project Coordinator
Adrienne Martinez

Graphics and Production Specialists
Jennifer Mayberry
Rashell Smith
Amanda Spagnuolo

Quality Control Technician
Susan Moritz

Proofreading
Linda Seifert

Indexing
Johnna VanHoose

Wiley Bicentennial Logo
Richard J. Pacifico

For Cathy.

Acknowledgments

Thanks to Courtney Allen, who is always a joy to work with, for valuable input as this book developed; to Cricket Krengel for keeping the project on track; and to tech editor Mike Sullivan, whose more than a decade of experience shooting digital cameras proved invaluable. Finally, thanks again to my agent, Carol McClendon, who handles all the behind-the-scenes details so I can concentrate on taking photos and putting what I've learned down on paper.

Contents

Part II: Creating Great Photos with the Sony Alpha DSLR-A100 59

Chapter 3: Photography Essentials 61

Introduction

What an exhilarating breath of fresh air the Sony Alpha DSLR-A100 has been! Serious photographers who had been using Konica Minolta's digital SLRs initially felt left out in the cold when the pioneering photography company decided to back out of the camera business in 2006. However, Sony's prompt and enthusiastic adoption of Konica Minolta's existing technology, infused with innovations from Sony's own laboratories, proved that there was a lot of life left in the product line. Enough vigor and innovation, in fact, that *Popular Photography & Imaging* magazine was moved to name the Alpha as its 2006 Camera of the Year.

Announced June 5, 2006, the Alpha boasts a high-resolution 10.2 megapixel sensor, improved image stabilization built into the body, and an anti-dust feature that shakes dust right off the sensor when the camera is powered down. It has the further advantage of being compatible with hundreds (nay, thousands) of existing A-mount Minolta lenses.

The Sony Alpha A100's Advantages

If you visit the online forums, you'll find endless debates on which digital SLR in the $1,000 price range is the best. Rather than enter the debate here (if you're reading this, you've almost certainly decided in favor of the Sony camera), it makes more sense to provide a brief checklist of the Alpha's advantages.

Sony lenses

An advantage of the A100 is the ready availability of a vast number of Sony lenses. Other dSLRs may be able to use only a limited number of lenses made especially for them, and, with some less popular brands, the selection is sparse.

In contrast, nearly all of the Minolta A-type mount lenses offered for Minolta and Konica Minolta cameras are compatible with the Alpha A100. There are hundreds of newer lenses, many at bargain prices, that work just fine on the A100. Third-party vendors like Sigma, Tokina, and Tamron, offer a full range of attractively priced lenses with full autofocus, auto-exposure functionality.

Full feature set

You don't give up anything in terms of features when it comes to the Sony A100. Some vendors have been known to "cripple" their low-end dSLR cameras by disabling features in the

camera's firmware (leading to hackers providing firmware "upgrades" that undisabled the features).

The A100, on the other hand, has a significant number of improvements over the Konica Minolta Maxxum 5D it "replaced," including a new Bionz image processor, 40-segment pattern metering (compared with 14-segment metering on the earlier cameras), higher shooting resolution, and a back-panel color LCD with nearly twice as many pixels.

Fast operation

The Sony A100 operates more quickly than many other digital SLRs. It includes a memory buffer that's large enough to allow shooting pictures continuously at three frames per second at any image quality setting until the memory card is full (assuming a reasonably fast Compact Flash card). Many A100 users report being able to fire off shots as quickly as they can press the shutter release for as long as their index finger (or memory card) holds out.

One popular low-end dSLR takes as long as three seconds after power-up before it can take a shot. If you don't take a picture for awhile, it goes to sleep, and you have to wait another three seconds to activate it each time. The A100 switches on instantly and fires with virtually no shutter lag. (Actually, it uses so little juice when idle you can leave it on for days at a time without depleting the battery much.) Performance-wise, the A100 compares favorably with digital cameras costing much more. Unless you need a burst mode capable of more than three frames-per-second, this camera is likely to be faster than you are.

Great expandability

There are tons of add-ons for Konica Minolta cameras that you can buy that work great with the A100. These include bellows and extension rings for close-up photography and several different electronic flash units from Sony and third parties that cooperate with the camera's through-the-lens metering system. Because the Alpha's predecessor SLRs have been around for so long, there are lots of accessories available, new or used.

The Alpha Fast Track

This book puts you on the fast track to learning how to use your Sony Alpha DSLR-A100. Certainly, if you were patient enough, you could learn to use the camera by working your way through the manual. All the basics are in there (although the manual does have some surprising omissions when it comes to fully explaining how to use all the most important features).

The problem is *finding* what you need to know. The black-and-white line drawings can be confusing, and there are multiple cross-references that may have you flipping back and forth among various sections of the book until you encounter the information you're

seeking. The original manual has tiny monochrome pictures that aren't really examples of what you can accomplish with the Alpha.

This Digital Field Guide is different from the other Alpha start-up options. All the pictures in this book are in full color — even the road-map illustrations that help you locate every button and dial on this camera. Explanations of what each control does, when you might want to use it, and pitfalls to avoid when making a particular setting help you minimize mistakes while maximizing the number of great photos you take right out of the box.

Within these pages are explanations of photography essentials, such as exposure, use of lenses, and the best ways to work with various types of illumination, including electronic flash. In addition, you can find recipes for taking photos in the most common types of situations, so you know how to take a good sports picture or travel shot, even if you had mediocre results in the past.

Quick Tour

Regardless of the kind of camera you were using before, the Sony Alpha brings a lot of cool features and capabilities to the table. So whether you were using a film SLR, some other type of digital camera, or even a different digital single lens reflex, it's exciting to hold such a sophisticated picture-taking tool in your hands. And fortunately, no matter what your previous experience level is, you can begin taking great pictures immediately, assuming you've charged the battery, inserted a digital memory card, and remembered to take off the lens cap! It takes only a few seconds to get started with this camera.

This Quick Tour tells you everything you need to know to begin using the Sony Alpha DSLR-A100's basic features immediately. And, by the end of the Quick Tour, you'll already be producing good images with your camera. Once you've gotten a taste of what it can do, you'll be ready for later chapters that explain the more advanced controls and show you how to use them to capture even better photos in challenging situations, or to apply them creatively to create special pictures.

The Quick Tour assumes you've already unpacked your Sony Alpha DSLR-A100, mounted a lens, charged and installed the battery, and inserted a CompactFlash memory card or a Memory Stick Pro Duo using the supplied CompactFlash-to-Memory Stick Duo adapter card.

If you've reviewed the manual furnished with the camera, so much the better. And, you definitely need to have reviewed the manual to work with later chapters in this book. I include only the basics in this Quick Tour. If you really want (or need) to know more right off the bat, you should just skim this section and then jump ahead to Chapter 1.

Selecting a Picture-Taking Mode

Once your A100 is powered up, you should choose a picture-taking mode for your first

pictures. You change modes by rotating the Mode dial on the right top side of the camera.

Note *The full name of the camera is the Sony Alpha DSLR-A100. As you work through this Quick Tour and the rest of this Digital Field Guide, I'm not going to use the official camera name very often. Generally I'll call it the Sony Alpha, Alpha, or A100 to provide a little variety. There's no sense in slowing you down with nomenclature when I know you're eager to get started taking pictures.*

Aperture Priority Shutter Priority

Program Manual

Full Auto Night Portrait/Night View

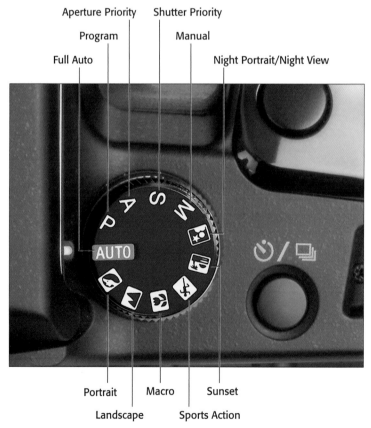

Portrait Macro Sunset

Landscape Sports Action

QT.1 Use the Mode dial to set the picture-taking mode.

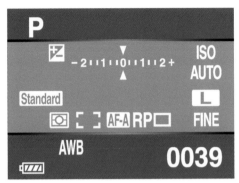

QT.2 The current mode appears in the upper left of the status display on the back of the camera – here indicating that the camera is in Automatic mode.

The A100's main shooting modes are Program, Aperture Priority, Shutter Priority, and Manual Exposure, represented in the status display by the letters P, A, S, and M, as well as a fully automatic mode and six Scene modes: Portrait, Landscape, Macro, Sports/Action, Sunset, and Night View/Night Portrait. The latter are represented by icons you can see on the Mode dial in figure QT.1. Photographers tend to favor the P, A, S, and M modes, which enable them to customize how the camera performs, over the automatic and Scene modes, which take most of the decision-making out of your hands. The following list explains the main shooting modes briefly and advises when they are best used and not used.

✦ **Program.** *When to Use:* When you want your camera to make the basic settings, while still giving you full control over the adjustments to fine-tune your picture.

When Not to Use: If you need to use a particular lens opening to control depth of field, or a certain shutter speed or shutter speed range to stop action or to use blur for creative purposes.

✦ **Aperture Priority.** *When to Use:* When you want to use a particular lens opening, usually to control how much of your image is in sharp focus, and want the A100 to select a shutter speed for you automatically.

When Not to Use: If there is insufficient light to produce a good exposure at your preferred lens opening; blurry photos can result. Conversely, Aperture Priority is not a good choice if there is too much light for your selected aperture with the available range of shutter speeds.

✦ **Shutter Priority.** *When to Use:* When you want to use a particular shutter speed, usually to freeze or blur moving objects, and want the A100 to select the lens opening for you automatically.

When Not to Use: If there is insufficient light or too much light to produce a good exposure at the preferred shutter speed.

✦ **Manual.** *When to Use:* When you want full control over the shutter speed and lens opening to produce a particular tonal effect. Manual can also be useful when you work with external non-dedicated electronic flash units that are not compatible with Sony's electronic flash autoexposure system, and you need to set the shutter speed and lens opening yourself.

When Not to Use: If you are unable to measure using the scale that appears in the viewfinder, or guess exposure properly, or don't have time to adjust exposure based on a review of the most recent picture you've taken on the LCD screen and histogram.

 Cross-Reference *You can find more information on using histograms in Chapter 3. And, for more information on all modes, see Chapter 1.*

The Scene modes limit your fine-tuning choices; however, they do give you some basic settings that are best suited to particular types of pictures. They are often useful when you're just getting started using the A100, or when you're in a hurry and don't have time to make basic settings yourself. When you use one of the Scene modes, you can be confident that you'll get pretty good results most of the time, even though you can often take better photos when you provide your input creatively using one of the main shooting modes. The following list briefly explains the Scene modes and when to use or not to use them.

✦ **Full Auto.** *When to Use:* When you want good results without making decisions, as when you hand your Sony Alpha to a friend and say, "Here, take my picture!"

When Not to Use: If you want every picture in a series to have the same exposure. If you change shooting angles or reframe your image, the A100 might match your shot with a different image in its database and produce a slightly different (but still optimized) look.

✦ **Portrait.** *When to Use:* When you're taking a portrait of a subject standing relatively close to the camera, and you want the background to be blurry.

When Not to Use: If your portrait subject is *not* the closest object to the camera.

✦ **Landscape.** *When to Use:* When you want extra sharpness and the rich colors of distant vistas.

When Not to Use: In dark situations, unless you have a tripod or want to use the Super SteadyShot image stabilization feature, as the shutter speed can be quite long.

✦ **Macro.** *When to Use:* When you're shooting close-up pictures of a subject from one foot or less, and the subject is centered in the viewfinder.

When Not to Use: If you want to use focus creatively.

✦ **Sports Action.** *When to Use:* When you're shooting fast-moving action and want to freeze your subjects. This mode activates a continuous shooting mode so you can capture a sequence of frames.

When Not to Use: If you want to incorporate a little blur into your photos to create a feeling of motion.

✦ **Night Portrait/Night View.** *When to Use:* When you want to illuminate a subject in the foreground with flash (night portrait), but still allow the background to be exposed properly. If you're using this mode for scenes at a distance, don't use the flash. In either case, exposures can be up to two seconds long.

When Not to Use: If you are unable to hold the camera steady and can't use a tripod or other steadying device, or feel that Super SteadyShot won't suffice for the longer exposures.

Activating Super SteadyShot vibration reduction

Sony's Super SteadyShot vibration reduction mode is a powerful camera-steadying mechanism built into the camera body itself, providing a form of image stabilization that reduces the effects of camera shake on your photos. You can often take pictures at shutter speeds that are two to three settings slower than you'd need to eliminate camera motion without this feature. For example, if you want to take a picture under certain dim lighting conditions, without Super SteadyShot, an exposure of f/4 at 1/125 second might be required to eliminate camera motion. With the feature activated, you could shoot the same picture at f/5.6 at 1/30 second, a much happier combination under most circumstances because of the increased range of sharpness at f/5.6.

 Cross-Reference *You can find more information on choosing the best exposure combinations in Chapter 3.*

However, it's important to note that Super SteadyShot reduces camera shake only — if your subject is moving quickly, you still need a higher shutter speed to freeze the action. If you shoot a person posing for your camera at the f/5.6 and 1/30 second combination, you could end up with a wonderful picture. However, if the person were running past the camera's field of view, you might have a blurry photo instead.

Because you won't need Super SteadyShot for most shooting, you can leave it switched off to save power and improve the performance of your Alpha. Should conditions warrant using the feature, a camera shake

warning appears (an icon of a camera with wavy lines under it) at the right side of your viewfinder. To activate Super SteadyShot, flip the slider shown in figure QT.3 upward.

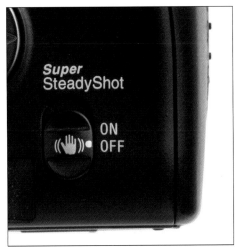

QT.3 The Super SteadyShot button activates the anti-shake feature of the A100.

Using Autofocus or Manual Focus

The camera body has a lever next to the lens mount on the left side (as you hold the camera), shown in figure QT.4, that you can set to MF (for manual focus), or AF (for autofocus). With the M setting, you always control the focus of the camera, although the green focus confirmation light in the viewfinder illuminates when proper focus is achieved.

When you set the focus lever of the A100 on A, the camera begins to focus on your subject when you move your eye to the

viewfinder. This feature is called Eye-Start AF, and, although it consumes more battery power, can help you work more rapidly if you're shooting subjects at a variety of focus distances.

 You can switch Eye-Start AF off if you'd rather not use it. I show you how in Chapter 2.

In the default Single-shot AF mode (AF-S), the A100 locks focus when you partially depress the shutter release, and keeps that focus point until you take a photo or release the shutter button. The Alpha also has three optional modes: Direct Manual Focus (DMF), which enables you to adjust focus even if the focus has been locked in; Continuous Autofocus (AF-C), which changes focus if your subject moves or you reframe the image; and Automatic Autofocus (AF-A), which alternates between AF-S and AF-C as appropriate.

 You learn when and how to choose these other focus settings in Chapter 1.

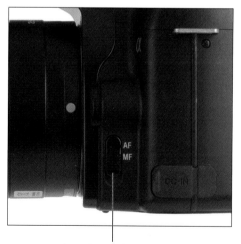

Autofocus/Manual focus switch

QT.4 The camera body focus-mode selector.

Taking the Picture

Go ahead and press the shutter button all the way down. After the shutter is tripped and the mirror flips back into viewing position, the photo you just took is displayed on the LCD on the back of the camera, unless you've turned off review display.

 You learn how to change the review and playback options in Chapter 1.

Press the Trashcan icon (the button located to the left of the LCD) if you want to delete the picture you just took. A message saying, "Delete this image? Yes No" appears on the LCD. To delete it, press the Controller button left to highlight the Yes choice and then press the Controller's center button to confirm the deletion.

You might want to activate a few more options for your first pictures. Here's an overview of the most common features.

Applying the Depth-of-Field preview

The A100 has a button called the Depth-of-Field (DOF) preview that temporarily changes the lens opening to the one that is currently selected by the exposure system. The button is located on the body, just to the right side of the lens (as you hold the camera). Press the DOF preview button to get a better idea of the range of sharp focus that will appear in your final image. The preview image is dimmer, of course, because you're viewing it through a smaller aperture, but you can often get a good idea of the actual depth of field using this control. Release the DOF preview button to restore the original bright view.

Depth-of-Field preview button

QT.5 Hold down the Depth-of-Field preview button to see roughly how much of your image will be in sharp focus at the current lens opening.

Using the self-timer

Sometimes you want to delay taking the photo for a few seconds. Or, perhaps you're taking a long exposure and don't want to risk jiggling the camera when you press the Shutter Release button. The self-timer provides this delay.

To use the self-timer, follow these steps:

1. **Press and hold the Drive button on top of the camera.**

2. **Press the Controller left or right to highlight the self-timer mode. When the self-timer mode is highlighted on the LCD screen, press the Controller Up or Down to switch between a 2-second or 10-second delay.**

3. **Press the center button of the Controller to lock in your choice.**

4. **Compose your photo and, when you're ready, press the shutter-release button all the way down.** The self-timer starts, and an accompanying blinking red light on the front of the camera handgrip warns you that a picture is about to be taken. About two seconds before the exposure is made, the lamp begins blinking very rapidly just before the photo is taken. You can cancel the 10-second self-timer by pressing the Drive button.

Tip *Sony recommends covering the viewfinder eyepiece with the eyepiece cap attached to the neck strap to prevent light entering through the eyepiece, which could confuse the exposure meter. However, this extraneous light is seldom a problem unless a bright light source is coming from directly behind the camera.*

Drive button

QT.6 Hold down the Drive button while pressing the Controller button to choose the self-timer feature.

Reviewing the Image

You can review the images you've taken at any time. Hold down the Playback button and press the left and right buttons on the Controller to move forward and backward among the stored images. The image display wraps around, meaning that when you have viewed the last image on your memory card, the first one appears again. The Up and Down buttons change the type of information about each image that appears on the screen.

Cross-Reference *You can find descriptions of all the playback and review options in Chapter 2.*

In addition, you can perform the following functions with the other buttons shown in figure QT.7:

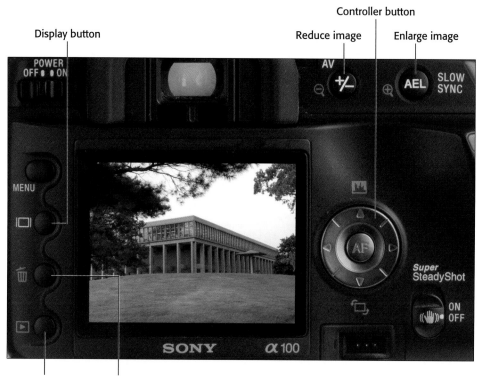

Display button

Controller button

Reduce image Enlarge image

Playback button Delete button

QT.7 Use the Playback button and left and right keys on the Controller button to review the images on your memory card.

✦ Press the Display button to cycle among a single full-sized image, an image with information display, or an index image showing six thumbnail images, on the LCD.

✦ When viewing thumbnails, use the Controller to navigate among the miniature images to highlight any of them. Then press the Center button to enlarge the selected image to full size.

✦ Press the Enlarge or Reduce button when viewing a full-size image to zoom in and out within that image. You can use the Controller keys to scroll around within the image.

✦ Press the Delete button and confirm that you want to delete a photo to remove it.

Using the Sony Alpha DSLR-A100

Exploring the Sony Alpha DSLR-A100

If you've gone through the Quick Tour and gained some basic familiarity with the layout and controls of the Sony Alpha A100, you've probably gone out and taken some initial pictures with your camera. Even a few hours' work with this advanced tool has probably whetted your appetite to learn more about the A100's features and how to use them.

Even if you're an old hand with digital single lens reflex (dSLR) cameras or have previously used Konica Minolta cameras with similar layouts, I think you'll find the roadmap features of this chapter especially useful for locating the key controls amidst the bewildering array of dials and buttons that cover just about every surface of the A100.

Of course, many new A100 owners are not old hands when it comes to dSLR photography. Learning to use the A100 as your first dSLR poses a bit of a challenge. For Alpha owners in this category, I provide a bit more detail on controls and features in this chapter and those that follow. It's likely that you find the information in this book more accessible and easier to understand than the descriptions in the manual furnished with your camera. However, this book isn't intended to completely replace the manual—you still need it to look up seldom-used settings and options—but it should help you use your camera effectively more quickly.

Although you may have reviewed your A100's buttons and wheels in the manual, this chapter's illustrations are designed to help you sort through the A100's features and controls quickly, especially when you're out in the field taking photos. It concentrates on the buttons, dials, and other controls that you can access directly, without visiting menus.

Up Front

The front panel of the Sony Alpha A100 is shown in figure 1.1. You can't see all the buttons and controls from a straight-on perspective, so I'll show you separate,

three-quarters-view looks at each half of the front of the camera, which I've color-coded green (the left side of the camera when looking at it head-on) and red (the right side of the camera when seen from this angle).

 This chapter does not cover the A100's menu and set-up options. To learn more about the menu and set-up options, see Chapter 2.

You activate many of the controls on the A100 with your left hand. However, there are a few controls within the reach of your right hand's digits, as shown in figure 1.2. These controls and features include the following:

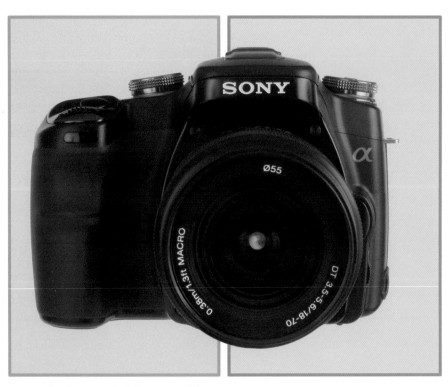

1.1 The business end of the Sony Alpha A100.

Control dial Self-timer lamp

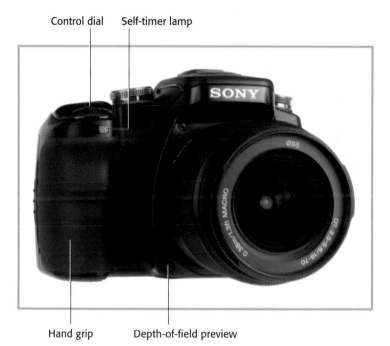

Hand grip Depth-of-field preview

1.2 The Sony Alpha A100's left-front side, viewed from the subject's position.

✦ **Hand grip.** The grip is the housing for the A100's battery, and also serves as a comfortable handhold for your fingers. You can hold the grip for both horizontal and vertical photos.

✦ **Depth-of-field preview.** This is the lower button (see figure 1.2) next to the lens mount. Press and hold the depth-of-field preview button. The lens stops down to the taking aperture, the view through the finder might dim a little (or a lot), and you can see just how much of the image is in focus.

✦ **Control dial.** This is the dial used to dial in settings such as shutter speed (by default) in manual or program shift modes. You can redefine its behavior in the Custom 1 menu so that it changes the aperture instead in both modes.

✦ **Self-timer lamp.** This front-mounted source of illumination serves as the count-down indicator for the self-timer.

The other side of the A100 has a few more controls, as shown in figure 1.3. These include the following:

Lens mount aligning indicator Neckstrap lug

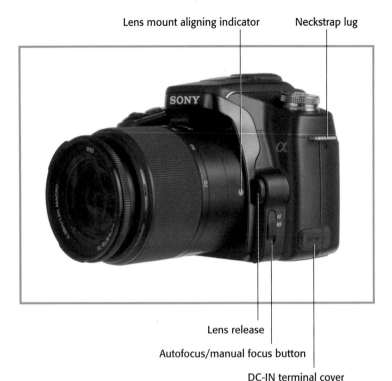

Lens release

Autofocus/manual focus button

DC-IN terminal cover

1.3 The Sony Alpha A100's right-front side, viewed from the subject's position.

✦ **Neck strap lug.** You can loop the neck strap of the A100 through this piece to more conveniently transport your camera.

✦ **Lens release.** Press and hold this button to unlock the lens so you can rotate the lens to remove it from the camera.

✦ **Focus mode selector.** You can flip the autofocus mode lever on the camera body to set the focus mode to either Autofocus (AF) or Manual focus (MF).

✦ **DC-IN terminal cover.** On the side of the camera, you can see a rubber cover that protects the A100's external adapter port. Flip open this cover and connect the external power source when you need extra juice for long exposures or taking photos over an extended period of time (say, in the studio).

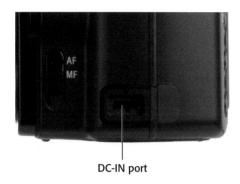

DC-IN port

1.4 DC power from the adapter connects here.

The internal electronic flash unit (figure 1.5) must be elevated manually as required by the lighting conditions but fires only when required. If you want to ensure that the flash is used, set the Function dial to Flash, and choose the Fill Flash option, as I describe in Chapter 5. The elevation of the flash helps reduce the possibility of red-eye effects.

1.5 The built-in flash is elevated high above the lens, which helps reduce the possibility of red-effects.

On Top

A bird's-eye view provides the best perspective of some of the controls on the lens. You can see the basic controls found on many zoom lenses in figure 1.6.

Not all these controls are found on all lenses, however, and some of them might be in different positions on different lenses (particularly those not produced by Sony). The key components are

✦ **Lens hood.** This is a removable circular device that bayonets onto the front of the lens and protects it in two ways: it shields the lens from extraneous light outside the picture area that can cause flare that damages your image (producing reduced contrast or unwanted light artifacts), and it serves as protection for the glass if you should happen to bump the camera lens against something.

✦ **Focus ring.** This is the ring you turn when you manually focus the lens when the camera is set to MF (Manual) focus.

✦ **Zoom ring.** This is the ring you turn to change the zoom setting. With many lenses, turning this ring to the right increases the focal length, but you might find that the opposite is true with some lenses, especially those from third parties (which can be very frustrating!).

Lens mount aligning indicator Electrical contacts Lens hood Focus ring

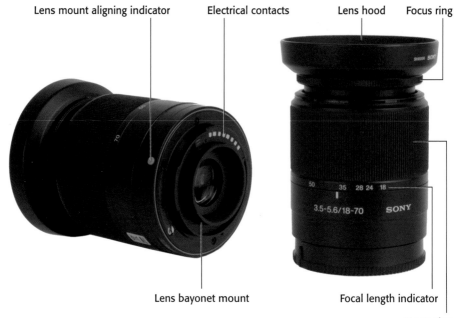

Lens bayonet mount Focal length indicator

Zoom ring

1.6 The top and rear views of the 18–70mm kit lens.

✦ **Focal length indicator.** These markings on the lens show the current focal length selected.

✦ **Lens bayonet mount.** This is the mounting flange that mates with a matching flange on the camera when attaching a lens.

✦ **Lens mount aligning indicator.** Line up the red dot on the lens with the matching red indicator on the camera body's bayonet mount when attaching a lens.

✦ **Electrical contacts.** These connectors convey focus and exposure information between the camera and lens.

The top surface of the A100 has its own set of controls, as shown in figure 1.7. They include:

✦ **Function dial.** This dial is your access to a variety of functions not related to choosing a shooting mode. You access any of the functions by turning the Function dial to the desired position and pressing the Function button in the center of the dial. This activates a selection menu on the LCD screen for choosing that function's options. Functions available on this dial include Meter, Flash, and Focus options, ISO/zone settings; White Balance; D-R (Dynamic Range) optimizing (to improve tonal values); and DEC (Digital Effects Control for color, saturation, and contrast adjustments).

 Cross-Reference *Learn about each of the Function dial's settings in Chapter 2.*

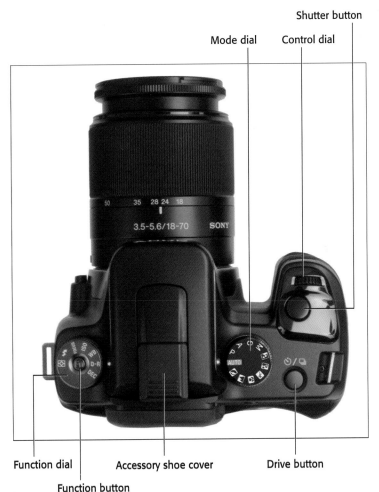

Shutter button

Mode dial Control dial

Function dial Accessory shoe cover Drive button

Function button

1.7 Key components on the top panel of the A100.

✦ **Accessory shoe cover.** After removing this cover, you can mount a Sony external electronic flash on the slide-in shoe. The shoe includes multiple electrical contacts to trigger the flash and to allow the camera and flash to communicate exposure and other information. You can also attach other flash units made by other vendors, but not all functions may operate.

✦ **Mode dial.** Turn this dial to set the A100 to Manual, Shutter-Priority, Aperture-Priority, or Program semi-automatic exposure modes, or to one of the fully automated modes such as Auto, Portrait, Landscape, Macro, Sports Action, Sunset, or Night View/Night Portrait.

✦ **Control dial.** This is the dial you use to change settings such as shutter speed (by default) in manual or program shift modes. You can redefine its behavior in the Custom 1 menu so that it changes the aperture instead in both modes.

✦ **Shutter button.** Partially depress this button to lock in exposure and focus; press it all the way to take the picture. Tapping the shutter release when the camera has turned off the auto exposure and autofocus mechanisms reactivates both. When a review image is displayed on the back-panel color LCD, tapping this button removes the image from the display and reactivates the auto exposure and autofocus mechanisms.

✦ **Drive button.** Press this button to produce the Drive mode menu on the LCD, where you can choose self-timer, single shot, continuous shooting, and several different single/continuous shot bracketing mode options.

 Learn about each of the self-timer, continuous advance, and bracketing drive functions in Chapter 2.

On the Back

The back panel of the Sony Alpha A100 is studded with more than 15 controls, many of which serve more than one function. Where other cameras force you to access a menu to make many basic settings, you just press the appropriate button on the A100, turn the command dial or use the multi-selector, and make the adjustment you want. I've divided this crowded back panel into three color-coded sections.

Top

The top quarter of the back panel includes a few frequently-accessed controls.

✦ **Power switch.** Turns the camera on and off.

✦ **Viewfinder eyepiece.** The rubber eyecup shields the viewfinder from extraneous light, much like a lens hood — a necessary component because light entering the viewfinder can affect the exposure meter. The eyecup is removable.

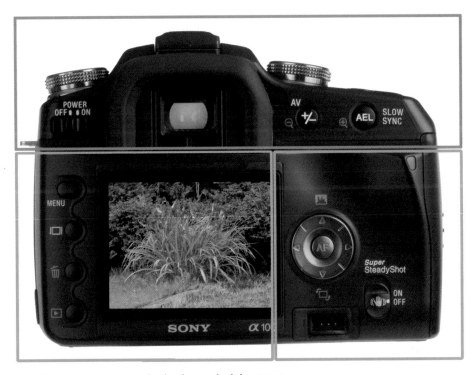

1.8 Key components on the back panel of the A100.

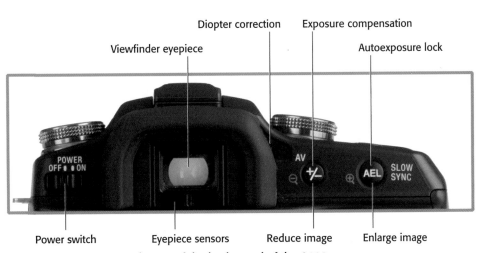

1.9 Key components on the top of the back panel of the A100.

✦ **Eyepiece sensors.** These sensors detect whether or not the photographer is looking through the viewfinder. In Custom menu 2 (see Chapter 2), you can set the A100 so that the LCD turns off automatically when you look into the viewfinder (the default), or so the monitor stays on. In addition, in Setup menu 3, you can change the length of time the LCD remains on (whether or not you're looking through the viewfinder), with settings of 5, 10, 30, or 60 seconds. Activate the LCD again by tapping the shutter release button or performing another operation that requires the LCD.

✦ **Diopter correction.** Rotate this knob to adjust the diopter correction for your eyesight.

✦ **Exposure compensation/Reduce image.** While shooting, you can hold down this button and spin the Control dial to the left to reduce exposure, or to the right to increase exposure.

✦ **Autoexposure lock/Enlarge image (AEL).** While shooting, pressing this button locks the exposure at the current setting. During playback, this button zooms in on the image on the LCD.

Lower left

This is the A100's hot corner, because it has a collection of some of the function buttons you may use most frequently. They each can have multiple functions, so you need to keep your camera's current mode (playback/shooting, and so on) in mind when you attempt to access a specific feature. A more complete description of each button's functions appears later in this chapter. The buttons include:

✦ **Menu.** Use this button to access the A100's multilevel menu system. You can find two pages each of Recording, Playback, and Custom menu items, plus three pages of Setup menu options. Note that Sony has configured the menus in both vertical and horizontal formats, and when you tilt the camera from one orientation to another the menus adjust to a new layout. I use the landscape orientation exclusively when showing menu entries in this book.

 Cross-Reference *I explain all the Custom menu items and Setup menu options in Chapter 2.*

✦ **Display.** This button changes the amount of status information shown on the screen in Recording mode, and the image display in Playback mode. Unlike some other dSLRs you might be familiar with, the A100 lacks a monochrome status display that shows the current shooting settings. Instead, this information, including shooting mode, shutter speed, and aperture, appear on the LCD display. The Display button changes from a detailed display, such as the one in figure 1.11, to an enlarged display of the same basic information with larger letters. Both views rotate when you hold the camera in vertical orientation. In Playback mode, the Display button shifts between a single screen image with recording data, a single screen image without recording data, and an index screen showing several thumbnails.

Display Menu LCD

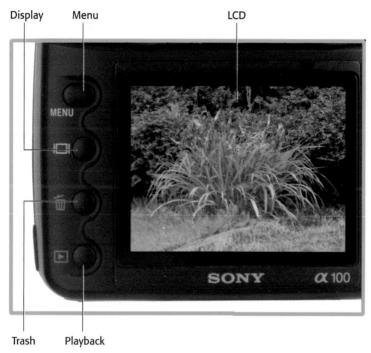

Trash Playback

1.10 Key components on the back left panel of the A100.

✦ **Trash.** In Playback mode, press this button to delete the displayed image. A dialog box reading "Delete this image? Yes No" appears. Select Yes with the Controller keys and press the center key to delete the image.

✦ **Playback button.** Use this button to enter the picture review (Playback) mode. Press again or press the shutter button halfway to return to shooting mode.

✦ **LCD.** The color LCD displays your images for review and provides access to the menu system.

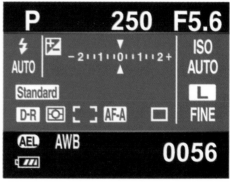

1.11 The LCD menu displayed in detailed, horizontal mode.

Lower right

You'll find a second cluster of controls and components in the lower-right corner of the back panel:

✦ **Controller.** You use this cursor-pad type controller to navigate menus as well as scroll through photos you're reviewing using the left/right keys. The up/down keys have secondary functions, too. Pressing the up key produces the information display with a histogram for the current image; the down key rotates the current image.

 Cross-Reference *You can read about histograms in Chapter 3.*

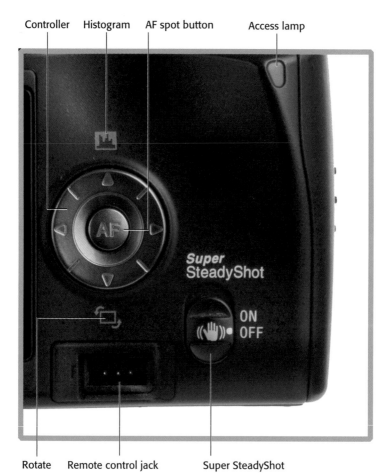

Controller Histogram AF spot button Access lamp

Rotate Remote control jack Super SteadyShot

1.12 Key components on the lower-right corner of the back panel of the A100.

✦ **AF spot button/center button.**
This key embedded in the center
of the Controller pad changes the
autofocus area to the center spot
in the viewfinder when you press
it; it also serves as an "enter" or
"set" key when you navigate menu
options.

Cross-
Reference *Chapter 2 contains coverage of*
choosing focus area modes.

✦ **Access lamp.** This lamp blinks
while an image writes to the
Compact Flash or Memory Stick
Duo cards, when the camera is first
started, goes to sleep, or is turned
off.

✦ **Super SteadyShot.** Slide this
switch up or down to activate or
deactivate the A100's anti-shake
feature.

✦ **Remote control jack.** Hidden
under a rubber cover, this port can
be connected to a remote control
triggering device, such as the Sony
RM-S1AM Remote Commander.

One additional port tucked out of sight is
the Video/USB jack, located beneath the
Compact Flash/Memory Stick Duo Adapter
door. Using one of the cables supplied with
your Sony Alpha, you can use this port to
connect to the video port on your television
or composite monitor. Another cable plugs
into the same port and connects to a USB
port on your computer; you use it to trans-
fer photos directly from your camera to your
computer.

Video/USB jack

1.13 The video/USB jack enables you to
connect your A100 to your video monitor or
computer.

Viewfinder Display

The A100 provides a lot of status informa-
tion in the viewfinder, as you can see from
figure 1.14, although not all of it is visible at
one time. Here's the skinny:

✦ **Wide focus frames.** This is the
boundary within which the nine
focus frames used for autofocus
(shown in blue and black in figure
1.14) reside.

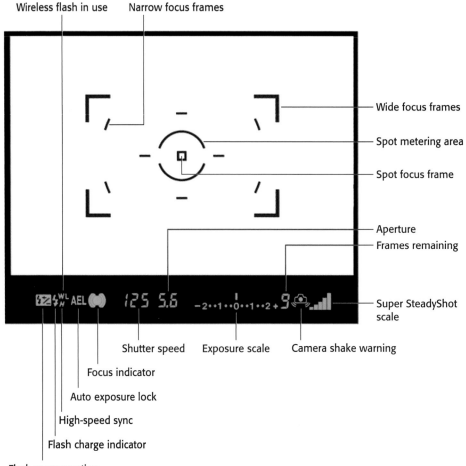

Wireless flash in use Narrow focus frames

Wide focus frames

Spot metering area

Spot focus frame

Aperture
Frames remaining

Super SteadyShot scale

Shutter speed Exposure scale Camera shake warning

Focus indicator

Auto exposure lock

High-speed sync

Flash charge indicator

Flash compensation

1.14 The viewfinder includes these readouts and indicators (with color added for clarity).

✦ **Narrow focus frames.** These are the eight focus frames used when Wide AF area autofocus is selected, as I explain in Chapter 2. The focus frame selected by the camera is illuminated in red when you press the shutter button halfway. In this mode you can switch to the center Spot focus frame by pressing the AF/center button of the controller.

✦ **Spot focus frame.** This is the focus frame used exclusively when you've selected Spot AF area focus mode, or when you're using Wide AF area or Focus Area Selection modes and you press the AF/center button of the Controller.

✦ **Spot metering area.** This marks the area used for spot metering.

 Chapter 2 explains more about spot metering.

✦ **Flash compensation.** This shows the amount of added/reduced exposure for electronic flash shots (see Chapter 5).

✦ **Flash charge indicator.** This blinks while the electronic flash is charging for use; it remains lit when the flash is fully charged.

✦ **Wireless flash in use.** This is displayed when HVL-F56AM or HVL-F36AM flash units are being used off-camera in wireless mode.

✦ **High-speed sync.** This appears when HVL-F56AM or HVL-F36AM flash units are being used at shutter speeds higher than 1/160th second.

Cross-Reference *See Chapter 5 for more information about using High-speed sync to shoot at shutter speeds shorter than 1/160 second.*

✦ **Auto exposure lock.** This illuminates when you press the autoexposure lock button.

✦ **Focus indicator.** This indicator changes to show the focus status. When focus is locked, a green dot appears. When the green dot is surrounded by round brackets (as in figure 1.14), focus is confirmed but the focus will follow a moving object. When the round brackets are illuminated, but the green dot isn't visible, the camera is still autofocusing and the shutter release

is locked out. A flashing green dot indicates that the A100 is unable to achieve focus (you might be too close to your subject).

✦ **Shutter speed.** This displays the currently set shutter speed.

✦ **Aperture.** This displays the currently set f-stop.

✦ **Continuous frames remaining.** This indicates the number of continuous frames that can be shot. As photos are moved into the buffer and then out to the memory card, this number changes dynamically. For example, a 9 may appear when you begin shooting, then decrease until it reaches 3, and then increase again as the camera offloads shots to the memory card. When you're shooting JPEGs at any resolution, the A100 generally "keeps ahead" of the available space in the buffer, so there is no limit to the number of shots that you can take continuously at 3 fps (frames per second) until the memory card fills. The camera can take about three images continuously using RAW+JPEG, or six images using RAW alone.

✦ **Exposure scale.** This readout shows the calculated ideal exposure (in the center of the scale) with a marker showing the selected exposure, if it's plus or minus two f-stops from the recommended setting. When the camera is bracketing, a set of three markers appears showing the range covered by the bracketed exposures.

✦ **Camera shake warning.** This indicator flashes whenever the camera detects a shutter speed setting slow enough to cause blur if the camera is hand-held or Super SteadyShot is not activated. When you see this warning, you should either turn on Super SteadyShot (if it's not already activated) or use a tripod.

✦ **Super SteadyShot scale.** One to five bars appear showing the degree of camera shake detected by the Sony Alpha A100.

LCD Display

The LCD status display shows a broad range of current status information. This display is a bit much to bite off in one chunk, as you can see by the full display in figure 1.15. In practice, only a fraction of this information appears at any one time.

Along the top edge, you can find:

✦ **Shooting mode.** This indicates whether the Program, Aperture Priority, Shutter Priority, or Manual exposure modes; Auto mode; or one of the Scene modes are in use.

✦ **Exposure scale.** This readout shows the calculated ideal exposure (in the center of the scale) with a marker showing the selected exposure, if it's plus or minus two f-stops from the recommended setting. When the camera is bracketing, a set of three markers appears showing the range covered by the bracketed exposures.

✦ **Shutter speed.** This displays the currently set shutter speed.

✦ **Aperture.** This displays the currently set f-stop.

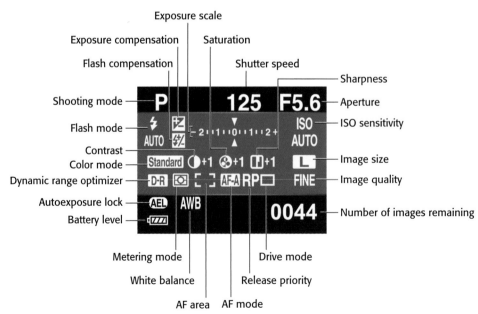

1.15 LCD status display readouts and indicators.

Along the left side, you'll find:

✦ **Flash mode.** This shows whether Auto, Fill Flash, Rear Sync, or Wireless flash mode is in use. (In Auto mode, Front Sync is used by default.)

✦ **Exposure compensation.** This shows the amount of added/reduced exposure.

✦ **Flash compensation.** This shows the amount of added/reduced exposure for electronic flash shots.

 For more on flash modes, see Chapter 5.

✦ **Color mode.** This indicates which color mode is being used, from Standard, Vivid (extra saturation), B/W (black and white), Adobe RGB (red, green, blue), Portrait, Landscape, Sunset, or Night View.

✦ **Contrast.** This shows the amount of contrast adjustment made, on a scale of plus or minus 2.

✦ **Saturation.** This shows the amount of saturation adjustment made, on a scale of plus or minus 2.

✦ **Sharpness.** This shows the amount of sharpness adjustment made, on a scale of plus or minus 2.

✦ **Dynamic range optimizer.** This appears if D-R Optimizer or D-R+ Optimizer tonal adjustments have been activated.

✦ **Metering mode.** This shows whether multisegment (matrix), center-weighted, or spot metering is active.

✦ **AF area.** The Autofocus area indicates whether Wide AF area, Spot AF area, or Focus area selection (user-selectable focus area) is in use.

✦ **AF mode.** Autofocus mode shows whether AF-S (Single-shot Autofocus), AF-C (Continuous Autofocus), AF-A (Automatic Autofocus), or DMF (Direct Manual Focus) have been set.

✦ **Release priority.** In Custom menu 1, you can set whether the shutter is locked when focus is not confirmed (the default value, AF), or specify that you can release the shutter even when focus is not set. In that case, the RP icon appears here.

✦ **Drive mode.** This shows whether single shot, continuous shooting, self-timer, continuous exposure bracketing, single shot exposure bracketing, or white balance bracketing is selected.

Along the bottom edge, you can find:

✦ **Battery level.** This shows the amount of remaining battery power.

✦ **White balance.** This indicates whether auto white balance, a white balance preset, a precise color temperature, a color correction filter adjustment, or a custom color balance has been selected.

✦ **Autoexposure lock.** This appears when you press the autoexposure lock (AEL) button.

✦ **Number of images remaining.** This shows the number of frames that can be taken using the available memory card space.

Along the right side:

✦ **ISO sensitivity.** This displays the current ISO setting, Auto setting, or Zone matching (Lo80 or Hi200).

✦ **Image size.** This indicates whether L (10 megapixels (MP), 3872 x 2592 pixels), M (5.6MP, 2896 x 1936 pixels), or S (2.5MP, 1920 x 1280 pixels) have been selected.

✦ **Image quality.** This shows whether Fine or Std (standard) JPEG (only), RAW, or RAW+ (RAW plus JPEG Fine) have been selected.

Viewing and Playing Back Images

The A100's Playback mode lets you review your images, delete the bad ones, and decide on exposure or compositional tweaks to improve your next shots.

Follow these steps to review your images:

1. **Press the Display button.** This cycles among a display of the image with basic shooting information (see figure 1.16), no information, or an index screen.

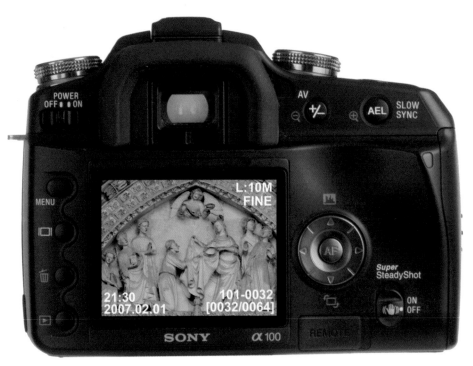

1.16 Review your photos using the color LCD.

2. **Press the left/right keys to scroll forward and backward among the images taken.** In Index mode, use the left/right/up/down keys to find the image you want. If your memory card contains several folders of images, you can also navigate between the different folder names, using the Reduce key to highlight a folder name.

3. **When viewing a single image, press Enlarge to zoom in, or Reduce to zoom out.** While zoomed, you can use the controller keys to scroll around within the image.

4. **To delete an image or folder, highlight the image or folder and press Delete.** Choose Yes when the dialog box appears, and press the center button of the controller to confirm.

5. **When viewing a single image, press the Up key to display the histogram, a thumbnail of the image, and a summary of the exposure information.**

Activating the Onboard Flash

The Sony Alpha A100 has a built-in flash unit you can activate by flipping it up manually with your finger. The camera uses the flash only when it detects low light levels suitable for flash photography and calculates the proper exposure for you.

Cross-Reference *Chapter 5 contains more information about using flash.*

Set the Function dial to Flash, press the Function button, and adjust to one of the following flash modes.

✦ **Auto.** This is the default mode and causes the flash to fire under low light conditions, or when your subject is backlit. This mode is not available when you use A, S, or M shooting modes.

✦ **Fill Flash.** The electronic flash always fires.

✦ **Rear-curtain sync.** The flash is delayed until just before the shutter closes. This records the flash image after any *ghost images* have faded. Ghost images result from a secondary exposure from ambient light when objects move during exposure so that the secondary images seem to trail the flash image. Unless you select this mode, the A100 uses front curtain sync, in which the flash fires as soon as the shutter opens.

✦ **Wireless.** Use this mode when you use an off-camera flash (either the HVL-F56AM or HVL-F36AM) in wireless mode.

Metering Modes

The A100 can use any one of three different exposure metering methods when it's set to P, A, S, or M exposure modes (which I discuss later in the chapter). Select the metering mode by turning the Function dial to the Metering icon, pressing the Function button, and choosing from these three options in the dialog box that appears:

✦ **Multisegment (matrix).** The camera examines 40 different zones in the frame and chooses the exposure based on that information. Figure 1.17 shows 39 of the zones highlighted in blue; the 40th zone is the area surrounding the honeycomb-shaped zones.

✦ **Center-weighted.** The camera collects exposure information over the entire frame, but when it makes its calculations, it emphasizes a central area of the screen.

✦ **Spot.** The exposure is calculated entirely from the center spot area (highlighted in red in figure 1.17).

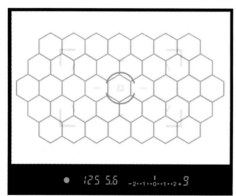

1.17 Multisegment and spot-metering zones.

Semiautomatic and Manual Exposure Modes

The Sony Alpha A100 has three semiautomatic exposure modes that enable you to specify shutter speed, aperture, or combinations of the two; and a Manual Exposure mode that gives you the complete freedom to set the shutter speed and aperture. You can also set these four exposure modes using the Mode dial. Your choices include:

✦ **Program.** In this mode, the A100 automatically chooses an appropriate shutter speed and f-stop to provide the correct exposure. However, you can override these settings. You can change to an equivalent exposure using a different shutter speed by spinning the Control dial; the A100 adjusts the aperture automatically using a feature called Program Shift. You can also change the behavior of the camera in Custom menu 1 so that rotating the Control dial changes the aperture, with the A100 adjusting the shutter speed. You can also add or subtract exposure from the metered exposure by pressing the Exposure Compensation button and rotating the Control dial.

✦ **Shutter Priority.** In this exposure mode, you specify the shutter speed with the Control dial, and the A100 selects an appropriate f-stop. If a correct exposure cannot be achieved at the shutter speed you select, the aperture value in the viewfinder flashes.

✦ **Aperture Priority.** In this exposure mode, you specify the f-stop to be used with the Control dial, and the A100 selects the shutter speed for you. If this isn't possible because there is insufficient or too much light, the A100 flashes the shutter speed value in the viewfinder. Change to a smaller aperture if there is too much light, or a larger one if there is too little light so the Aperture Priority function can operate.

✦ **Manual.** You can select both the shutter speed and f-stop using the Control dial (for shutter speed) and Exposure Compensation button + Control dial (for aperture). You can watch the exposure scale display in the viewfinder as a guideline; when correct exposure is achieved, the indicator is centered in the scale.

Programmed Exposure Modes

The A100 has six automated Scene modes, plus full Auto, which make all the setting decisions for you. You can choose these modes from the Mode dial. They include:

✦ **Auto.** In this mode, the A100's brains take care of the settings, based on what kind of shot you've framed in the viewfinder. For example, the camera knows how far away the subject is (from the automatic focus mechanism); the color of the light (which tells the camera whether you're indoors or outdoors); and from the multisegment metering exposure data and other information, the camera can make some pretty good guesses about the kind of subject matter (landscape, portrait, and so forth). After comparing your shot to its picture database, the A100 decides on the best settings to use when you press the shutter release. Auto is the mode to use when you want one of those fumble-fingered neophytes in your tour group to take your picture

in front of the Eiffel Tower. Don't use this mode if you want every picture in a series to be exposed exactly the same. If you change shooting angles or reframe your image, the A100 might match your shot with a different image in its database and produce a slightly different (but still "optimized") look.

✦ **Portrait.** In this mode, the A100 assumes you're taking a portrait of a subject (or two) standing relatively close to the camera. So, it automatically focuses on the nearest subject and uses a wider lens opening (which can help throw the background out of focus). Don't use this mode if your portrait subject is not the closest object to the camera.

✦ **Landscape.** Scenic photos are usually taken of distant objects, with vivid colors and sharp detail highly desirable, so that's what your A100 adjusts its settings to produce. However, you can assume that electronic flash isn't of much help in shooting your vistas, so Sony recommends lowering the flash unit when using this mode.

✦ **Macro.** Your A100 makes some adjustments suitable for close-up photos when you choose this mode. For example, the automatic focusing mechanism concentrates on the center of the frame (because that's where most close-up subjects are located), and doesn't seek sharp focus until you partially depress the shutter release button.

✦ **Sports Action.** The A100 switches into a Continuous Autofocus mode (AF-C) that tries to track moving subjects to keep them in focus. The A100 is switched into continuous shooting mode so you can capture action sequences at up to three frames per second. This Scene mode also uses higher shutter speeds.

✦ **Sunset.** In this mode, color, saturation, and exposure are optimized to reproduce the reds of sunsets and sunrises brilliantly.

✦ **Night Portrait/Night View** In this mode, the A100 uses shutter speeds as long as two seconds to allow dark backgrounds and shadows to be properly exposed. You can use flash if you want to illuminate subjects in the foreground, but don't use it for night scenes at a distance. For longer exposures, use either a tripod or make sure Super SteadyShot is turned on.

ISO Sensitivity

The A100 can choose the sensitivity setting (ISO) for you automatically, or you can choose a setting manually. Just turn the Function dial to ISO, press the Function button, and choose Auto, 100, 200, 400, 800, or 1600 from the menu. If you want to use the Zone Matching feature, select Lo80 to keep dark scenes from becoming underexposed, or Hi200 to keep extra bright scenes from becoming overexposed.

Setting White Balance

To more closely match the A100's color rendition to the color of the illumination used to expose an image, you can set the white balance. Turn the Function dial to WB, and choose one of the following selections: Preset value (daylight, shade, cloudy, tungsten, fluorescent, flash — each with plus/minus three fine-tuning settings); Color temperature (from 2500K to 9900K); or Recall/set a custom white balance.

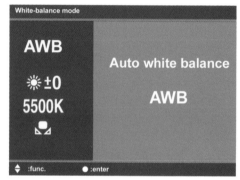

1.18 White balance options.

For more information on ISO and white balance, see Chapter 2.

Setting Up Your Sony Alpha DSLR-A100

CHAPTER 2

Y ou can find most of what you need to get started with your Sony Alpha A100 in the Quick Tour and first chapter of this book. This chapter shows you how to fine-tune the behavior and operation of your camera using the settings available in the menus. You can use these adjustments to choose the resolution of your images, set white balance, choose an appropriate focus mode, and set other preferences and options.

Again, I want to emphasize that this book is not intended to replace the manual furnished with the Sony Alpha A100, nor to simply provide a rehash of its contents, even though there is some unavoidable duplication between the pocket-sized, 158-page official manual and this expanded book. As a field guide, this book is written as a quick reference you can carry in your camera bag and pull out when you need quick advice on how to take a picture or how to set up your camera for a particular type of shot. In this chapter I list the key menu options to make it easy for you to find the setting that does what you want. I also explain some of the more confusing settings that require a little elaboration, or point you to a chapter in this book that provides the added information you need.

What's What in the Menus

The A100 has four main menus: the Recording menu, which has two pages of shooting options; the Playback menu, which has two pages of functions for reviewing, removing, and printing images; the Custom Menu, which has two screens of options that adjust how the camera and its controls operate; and the Setup menu, which has three screens for specifying your preferences for LCD brightness, power saving, date/time, video/audio, and other functions.

The A100 also has a complement of *direct set* controls that bypass the multilayered menu system to provide quick access to some of the most frequently used controls. For example, when you press the Drive Mode button on the top panel, a menu instantly appears that enables you to choose single or continuous shooting, self-timer modes, or exposure/white balance bracketing directly. More direct access adjustment screens are available when you spin the Function dial to the desired control and press the Function button in the center of the dial. I detail the use of each of these settings in this chapter.

To make any menu setting, press the Menu button, use the left/right and up/down buttons to navigate the menu pages, and press the controller's center Set button to make a selection. In most cases, pressing the Menu button backs you out of the current menu screen.

Recording Menu Preferences

You may find most of the picture-taking preferences you need to use while shooting within the Recording menu. This menu consists of two pages of options; on the first page are Image Size, Quality, Inst. Playback, Noise reductn, and Eye-Start AF, and on the second page are Red eye, Flash control, Flash default, Bracket order, and Reset.

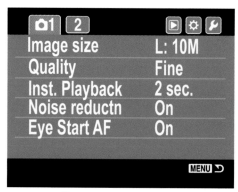

2.1 Recording menu 1

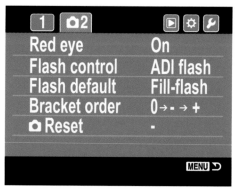

2.2 Recording menu 2

Image size

Here you can choose between the A100's full 10MB, 3872 × 2592-pixel size (L), and two alternates, M (2896 × 1936 pixels), and S (1920 × 1280 pixels.)

There's really little incentive to use anything other than the default L setting, even if a lower resolution is perfectly adequate for your intended application (say, a Web display). You may find that starting with a full-sized image gives you greater freedom for cropping and fixing problems with your image editor, and that an 800 × 600-pixel Web image derived from a full-resolution original often ends up better than one that started out at 1920 × 1280 pixels.

The M and S setting do let you cram more pictures onto a memory card, so you might find them useful in situations where your storage is limited and/or you don't have the opportunity to offload the pictures you've taken to your computer. For example, if you're on vacation and plan to make only 4- × 6-inch snapshot prints, a lower resolution can let you stretch your memory card's capacity. You can fit about 377 10MB (Large) JPEG Standard images on a 1GB memory card, or 640 5.6MB (Medium) images and 1262 2.5MB (Small) photos.

Quality

You might also consider file size and the capacity of your memory card when you choose the Quality setting. Your choices include:

✦ **RAW (RAW).** This setting produces a file that is not processed further by the camera after the image information has been converted from an analog to a digital format. You must import the files produced for your image editor using the Image Data Converter SR utility provided with your camera or a third-party tool such as Adobe Camera Raw; the files cannot be printed directly without being converted first. Use this option if you want to have complete control over the settings applied to your images when you import them to an image editor and want to preserve all possible image detail. The RAW setting is available only when you use the full-resolution, L, image size. The RAW file can be considered like a digital "negative" that can be returned to later if you want to again work with the "original."

✦ **RAW & JPEG (RAW+).** This "best of both worlds" option gives you a RAW file you can use for extensive manipulation if you need it, as well as a JPEG Fine file with the settings you chose at the time of the exposure already applied. Using RAW+ does require more space on your memory card and reduces the operating speed of the A100 slightly. This setting is available only when you're using the full-resolution, L, image size.

✦ **Fine (FINE).** This JPEG setting is a good all-around choice when you feel your images require only minor fine-tuning in an image editor. Available at any image size, JPEG Fine moderately compresses your image without discarding too much detail, producing file sizes that efficiently use the available memory card space. When shooting Fine, the A100 operates at its full speed, so you can take photos continuously at three frames per second until the memory card fills.

✦ **Standard (STD).** This setting compresses your images more aggressively, and you lose a little detail that you probably won't miss unless you're making enlargements bigger than 8 x 10 inches. You have less of a margin for cropping your images, too. However, this JPEG Standard setting makes the most of your available memory card space, and it can be a good choice when you must cram as many photos as possible onto a single card.

Instant playback

After you've taken a picture, the Sony Alpha A100 can display the image on the LCD for your review. During this display, you can delete a disappointing shot by pressing the Trash key. (When you shoot a continuous or bracketed series of images, only the last picture exposed is displayed on instant playback.)

Use the Instant Playback menu option to control whether the image appears for two seconds (the default), five seconds, or ten seconds. Picture review is automatically cancelled when you press the shutter button or perform another function, or if Eye-Start Autofocus is activated and you bring the camera to your eye, so you'll never be blocked from taking a picture because the last shot is currently on the LCD screen. If you don't want images to be displayed for review, you can also choose Off. You might want that option when taking photos in a darkened theater or concert venue to avoid distracting others, to save power, or simply to bypass reviewing each shot. You can always review the last picture you took at any time by pressing the Playback button.

Noise reduction

Your Sony Alpha DSLR-A100 can automatically remove noise caused by exposures of one second or longer using a process called *dark frame subtraction.* Following your original shot, the camera takes a second, blank picture and compares the artifacts found in this image with the original. The camera judges common artifacts as noise and suppresses then. While this noise reduction is taking place, a message "Processing..." appears on the LCD, and you can't take another picture until the process is complete.

Turn noise reduction off if this delay is objectionable, you don't mind the multi-colored speckles that appear, and/or you wish to perform noise reduction yourself using your image editor or RAW converter.

Eye-Start Autofocus

One of the Sony Alpha's most charming — or alarming — features is its ability to leap into action whenever you move the camera viewfinder to your eye. The image on the LCD vanishes, the camera adjusts autofocus, and, if you've selected an automatic exposure mode, it sets shutter speed and/or aperture for you. Eye-Start Autofocus (AF) is convenient, especially when you're shooting fast-moving subjects and want to take pictures quickly. You may find that focus is frequently achieved more rapidly than when Eye-Start AF is switched off and the A100 doesn't initiate focus until you partially depress the shutter button. However, this feature can be quirky in some shooting situations. The camera may turn off the LCD and switch on autofocus when a stray hand or other object passes near the viewfinder, and the feature does use significantly more battery power. If you choose to, you can turn off Eye-Start AF with the menu setting Eye-Start Off.

Red eye

Light from the built-in flash bouncing off the corneas directly back into the camera lens can produce a red eye effect (which appears as yellow or green eyes in animals). You can successfully remove red eye using specialized tools built into image editors, or you can take a stab at it using the red eye reduction feature, which is turned off by default. When activated, the A100's flip-up flash issues a few brief bursts prior to taking the photo, theoretically causing your subjects' pupils to contract and reducing the effect.

This option works only with the built-in flash, and doesn't produce any prebursts if you have an external flash attached. In most cases, the higher elevation of the external flash effectively prevents red eye anyway.

 Cross-Reference *You can find more about electronic flash in Chapter 5.*

Flash control

Use this option to switch the electronic flash between the ADI flash (Advanced Distance Integration) and Pre-flash TTL (Through the Lens) options. You'll find more details in Chapter 5. The options work as follows:

✦ **ADI flash.** When you use this setting, the built-in flash and compatible external dedicated flash units issue a preflash immediately before the picture is taken, and the A100 measures the amount of light reflected back to the camera and uses that data along with distance information provided by D-type lenses to calculate the optimal exposure.

✦ **Pre-flash TTL.** A pre-flash is emitted and the camera measures the amount of light reflected back through the lens to calculate exposure. Use this setting with non-D-type lenses that don't supply the camera with distance information, or when you are using close-up lenses, neutral density or other dense filters, as well as wide angle/diffuser panels on the flash unit.

Flash default

This setting controls whether the built-in electronic flash fires only when needed to illuminate an image when you use Auto, P, or one of the Scene modes; or whether the flash fires all the time when you use one of those modes, supplying Fill Flash illumination. Note that you must manually flip up the flash for this option to have any effect; the Sony Alpha built-in flash does not pop up on its own. When you use M (Manual), A(Aperture), or S (Shutter Priority) modes, the flash is under your control and you can adjust it using the Flash position on the Function dial; this is described later in this chapter.

Bracket order

This setting controls the order in which exposures are made when you take a set of three ambient illumination or flash illumination bracketed exposures. Bracket order does not apply to white balance bracketing. Your choices are

✦ **0Ev>-Ev>+Ev.** The first shot is taken at the normal exposure, the second shot is given less exposure, and the final image is taken with more exposure than the normal setting. You choose whether the increment used is 0.3Ev or 0.7Ev by pressing the Drive Mode button and selecting single or continuous bracketing with the increment you want. (I know it's annoying to split up the two controls for the same function, but you change the increment more often than the bracket order, so it makes a kind of sense.) This setting is the default, because

it means the first shot (the one taken immediately) will have the "ideal" exposure, while the following two are the "tweaked" images.

✦ **-Ev>0Ev>+Ev.** If you choose this bracket order, the first shot is taken at an increment less than the normal exposure, followed by the normal exposure, and then by the image with the extra exposure. This variation produces a nice ordered set of images that begins with the darkest picture, followed by a slightly denser normal image, and the lightest version last. You can use this option when each of the three images has an equal chance of being the best composed shot.

Reset

If you want to cancel any changes you've made to the factory default Recording Menu settings, use this menu entry. Choose Reset, press the right button until Enter appears, and then press the center Set button and choose either Yes or No when the Reset Recording Mode message appears. Press Set again to confirm.

Playback Menu Settings

The Playback menu includes two screens of options, represented by a blue right-pointing triangle in the menus. The choices on the first page are labeled Delete, Format, Protect, Index format; the second page includes Slide show, DPOF set, Date imprint, Index print, and Cancel print.

2.3 Playback menu 1

2.4 Playback menu 2

Delete

Sometimes you know an image is a bad one right after you take it. Perhaps you snapped a shot of your foot by mistake, or managed to take a real (non) prize-winner with goofed up settings. You can always delete a photo immediately after you take it by pressing the Delete key, but sometimes you need to wait for an idle moment to erase pictures that must never, ever see the light of day. This menu choice makes it easy to remove selected photos (Marked Images), or to erase all the photos on a memory card (All Images). Note that neither function removes images marked Protected.

To remove selected images, select the Delete menu item, and press the right key to choose Marked Images. Press the center Set button, and a screen of images appears on the LCD. Use the right and left directional keys to navigate among the available images. When an image you don't want is highlighted, press the up key to mark it for deletion. Use the down key to unmark an image and remove the Trash icon that is applied. When you've marked all the images you want to discard, press the center Set key and select Yes when the "Delete marked images?" message appears.

While you can use this menu choice to Delete All images, the process can take some time. You're better off using the Format command, described next.

Format

Format removes all the images on the memory card, and reinitializes the card's file system by defining anew the areas of the card available for image storage, locking out defective areas, and creating a new folder in which to deposit your images. It's usually a good idea to reformat your memory card before each use with a new set of pictures. (Don't reformat it using your computer or its card reader; the resulting file system may not be compatible with your A100.) Formatting is generally much quicker than deleting images one by one.

To reformat your memory card, choose the Format menu entry, press the right key to select the Format option, and press the center Set button. Choose Yes when the All data will be deleted. Format? message appears.

Protect

You might want to protect images on your memory card from accidental erasure, either by you or by others who may use your camera from time to time. This menu choice enables you to protect only Marked Images (using a procedure similar to the Delete Marked Images process described earlier), protect All Images on the memory card, or Cancel All, which unmarks and unprotects any photos you have previously marked for protection.

To protect only selected images, select the Protect menu item, and press the right key to choose Marked Images. Press the center Set button, and a screen of images appears on the LCD. Use the right and left directional keys to navigate among the available images. When an image you want to protect is highlighted, press the up key to mark it for protection. Use the down key to unmark an image and remove the key icon that is overlaid on it. When you've marked all the images you want to protect, press the center Set key to return to the menu screen.

Index format

When reviewing images in Index mode, you can have the pictures shown in the format you prefer: 16 images, 9 images, or 4 images per screen. You can also use File Browser mode, which displays six images per screen from the currently selected folder on your memory card.

Once you've set your index format preference here, you can navigate the index displays in Playback mode. Press the Display button until the Index view appears. Navigate among the images with the direc-

tional buttons. If you've chosen File Browser mode as your Index format, press the Reduce button to highlight the row of folders and press the left/right buttons to scroll among the folders. When the folder you want is highlighted, press the Reduce button again to navigate among the images displayed from that folder.

Slide show

The first item in Playback menu 2 is a simple slide-show option that allows you to display all the images on your memory card using a five-second delay between images. You don't have any choices for length of display or transitions, but you can end the show by pressing the down key or the Menu button; jump back to the previous image or jump ahead to the next one by pressing the left and right buttons (respectively), or pause the slide show by pressing the center Set button. The Display button controls whether the images appear with shooting information or just as images alone.

DPOF set

All recent digital cameras, including the Sony Alpha A100, are compatible with the DPOF (Digital Print Order Format) protocol, which enables you to mark in your camera which of the JPEG images on the memory card you'd like to print, and the number of copies of each that you'd like. You can then take your memory card to your retailer's digital photo lab or print-yourself kiosk, or use your own printer to print out the marked images and quantities you've specified.

You can choose to print All on Card or Marked Images. Selecting images is similar to the method you use to mark images for

deletion or protection. To print selected images, select the DPOF Set menu item, and press the right key to choose Marked Images. Press the center Set button, and a screen of images appears on the LCD. Use the right and left directional keys to navigate among the available images. When an image you want to print is highlighted, press the up key to mark it for printing. Continue pressing the up key to choose 2–9 prints of that image. To reduce the number of images, press the down key. Press the left/right keys to navigate to different images you want to print. When you've marked all the images you want to print, press the center Menu key to return to the Menus screen.

Your printer software or your retailer's equipment detects the marked images and can make the prints for you.

Date imprint

Choose this menu item to superimpose the current date onto images when they are printed. Select On to add the date; Off (the default value) skips date imprinting. The date is added during printing by the output device, which controls its location on the final print.

Index print

Set this option On to create an index print of all the JPEG images in a folder at the time the Index print option is invoked—when the images are printed. Choose Off to skip printing of an index print. Any pictures you take after you specify the index print are not included in the index; this should be your last step before having the images on a card printed.

Cancel print

This menu item removes all DPOF print selection and quantity marks, and removes the current index print. This entry is useful if you print photos from a memory card, but leave the images on the card while you shoot additional pictures. Removing the DPOF markings clears the card of print requests so you can later select additional or different images for printing from the same collection.

Custom Menu Options

You make settings to customize the behavior of your camera and its controls in the Custom menu, which is represented by a violet gear icon in the menu screen. It consists of two screens of options. Custom menu 1 has entries labeled Priority setup, FocusHoldButt., AEL button, Ctrl dial set, Exp. Comp. set, and AF illuminator. In Custom menu 2, you'll find Shutter lock (card), Shutter lock (lens), AF area setup, Monitor Disp., Rec. display, and Play. display.

2.5 Custom menu 1

2.6 Custom menu 2

Priority setup

This custom setting determines whether or not you can take a photo before the A100's autofocus system has locked in correct focus. With the default setting (AF), if you depress the shutter release all the way, but sharp focus hasn't been achieved, no picture is taken. This mode is sometimes called *Focus Priority*. If you set the alternate option, Release (RP), the picture is taken even if autofocus has not been confirmed. This mode is called *Release Priority*.

Most of the time, you probably want to use Focus Priority to avoid taking pictures that are even slightly out-of-focus. Say you're shooting a flower outdoors, and the wind is causing the blossom to tremble a little, moving it in and out of focus. It's helpful to have your A100 stop you from taking a blurry picture.

Release priority is useful when you want to take a photo right now and don't mind if the shot isn't perfect. Perhaps you're taking action photos at a football game and are trying to track a receiver who's about to catch the game-winning touchdown. You want *that* picture, taken at the instant you press the shutter release. A little focus blur won't hurt much—particularly if the Alpha has focused almost, but not quite, accurately. Indeed, for a sports photo, some blur might actually add a feeling of motion to the shot. Another typical release priority situation might be if you were photographing a fast-moving child and see an adorable, but fleeting, expression you want to capture. You probably won't care if the image is just slightly out-of-focus.

Focus hold button

Some Sony-branded lenses for the A100 (as well as some earlier lenses for the Minolta and Konica Minolta brands) include one or more focus hold buttons that you can press to lock in autofocus. You can use this Custom setting to change the behavior of the focus hold button so that it functions as a depth-of-field preview instead. Choose either Focus hold or D.O.F. preview in the menu entry.

At this writing, the Sony lenses that include focus hold buttons are the 35mm f/1.4 wide angle; 50mm f/2.8 macro; 100 f/2.8 macro; 85mm f1/4 short telephoto; the 500mm f/8 reflex telephoto, 70–200mm f/2.8 G-Series telephoto zoom (three buttons);and the 300mm f/2.8 G-Series super telephoto (four buttons). The multiple buttons found on some lenses all perform the same function, but are located in different positions on the lens so the photographer can find one easily by touch.

AEL button

This Custom setting changes the behavior of the AEL (AE Lock) button's two functions: autoexposure lock using the currently specified metering mode (multisegment, center-weighted, and spot); and spot autoexposure lock (which switches to spot metering and locks in exposure). Your choices include:

✦ **AE hold.** In this mode, hold down the AEL button to lock in the current exposure. Keep in mind that you need to hold down the AEL button while taking the picture to ensure that the exposure is locked.

✦ **AE toggle.** In this mode, you don't need to hold down the AEL button to lock exposure. Just press it once and the exposure is locked; press it again to unlock exposure (say, under lighting conditions that have changed).

✦ **AE hold (spot).** When this option is selected, hold down the AEL button to switch from your current metering mode to spot metering, and to lock in the current exposure. You may find this setting helpful if you want to use multi-segment or center-weighted metering most of the time, but would like the option to switch temporarily to spot metering for a particular shot. You must hold down the AEL button until the picture is taken to ensure that the spot exposure is locked.

✦ **AE toggle (spot).** In this mode, the A100 also switches to spot metering, but you don't need to hold down the AEL button to lock exposure. Just press it once and the spot-metered exposure is locked; press it again to unlock exposure (under lighting conditions that have changed). Again, this is a good choice when you use multi-segment or center-weighted metering most of the time, but want a quick spot metering option.

Control dial set

The Control dial has a specific, predefined function in Manual and Program shooting modes. By default, spinning the Control dial in Manual mode changes the shutter speed; holding the Exposure button and spinning the Control dial changes the aperture. In Program mode, rotating the Control dial changes the shutter speed as a "program shift" and the A100 modifies the aperture so the same effective exposure is produced using this new combination of shutter speed and f-stop. That's the behavior of the Control dial when this Custom menu entry is set to Shutter speed.

You can reverse the behavior by choosing the alternate setting, Aperture, instead. In that case, in Manual mode, rotating the Control dial changes the aperture, while the Exposure button + Control dial adjusts the shutter speed. In Program mode's program shift, the Control dial adjusts the f-stop and the camera selects a shutter speed to match.

How you have this Custom entry set depends entirely on your preferences; there is no advantage to one setting over the other from a photographic standpoint.

Exposure compensation set

This Custom option specifies what exposure elements (from shutter speed, aperture, ISO, and flash) are used to adjust exposure when you enter an exposure compensation change. This option can be a little confusing at first, but it's really not excessively complex.

In any shooting mode (including Scene modes), you can adjust the exposure upward or downward from the exposure calculated by the Alpha. Just press the Exposure button on the back of the camera, and rotate the Control dial to the right to add exposure (brighten the image) or to the left to decrease exposure (darken the image). The amount of exposure compensation you've dialed in appears on the exposure scale in the viewfinder and on the LCD display.

Ordinarily (with the default Ambient & Flash setting active), when you specify plus or minus exposure compensation, the A100 changes the shutter speed, aperture, and the ISO setting (in Auto mode only) to provide the additional or decreased exposure. If you're using flash, the amount of flash illumination used for subjects within the range of the flash is also taken into account.

If you choose the Ambient only setting, the amount of flash illumination is fixed; it does not increase or decrease even though

you've requested plus or minus exposure compensation. You can use this option when you're satisfied with the flash exposure, but want to make the subject matter out of the flash range lighter or darker.

AF illuminator

Often, you may flip up the A100's built-in electronic flash unit when shooting under dim illumination. This Custom setting controls whether the built-in flash emits a pre-burst when the shutter button is depressed halfway, to provide additional light so the A100's autofocus system can more easily achieve sharp focus. The default value, On, uses the flash as an autofocus illuminator. Change this setting to Off when you don't want to use a preflash for autofocus (usually in situations in which the flash is distracting) or you use the camera flash to trigger external flash units remotely through a slave device and the preflash would set them off.

Shutter lock (card)

By default, the Sony Alpha A100's shutter operates even if you don't have a memory card inserted. I feel that's a dangerous setting, because it's easy for a distracted photographer who isn't watching the LCD or viewfinder displays carefully to go off and take a batch of pictures with no "film" in the camera. Setting this shutter lock to Off is useful chiefly when you're experimenting with the camera and don't want to take any photos. I recommend using the On setting, which locks the shutter release when there is no memory card in the camera.

Shutter lock (lens)

This additional shutter lock function is less critical, as it enables/prevents (the default) taking a picture when no lens is mounted. In practice, there is little risk in setting this option to Off, which allows the shutter to be released when no lens is mounted. It's fairly difficult to not notice that there is no lens mounted on your camera and accidentally take "lensless" photos. On the other hand, there are certain situations when a lens that is not recognized as such is mounted on the camera (say, a lens on a nonautomatic extension tube, or a telescope that has been fitted to the camera) and you certainly do want the camera to take pictures even though it isn't aware that suitable optics are in place.

Change this setting to On (the default) if you want to lock the shutter when a lens is not mounted on the camera.

AF area setup

The Sony Alpha A100 shows the focus zone used to calculate autofocus by flashing its indicator bracket in red. By default, the focus frame is illuminated for 0.3 seconds. You can double the length of the display to 0.6 seconds, or turn it off entirely.

Monitor Display

The Alpha can turn off the LCD display when you've brought the camera up to your eye and are peering at the viewfinder display. The sensors located directly below the viewfinder window detect whether you are looking through the viewfinder or not. The default setting is Automatic; choose Manual if you want the LCD to remain for the length of time specified in the LCD backlight setting in Setup menu (5, 10, 30, or 60 seconds), or until you press the shutter release button halfway or perform some other task.

Recording display

Use this Custom setting to cause the recording information display to rotate when you hold the camera in a vertical position (which I find annoying because the layout of the display changes along with the orientation), or to remain as a horizontal display. Auto rotate is the default; choose Horizontal if you want the recording display to remain fixed.

Play display

Your Sony Alpha A100, as well as many software packages, can automatically rotate and display in portrait mode (with the long side of the image vertical) all images you have shot in a vertical orientation, using information embedded in the image file by the camera. That's usually a good thing when viewing the image on your computer screen, but it makes the image smaller when it plays back in your camera. The short dimension of the LCD shows the tall dimension of the image, and there's lots of wasted space on the LCD screen on either side of the rotated image. Auto rotate is the default setting. Choose Man. rotate if you prefer to rotate the image yourself (press the down button on the controller pad to rotate the image manually).

Setup Menu Options

The Setup menu is the engineering section of the menus with three separate screens, represented by a pumpkin yellow wrench icon, where you can control certain equipment-oriented options. In Setup menu 1, you can find LCDbrightness, Transfer mode, Video output, Audio signals, Language, and Date/Time set. Setup menu 2 includes File # memory/Reset, Folder name, and Select folder/New folder. Setup menu 3 has LCD backlight, Power save, MenuSec.Memory, Delete conf., Clean CCD, and Reset default.

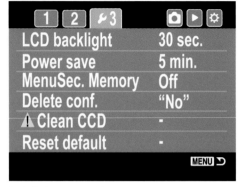

2.9 Setup menu 3

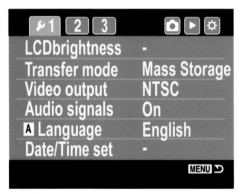

2.7 Setup menu 1

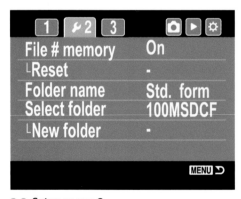

2.8 Setup menu 2

LCD brightness

When this menu item is on the screen, use the left/right controller keys or the Control dial to adjust the brightness of the LCD. You may find the monitor display difficult to view under direct light, particularly outdoors, and it may be brighter than you want under some indoor conditions. For example, when I shoot in theaters or at concerts, I turn down the LCD brightness to avoid distracting other people in attendance.

Transfer mode

This setting controls how the camera presents itself when linked by USB cable to another device. If you're connecting to a computer to transfer photos, the default setting of Mass Storage is the correct choice. Your computer then sees the camera as a mass storage device. If you want to send your images to a PictBridge compatible printer to print directly from the camera, choose the PTP (Picture Transfer Protocol) setting.

Video output

This option enables you to choose the video output protocol you use when you connect the camera to an external monitor. Use NTSC for television systems in the US, Japan, and some other countries or PAL for Europe and other regions.

Audio signals

Use this option to turn the A100's beep sounds (used to signal the self-timer count-down and provide warning signals) on or off.

Language

Choose Language from Setup menu 1, press the right key to highlight the six languages available, then press the up/down buttons to select from English, French, Spanish, Italian, Japanese, or Chinese. Press the center Set button to confirm your choice.

Date/Time set

This menu item produces a screen that lets you individually set the month, day, year, time, and date format (from mm/dd/yyyy to dd/mm/yyyy or yyyy/mm/dd).

File # memory

Usually you want the A100 to increment the number of each photo you take, regardless of whether you've changed media or refor-matted the memory card. By assigning a folder number (100MSDCF, 101MSDCF, and so forth) plus a sequential number from 0001 to 9999 to each image, you can avoid duplicate file names. You end up with images named, for example, DSC02883, DSC02884, and so forth. That's the default behavior for this first option in Setup menu 2.

You can also switch File # memory Off. In this case, the Alpha always starts numbering from 0001 when new media or a new folder is used, or when you're using a date form folder (see the section "Folder name" for more). However, if the memory card folder already contains images, a number one higher than the largest number applied will be used. For example, if the folder contains an image numbered DSC07884, the next photo taken will be labeled DSC07885.

Reset

This setting returns the file number to 0001, which is assigned to the next image unless the folder in use already contains a file; in that case, a number one higher than that number is used.

Folder name

The A100's default folder naming scheme uses folders labeled 100MSDCF, 101MSDCF, and so forth. A standard form new folder is created automatically when an existing folder has 9,999 images.

You can also choose the Date form folder option, in which case folders are created using the current date as part of their name, for example 1017055 for a folder created on May 5, 2007. Each time the date changes, a new folder with an appropriate name is cre-ated. This is a handy way of keeping track of images taken on particular days.

Select folder

This Setup option enables you to choose from among two or more standard form folders. Press the right directional key to choose Select folder, then scroll among the available folders using the up/down keys. Press the center Set button to confirm your choice, which becomes the current folder used to store images. Note that you cannot elect to make a date form folder the active folder; when date form folder naming is active, images are always saved in a folder corresponding to the current date.

New folder

Use this option to create a new folder for storing images. You might want to do that when traveling on vacation, so that photos taken in each city you visit are stored in individual folders.

LCD backlight

The first Setup menu 3 setting enables you to specify the length of time the recording information display remains on the LCD monitor. Your choices include 5, 10, 30, and 60 seconds. The display also switches off if you press the shutter button down halfway or perform some other function.

Power save

To improve the performance of your A100's rechargeable battery, you can specify how long the camera remains active before it shifts into a power-saving mode that draws significantly less juice. Once in this mode, you can return the camera to life by tapping the shutter release button, or using any of the other controls. The default value is 3 minutes. If you really want to stretch your power, or know you'll be taking photos only intermittently, use the 1 minute setting.

If you find it inconvenient to have your camera go to sleep on you, change this setting to 5, 10, or 0 minutes.

Menu Section Memory

Each time you press the Menu button, the Alpha displays the Recording menu 1 screen first if you are in Recording mode, or the Playback menu 1 screen if you are currently viewing photos on the LCD. If you find yourself frequently using the same menu items over and over (for example, you're taking long exposures but want to turn noise reduction on or off for specific shots), change the setting from Off (the default) to On, which tells the A100 to display that last viewed menu item first.

Delete confirm

For safety's sake, when you delete images or folders, the confirmation screen defaults to No. If you're confident that you won't accidentally remove items you want to keep, you can change this setting to Yes, so that all you need to do is press the center Set button when the confirmation screen appears.

Clean CCD

When it's time to clean the sensor (despite the best efforts of the camera's highly effective Anti-Dust system), use this menu entry to lock the mirror up to provide access to the charge-coupled device (CCD). You can find suggestions for performing this cleaning task

in Appendix A. Use a fully charged battery or optional AC adapter, choose Clean CCD from the Setup menu 3, press the right directional button and then press the center Set button to activate the lock. A warning screen pops up "After cleaning the CCD, turn camera off. Continue? Yes No." Choose Yes with the left directional button and press the center Set button to move the mirror into its fully upright and locked position.

Reset default

This menu choice resets most of the main functions of the camera to their factory default positions. These include ISO, White Balance, Color mode, Contrast, Saturation, Sharpness, Autofocus mode, Metering mode, Drive mode, Exposure compensation, and other settings.

Function Dial Setup

The Sony Alpha A100's Function dial takes the place of the multiple direct function buttons found on dSLRs from other vendors. These cameras are studded with ISO, White Balance, Metering mode, and Flash buttons. The A100, on the other hand, combines all these control buttons, and more, onto a single Function dial that you can rotate quickly to summon a menu on the LCD. The Function dial, located on the upper left top panel, is a fast way to access some of the most-used settings quickly without the need to wade through pages of menus.

To access any of these features, spin the Function dial to the relevant setting and press the Function button in the center of the dial to display the menu.

Metering Mode

The Metering Mode screen has three choices for the types of metering that you can use in P, A, S, and M shooting modes (but not in Auto or the Scene modes, which automatically use multisegment metering). Figure 1-17 in Chapter 1 shows the parts of the frame evaluated by each of these modes. To recap, your choices are

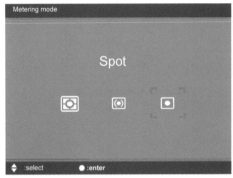

2.10 The Metering Mode has red brackets around the icon representing the multisegment, center-weighted, or spot metering option selected.

✦ **Multisegment (matrix).** The camera looks at 39 hexagon-shaped zones concentrated in the middle of the frame, as well as a 40th zone that encompasses the outer edges of the picture area. The A100 uses the pattern of light and dark areas that it finds to make some intelligent guesses about what kind of picture you are taking (such as landscape or portrait subject) and calculates an exposure that best suits that type of subject. Multisegment metering is usually your best choice for a variety of different kinds of pictures. If the lighting pattern in your image is

unusual, you can opt for one of the other two metering modes.

✦ **Center-weighted.** The camera collects exposure information over the entire frame, but when it makes its calculations, it emphasizes a central area of the screen. This mode is an excellent choice when the most important part of your subject is in the middle of the frame, but you want the rest of the picture area taken into account, too. Center-weighting tends to provide excellent exposures for scenes in which lighting is equally distributed, without being thrown off by bright areas (spotlights, areas of sky, and so forth) near the edges of the frame.

✦ **Spot.** Exposure is calculated entirely from the center spot area. This is the mode I use at concerts or stage events where the performers are often spot lit and surrounded by dark backgrounds.

Don't forget that even though you've chosen multisegment or center-weighted metering mode here, you can quickly switch to spot metering and lock in an exposure in that mode if you've chosen AE hold (spot) or AE toggle (spot) in the Custom menu, as described earlier in this chapter.

Flash

Turn the Function dial to the Flash position, and a menu appears with two types of options. You can choose Flash mode (Auto, Fill Flash, Rear-curtain sync, and Wireless) or Flash compensation.

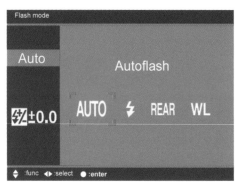

2.11 Flash setup showing the Autoflash option selected.

There are four Flash modes:

✦ **Autoflash.** If you've set this as the main mode using the Flash default setting in Recording menu 2, Autoflash operates if you are using Auto, P, or one of the Scene modes, and have flipped up the flash. It causes the flash to fire when light levels are low, or the subject is backlit. Autoflash is not available when you're using Aperture Priority, Shutter Priority, or Manual shooting modes.

✦ **Fill Flash.** You can set this as the main flash mode using the Flash default setting in Recording menu 2. When the mode is active, if the electronic flash is flipped up, it always fires to brighten the dark areas of your image when you're using Auto, P or one of the Scene modes. Most of the exposure is made by the ambient (available) light, with the flash balanced to fill in the shadow areas.

✦ **Rear-curtain sync.** The flash delays until just before the shutter closes. This mode is useful when you want streaks caused by a secondary exposure from the ambient light to trail behind moving subjects.

 Cross-Reference *You can find more information on rear-curtain sync in Chapter 5.*

✦ **Wireless.** Use this mode when using an off-camera flash (either the HVL-F56AM or HVL-F36AM) in wireless mode. You'll find a description of how to use these external flash units wirelessly in Chapter 5.

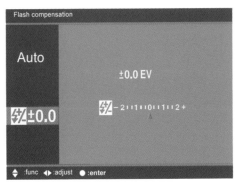

2.12 Flash compensation is shown in this scale.

Flash exposure compensation enables you to add or subtract a little exposure (plus or minus two f-stops worth) from the automatic exposure your A100 calculates for a flash picture.

With the Flash function screen visible on the screen, press the down directional control to select flash compensation. Then use the left/right directional buttons to add or subtract exposure, in 1/3 f-stop increments, using the exposure scale shown. The exposure scale also appears on the recording information display on the LCD, below the ambient light exposure compensation. This feature is especially useful when you're trying to use fill flash to brighten up shadows and your Sony Alpha A100 provides either too much or too little fill.

Focus

This function enables you to choose the focus area used to calculate correct focus, as well as the type of autofocus system used to lock in focus.

The Sony Alpha A100 has four different focus modes, chosen from the AF Mode screen:

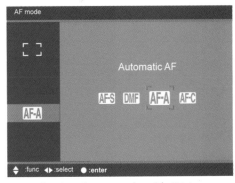

2.13 The Autofocus mode with AF-A selected

✦ **Single-shot AF (AF-S):** In this mode, the A100 tries to focus the image as soon as you partially depress the shutter-release button. When focus is achieved, the in-focus indicator light illuminates, and focus is locked at that point. If you don't release the shutter button completely between shots and instead keep it depressed while continuous shots are taken, the focus remains at the locked point for all the shots. Use this mode for subjects that are relatively motionless.

✦ **Continuous AF (AF-C).** In this mode, the A100 attempts to focus the image when you partially depress the shutter-release button, and then continues to refocus until you take the picture. Use this mode for action photography and other moving subjects.

✦ **Automatic AF (AF-A).** In this mode, the camera selects either AF-S or AF-C for you, depending on whether the subject is moving and other shooting conditions. This is the default focus mode for the A100, and enables you to shoot both motionless and moving subjects without worrying about when focus is locked.

✦ **Direct Manual Focus (DMF).** Despite the name, this is an auto-focus mode. However, it enables you to fine-tune focus manually after autofocus has been achieved. Use this mode to correct the focus when an intervening subject enters the frame. (You can also switch the lens to manual focus for full-time manual focusing, which disables this autofocus feature. The green confirmation light in the viewfinder lets you know when the image is correctly focused.)

You can also choose how the focus zone used to calculate correct focus is selected. Choose from:

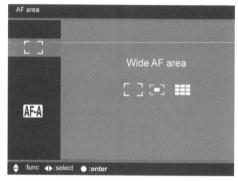

2.14 The autofocus area

✦ **Wide AF Area.** This is the default mode. The Alpha chooses the most suitable of the nine focus frames that are located within the wide focus frame, and illuminates the frame in red momentarily so you know what part of your subject the camera is basing its focus on. To switch to the center focus spot, press the center Set/AF button on the controller pad and hold it down until you've pressed the shutter release all the way.

✦ **Spot AF area.** In this mode, the center spot focus frame is used to calculate focus.

✦ **Focus Area Selection.** Use this mode if you want to choose the focus frame yourself. Press the controller's directional keys (north, south, east, west, plus northwest, northeast, southwest, and southeast — eight directions in all) to navigate to the focus frame you want to use. Press the controller's center Set/AF button to switch to the center spot focus frame.

ISO

This function enables you to choose the sensitivity setting manually or enable the Alpha to choose the ISO for you. Select from Auto (which uses ISO settings from 100 to 800 only), 100, 200, 400, 800, or 1600. If you want to use the Zone Matching feature, select Lo80 to keep dark scenes from becoming underexposed, or Hi200 to keep extra bright scenes from becoming overexposed.

Boosting the ISO setting increases the amount of noise in your photo, but enables you to take pictures under reduced light levels. Higher ISO settings also increase the range of your electronic flash.

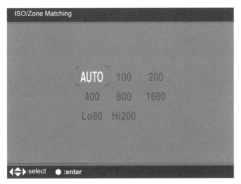

2.15 The ISO setup

White balance

White balance is the relative color of the light source, measured in terms of *color temperature*. Indoor, incandescent illumination has a relatively low (warm) color temperature number in the 3000K (degrees Kelvin) range; outdoors in sunlight, the color temperature number is higher (which means it's colder), from about 5000K to 8000K. Electronic flash units have a color

temperature of about 5400K, but this can vary with the length of the exposure. Flash units provide reduced exposure by quenching the flash energy sometime during the flash itself.

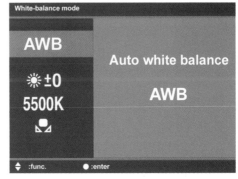

2.16 The white balance setup

Your A100 makes some pretty good guesses about the color temperature of its environment. In addition, you can specify color temperature yourself using this function's four menu entries: White balance mode, Preset white balance, Color temperature, and Custom white balance.

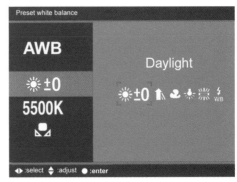

2.17 The preset white balance

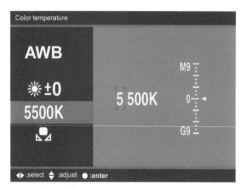

2.18 The color temperature setup

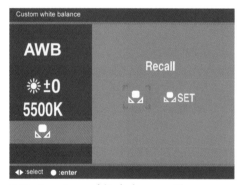

2.19 A custom white balance setting

Remember that you can't change the white balance of JPEG images once the picture is taken, although you may be able to do some color balance correction in your image editor. If you shoot RAW images, the A100 applies the white balance setting to the image, but you can change to any other white balance when the RAW file is imported into your image editor using Sony's Image Data Converter SR, Adobe Camera RAW, or another RAW converter utility.

✦ **Auto white balance.** Choose this setting and the A100 adjusts white balance for you. This is the default and works in most situations. If you find that the colors of your JPEG images have poor color balance, you can use one of the other modes to fine-tune the white balance.

✦ **Preset white balance.** Use the A100's built-in preset values tailored for specific types of illumination. Use the down directional key to move down to the Preset white balance correction, and then press the right key to select Daylight, Shade, Cloudy, Tungsten, Fluorescent, or Flash. When any of these are highlighted, you can press the up/down keys to fine-tune the preset's white balance. The up key makes the image warmer/more reddish; the down key produces a cooler/bluer color temperature. Values of plus/minus 3 are available for all presets except Fluorescent, which can be adjusted from plus 4 to minus 3. Press the controller's center Set button to confirm your choice.

✦ **Color temperature.** Use the down directional key to highlight the Color temperature choice, and then press the right key to move the cursor to the Thousands column (to make large changes in 1000 degrees Kelvin); to the Hundreds column (to change color temperature 100 degrees Kelvin at

a time); or to the Color correction filter column, which allows you to adjust the color temperature on a scale from Green (at the bottom of the scale) to Magenta (at the top). Use the up/down directional keys to adjust the Kelvin degrees or Color correction values. When you use color temperatures, the available range is 2500K to 9900K.

✦ **Custom white balance.** Setting a custom white balance enables you to measure the actual color temperature of a scene and use that as the A100's white balance setting. This mode works best for scenes that have mixed light sources (window light and incandescent lamps). To set a custom white balance, scroll to the Custom option with the down key, and then press the right directional key to display the Custom white balance screen. Select Set and then follow the directions that lead you through taking a custom white balance sample image. Choose Recall to set white balance to the memorized value.

Dynamic Range Optimization

The Sony Alpha's Dynamic Range Optimization (D-RO) function is a cool feature that provides a way to correct for difficult brightness and contrast in an image without resorting to an image editor's sophisticated curves features. Instead, when one of the Alpha's D-R options is selected, the camera uses a built-in library of 400,000 curves to select one that produces the best tonal values in your image. Working with curves deserves an entire chapter of its own and is best addressed in a book on Photoshop or another image editor; it's beyond the scope of this book.

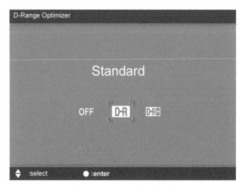

2.20 Dynamic Range Optimization

The A100 has two D-RO variations. D-R (Standard), the default, provides the fastest working processing capabilities, because it adjusts the brightness and contrast of the entire image using its collection of curves. D-R+ (Advanced) is a more sophisticated tool that examines and corrects each image area by area, and corrects color reproduction at the same time. If you like, you can switch D-RO off entirely in this function menu.

Dynamic Range Optimization operates only when the A100 is set to multisegment metering (it doesn't work with center-weighted or spot metering), and can be used with Auto, P, A, S, or Scene modes. (It won't operate in

Manual mode.) Moreover, you must be shooting JPEG only; RAW or RAW & JPEG aren't options for D-RO functions.

Color/DEC

This Digital Effect Control (DEC) function lets you correct color, contrast, saturation, and sharpness, when using P, A, S, or M modes. The Color/DEC screen includes a slider at top that enables you to choose Standard, Vivid, Portrait, Landscape, Sunset, Night View, Black-and-White, and Adobe RGB modes, and then adjust the contrast, saturation, and sharpness for any of them.

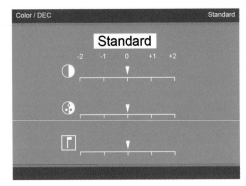

2.21 Color/DEC

Creating Great Photos with the Sony Alpha DSLR-A100

Photography Essentials

Y ou're out in the field, see a perfect picture-in-the-making, and want to use a little creativity to make it extra special. Then, you realize that you've relied on your A100's automated features so much that you're a little rusty on some of the basics you need to apply. Don't panic! In this chapter, you can find a quick refresher in some photography basics. Spend a minute or two boning up on exposure, depth of field, and a few other topics, and then capture that award-winning shot!

Understanding Exposure

As a Sony Alpha user, you probably have a pretty good grasp of proper exposure already. You may understand f-stops and shutter speeds and their relationship with ISO settings, and have already used them effectively in your photography. However, the A100 does such a good job of calculating exposure on its own, whether you're using one of the Scene modes, programmed exposure modes, or even Aperture- or Shutter-Preferred modes. The A100 doesn't leave you entirely on your own in Manual mode, either, because the exposure scale indicator in the viewfinder shows you when your manually selected f-stop and shutter speed are more or less correct.

Creative photography often calls for an understanding of how exposure works. Here's a quick overview to bring you up to speed.

What affects exposure?

Digital cameras, like film cameras, react to light passing through the lens and form an image when sufficient illumination reaches the sensor. The amount of light the sensor receives varies, depending on how much light is reflected or

transmitted by the subject, and how much actually makes it through the lens. Insufficient light results in an image that's too dark; too much light gives you an image that's too bright. The levels in-between form your image.

Proper exposure occurs when just enough light reaches the sensor to provide detail in the darkest areas of your image, while avoiding excessive illumination in the brightest areas (which cause them to wash out.) As you may know, four things affect exposure:

✦ **Light reaching the lens.** Your subject may reflect light (say, a flower basking in the sunlight), transmit light (for example, a back-lit flower with light coming through its petals), or be a light source on its own (as with a candle flame.) To change the exposure, you simply increase or decrease the amount of illumination from the light source that reaches the lens, for example, by increasing the amount of illumination or moving it closer to the subject.

✦ **Light passing through the lens.** The amount of light that makes it through the lens is limited by a number of factors, the most important of which is the size of the lens opening. Except for a few specialized lenses (such as mirror lenses like Sony's SAL-500F 80-500mm f/8 Reflex Super Telephoto lens), the optics for your A100 include a diaphragm that can be adjusted, usually through an arrangement of thin panels that shift to enlarge or reduce the size of the lens opening, as shown in the simplified image in figure 3.1. The relative size of the aperture is called the f-stop.

✦ **Light passing through the shutter.** The amount of light admitted by the lens is further adjusted by the duration of the exposure, as determined by the shutter. With the A100, shutter speeds can be as brief as 1/4000 second, or as long as many seconds.

3.1 The diaphragm controls the size of the lens opening.

✦ **Sensitivity of the sensor.** The sensor, like film, has an inherent response to the light that reaches it. This sensitivity is measured using ISO ratings, in much the way that various types of film are assigned ISO speed ratings. When the A100 is adjusted to use a higher the ISO setting, the signal produced is amplified, creating the same effect as a higher-sensitivity sensor.

All four factors work together to produce an exposure. Most important, they work together proportionately and reciprocally, so that doubling the amount of light reaching the lens, making the lens opening twice as large, leaving the shutter open for twice as long, or boosting the ISO setting two times all increase the exposure by the same amount.

Exposure adjustments

From an exposure standpoint, if you need more or less light falling on the sensor to produce a good exposure, it doesn't matter which of the four factors you change. In practice, however, that's seldom true, because each factor affects the picture in different ways, whether you are adjusting the exposure yourself or letting your A100 make the settings for you.

Adjusting the light reaching the lens

The lighting of your scene has an affect on both the artistic and technical aspects of your photograph. The quality of the light (soft, harsh), its color, and how it illuminates your subject determine its artistic characteristics. In exposure terms, both the quantity of the light and whether your subject is illuminated evenly have a bearing on the settings. You can do one of these things:

✦ **Increase or decrease the total amount of light in the scene.** Move your subject to an area that's better illuminated, or that has less light. Add lights or an electronic flash, or remove them. Bounce illumination onto your subject using a reflector placed in the light path to redirect it.

✦ **Increase or decrease the amount of light in parts of your scene.** If there is a great deal of contrast between the brightly lighted areas and the shadows in your picture, your A100's sensor will have difficulty rendering the detail in both. Your best bet is usually to add light to the shadows with reflectors, fill flash, or other techniques (all described in Chapter 5), or to move your subject to an area that has softer, more even lighting. Figure 3.2 shows a close-up made with two lights, with the second one added to fill in inky shadows. In figure 3.3, the extra light has been switched off. The shadows are darker and more dramatic.

3.2 Light has been added to the shadow areas, making for an even exposure.

3.3 Allowing the shadows to go dark makes a different kind of image, in some ways one that's more dramatic.

Adjusting the aperture

Changing the f-stop adjusts the exposure by allowing more or less light to reach the lens. In Manual or Aperture Priority modes, you can change the aperture independently by spinning the subcommand dial on the front of the camera. The f-stop you choose appears in the viewfinder and on the LCD status panel on top of the camera. There are several considerations to keep in mind when changing the lens opening.

✦ **Depth of field.** Larger openings (smaller numbers, such as f/2.8 and f/3.5) provide less depth of field at a given focal length. Smaller openings (larger numbers, such as f/16 or f/22) offer more depth of field (see figure 3.4). When you change exposure using the aperture, you also modify the range of your image that is in sharp focus, which you can use creatively to isolate a subject (with shallow depth of field; see figure 3.5) or capture a broad subject area (with extensive depth of field).

✦ **Sharpness.** Most lenses produce their sharpest image approximately two stops less than wide open. For example, if you're using a zoom lens with an f/4 maximum aperture, it will probably have the best resolution and least distortion at roughly f/8.

✦ **Diffraction.** Stopping down further from the optimum aperture may create extra depth of field (referred to as DOF), but you lose some sharpness due to a phenomenon known as diffraction. You want to avoid f-stops such as f/22 unless you must have the extra depth of field, or need the smaller stop so you can use a preferred shutter speed.

Note *Diffraction is the bending of electromagnetic waves (such as light) as they pass around corners or through holes smaller than the wavelengths of the waves themselves, such as the edges of the lens diaphragm.*

✦ **Focal length.** The effective f-stop of a zoom lens can vary depending on the focal length used. That's why the A100's kit lens is described as an f/3.5–f/5.6 optic. At the 18mm position, the widest lens opening is equivalent to f/3.5; at 70mm, that same size opening passes one and a half stops less light, producing an effective f/5.6 f-stop. At intermediate zoom settings, an intermediate effective f-value applies. Your A100's metering system compensates for these changes automatically, and, as a practical matter, this factor affects your photography only when you need that widest opening.

✦ **Focus distance.** The effective f-stop of a lens can also vary depending on the focus distance, but it is really a factor only when you shoot close-ups. A close-focusing macro lens can lose a full effective f-stop when you double the magnification by moving the lens twice as far from the sensor. The selected f-stop then looks half as large to the sensor, which accounts for the light loss. Your A100's exposure meter compensates for this, unless you're using gadgets like extension tubes, bellows, or other add-ons that preclude autoexposure.

Tip *Teleconverter lenses, which fit between your prime or zoom lens and your camera to magnify an image, can cost you from 0.4 to 2 f-stops. These include the Sony SAL-14TC and SAL-20TC.*

3.4 At f/22, both seashells are in focus.

3.5 At f/5.6, only the shell in front is within the plane of focus.

✦ **Rendition.** Some objects, such as points of light in night photos or backlit photographs, appear different at particular f-stops. For example, a streetlight, the setting sun, or another strong light source might take on a pointed star appearance at f/22, but render as a normal globe of light at f/8. If you're aware of this, you can avoid surprises and use the effect creatively when you want.

Adjusting the shutter speed

Adjusting the shutter speed changes the exposure by reducing the amount of time the light is allowed to fall on the sensor. In Manual and Shutter Priority modes, you can change the shutter speed by spinning the Control dial on the top of the camera. The speed chosen appears in the viewfinder and LCD status panel of the camera. You're probably familiar with most of the considerations involved when altering shutter speed:

✦ **Action stopping.** Slow shutter speeds allow moving objects to blur and camera motion to affect image sharpness. Higher shutter speeds freeze action and offer almost the same steadying effect as a tripod.

✦ **Wider vs. smaller f-stop.** When you change shutter speed, you also need to adjust the f-stop, so you might end up with less effective depth of field (when you use a high shutter speed and large f-stop) or much more depth of field (when you use a low shutter speed and smaller f-stop).

3.6 A high shutter speed freezes all the action — except for the fast-moving baseball.

Changing ISO

You can produce the same effect on your exposure as opening up one f-stop, or doubling the shutter speed, by bumping up the ISO setting from ISO 200 to 400. However, at least one side effect occurs when you boost the A100's ISO setting. Noise artifacts, those multicolored speckles that are most noticeable in shadow areas but which can plague highlights, too, appear denser and more numerous as the ISO setting is increased.

The Sony Alpha performs very well in this regard, fortunately. You probably won't notice much more noise at ISO 400, and

ISO 800 can produce some very good images indeed. While ISO 1600 is still quite usable, you can expect noise to be visible.

You can change the ISO by setting the Function dial to the ISO position, and then pressing the Fn button in the center of the dial to produce a screen of choices from Auto to ISO 100 through ISO 1600. The Alpha also offers "low standard" (ISO 80) and "high standard" (ISO 200), which optimize the response of the sensor for low-key dark, low-contrast images and high-key, light high contrast images respectively. Press the Set button to lock in your choice.

3.7 At ISO 200 (left), sensor noise is almost invisible. Boost the ISO to 1600 (right) and you'll be able to detect noise, particularly in the darker areas, and when the image is enlarged this much.

Getting the Right Exposure

If you're a more experienced photographer, you understand that good exposure involves much more than keeping your picture from coming out "too dark" or "too light." That's because no sensor can capture all the details possible in an image at every conceivable light level. Some details will be too dim to capture, and others will overload the photosites in the sensor and not register at all or, worse, overflows into adjoining pixels and cause washed out pixels, or *blooming* and other undesirable effects.

Digital sensors can't handle large variations between the darkest and lightest areas of an image, so the optimum exposure is likely to be one that preserves important detail at one end of the scale while sacrificing detail at the other. That's why you, the photographer, are often smarter than your A100's exposure meter. You know whether you want to preserve detail in the shadows at all costs, or if you are willing to let them fade into blackness in order to preserve the lightest tones.

Left to its own devices, the A100 has a tendency to allow the highlights to be clipped ("blown out") to preserve shadow detail. When you beginning using your A100, you may think it underexposes most pictures. However, when you begin making adjustments on your own, you will realize the camera is rescuing those parts of the image that are most easily corrected. You can often boost detail in areas that are underexposed, whereas there's not much you can do with blown highlights.

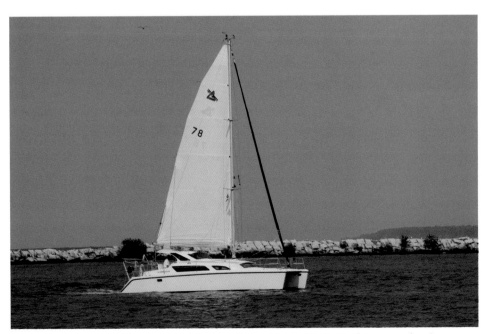

3.8 Only you can decide whether the detail in the highlights (as in this example of a sailboat) or the detail in the dark areas and shadows is most important for the image you're trying to take.

Understanding tonal range

The number of light and dark shades in your image is called its *tonal range*, and the A100 provides a tool called the *histogram*. While histograms can be shown live in the preview image of point-and-shoot cameras, for dSLR owners, they're generally an after-the-shot tool used to improve the *next* exposure.

You can view the histogram for any image you've taken by pressing the Playback button on the back of the camera (left of the LCD) to display the image on the monitor LCD. Then press the Up or Down Controller button (to the right of the LCD) until the information screen with the histogram graph appears.

A histogram is a simplified display of the numbers of pixels at each of 256 brightness levels, and produces an interesting mountain range effect, as you can see in figure 3.9. Each vertical line in the graph represents the number of pixels in the image for each brightness value, from 0 (black) on the left and 255 (white) on the right. The vertical axis measures the number of pixels at each particular brightness level.

This sample histogram shows that most of the pixels are concentrated roughly in the center, with relatively few very dark pixels (on the left) or very light pixels (on the right). Even without looking at the photo itself, you can tell that the exposure is good, because no tonal information is being clipped off at either end. The lighting of the image isn't perfect, however, because some of the sensor's capability to record information in the shadows and highlights is being wasted. A perfect histogram would have the toes of the curve up, snuggled comfortably with both the left and right ends of the scale.

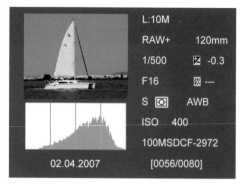

3.9 A histogram of an image with correct exposure and normal contrast will show a mountain-shaped curve of tones extending from the shadow areas (left) to the highlight areas (right).

Sometimes, your histogram will show that the exposure is less than optimal. For example, figure 3.10 shows an underexposed image; some of the dark tones that appeared on the graph in the original exposure are now off the scale to the left. The highlight tones have moved toward the center of the graph, and there's a vast area of unused tones at the right side of the histogram. Adding a little exposure by opening up the aperture or using a slower shutter speed will move the whole set of tones to the right, returning the image to the original, pretty-good exposure.

An overexposed image is shown in figure 3.11, with highlight tones lost off the right side of the scale. Reducing exposure by stopping down the aperture or using a faster shutter speed can correct this problem. As you work with histograms, you can use the information they contain to fine-tune your exposures.

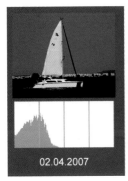

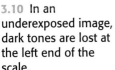

02.04.2007

02.04.2007

3.10 In an underexposed image, dark tones are lost at the left end of the scale.

3.11 In an overexposed image, tones are lost at the right end of the scale.

Fine-tuning

When you use P, A, S, and M modes, you can fine-tune your exposure and the tonal range of your images several ways. Here's a quick checklist:

✦ **In Manual mode.** Adjust the aperture or shutter speed to add or subtract exposure.

✦ **In Program, Shutter Priority, or Aperture Priority modes.** Perhaps you feel that choosing a different metering mode will let your A100 choose an appropriate exposure more easily. Turn the Function button to the Metering Mode position and press the Function button. Then, choose Multi-Segment, Center-Weighted, or Spot metering. While Multi-Segment generally does a great job, sometimes you want to use Center Weighting to add emphasis to subject matter in

the middle of the frame, or use Spot metering to meter from one precise area in the frame.

✦ **Apply EV settings.** Hold down the EV (exposure value) button, and spin the Control dial to apply up to plus or minus two stops worth of exposure in one-third step increments. The amount of change appears in the exposure scale in the viewfinder. EV adjustment actually adds or subtracts exposure from the A100's default meter reading using aperture or shutter speed changes, depending on what the current program mode specifies. The new shutter speed or f-stop appears in the viewfinder, so you'll know what your EV change has done.

✦ **Bracketing.** Press the Drive button and use the Controller Left/Right keys to select Continuous bracket or Single bracket. Use the Up/Down keys to select either a one-third stop increment between bracketed shots (0.3Ev) or as two-thirds stop increment (0.7Ev). In Continuous bracket mode, the Alpha shoots a series of three shots continuously as you press and hold the shutter button until the series is completed. In Single bracket mode, you must press the shutter button three times to take the complete series. Bracketing doesn't fine-tune an individual exposure but, rather, lets you take a series of pictures, one of which, you hope, is optimal.

3.12 Bracketing lets you take a series of photos at different settings, as shown in this composite image of three different exposures.

Tip

When you're using Program mode, the A100 selects the correct exposure for you. Use Program Shift to set a different combination. Press the shutter button halfway, and then spin the Control dial to change the shutter speed to a higher or lower value. The A100 chooses the appropriate aperture for you. Program Shift lets you switch from, say, 1/500 second at f/11 to 1/1000 second at f/8 or 1/250 second at f/16 quickly and easily.

Understanding Depth of Field

The final basic aspect of photography that photographers sometimes need to review is depth of field. While DOF is a familiar topic for those who have been using film SLR cameras, anyone who has stepped up to the Sony Alpha from a point-and-shoot digital camera may be foundering in brand-new territory.

What is depth of field?

It's difficult to talk about depth of field in concrete terms because it is, for the most part, a subjective measurement. By definition, DOF is a distance range in a photograph in which all included portions of an image are at least acceptably sharp. What's acceptable to you for might not be acceptable to someone else, and it can even vary depending on viewing distance and the amount the image has been enlarged.

Strictly speaking, only one plane of an image is in sharp focus at one time. That's the plane selected by your A100's autofocus mechanism, or by you (if you've manually focused). Everything else, technically, is out of focus. However, some of those out-of-focus portions of your image may still be acceptably sharp, and that's how you get depth-of-field ranges.

Determining depth of field

Depth of field is determined by the focal length of the lens and the distance from the camera to the subject. So, that 7–21mm 3X zoom lens on your point-and-shoot camera may have the same field of view as a 35–105mm zoom on a full-frame film camera, but the depth of field will be much greater. The telephoto position, for example, had the same depth of field as any 21mm lens. Depth-of-field remains constant for any given focal length; only the field of view changes.

The larger sensor on your A100 calls for somewhat longer lenses, but the extra depth of field still accrues, although to a lesser extent. The kit lens, for example, has the same field of view as a 27–105mm lens on a film camera, but the depth of field at each zoom position is closer to what you'd expect from the 18–70mm lens it really is.

If depth of field is important to you because you want to maximize or minimize the range of your image that's in focus, the DOF preview button is your best friend. Some lenses have DOF markers on their barrel that let you estimate depth of field at a particular f-stop.

The DOF range extends one-third in front of the plane of sharpest focus, and two-thirds behind it. So, assuming your depth of field at a particular aperture, focal length, and subject distance is 3 feet, everything 1 foot in front of the focus plane and objects 2 feet behind it will appear to be sharp.

If you plan on making a grab shot and don't want to risk losing it while your A100 autofocuses, you can switch to Manual focus and set your lens at a point known as the *hyperfocal distance*. This distance is a point of focus where everything from half that distance to infinity appears to be acceptably sharp. For example, if your lens has a hyperfocal distance of 4 feet at a particular focal length, everything from 2 feet to infinity would be sharp. The hyperfocal distance varies by the lens focal length and the aperture in use. You can find charts on the Internet that help you calculate hyperfocal distance.

3.13 When you've focused on the spool of thread in front, the spool in the background is out of focus if you use a large f/stop with little depth of field.

3.14 When you've focused on the spool of thread in back, the spool closest to the camera will be out of focus when a large f/stop with little depth of field is used.

DOF and circles of confusion

Most of the time, DOF is described in terms of the size of the *circle of confusion* in an image. A portion of an image appears sharp to our eyes if fine details seem to be sharp points. As these sharp points are thrown out of focus, they gradually become fuzzy discs rather than points, and when that happens, you deem that part of the image unacceptably blurry. The closer you are to the image and the more it has been blown up, the larger its circles of confusion appear; so, for example, depth of field that looks acceptable in a small print might be unacceptable when the same image is enlarged to poster-size, hung on the wall, and examined up close.

To make things even more interesting, some of these out-of-focus circles are more noticeable than others, and can vary from lens to lens. This particular quality is called *bokeh*, after boke, the Japanese word for blur. The *h* was added to help English speakers avoid rhyming the word with broke. The bokeh qualities of a particular lens are determined by factors like the evenness of its illumination and the shape of the diaphragm. (In some cases, the out-of-focus circles can take on the shape of the lens iris!)

Lenses with good bokeh produce out-of-focus discs that fade at their edges, in some cases so smoothly that they don't produce circles at all. Lenses with intermediate bokeh qualities generate discs that are evenly shaded, or perhaps have some fade

to darkness at their edges. The worst lenses create discs that are darker in the center and lighter on their edges, as in figure 3.15. You've probably seen the "donut hole" bokeh that result from catadioptic or "mirror" lenses. This is either the most atrocious bokeh possible, or it is a creative effect, depending on your viewpoint. If you're going to be shooting lots of portraits, close-up pictures, or other shots where bokeh is especially important to you, it's a good idea to test a lens yourself before you buy it to see if its properties suit your needs.

3.15 Individual discs with dark centers and bright edges call attention to out-of-focus areas of your image.

All About Lenses

Although the Sony Alpha DSLR-A100 is called a single lens reflex (SLR), that doesn't mean you're limited to a single lens! In fact, the ability to swap out one set of optics for another is one of the top reasons for switching from a non-SLR digital shooter to a camera like the A100. Lenses give you extra flexibility and give your picture-taking possibilities a boost. Add-on lenses are arguably the number-one expansion option available for your camera.

This chapter covers everything you need to know about choosing and using the best lens for the job.

Expanding Your Lens Options

Some photographers buy their A100 cameras without a lens, because they plan to use the camera with an existing set of optics from a previous Konica Minolta SLR or digital SLR. If you don't already own a Konica Minolta SLR and lenses, you might have purchased your A100 with an interchangeable lens. If so, the odds are good that you went ahead and bought a multipurpose lens, such as the 18–70mm f/3.5–f/5.6 lens (often called the *kit* lens). If you splurged, you might have purchased the 18–200mm f/3.5–f/6.3 zoom lens. (Sony recently started selling this camera as a kit with the 18-200mm lens, too.) Some dealers supply lenses of similar zoom ranges built by a third-party lens vendor, such as Sigma.

For example, Sigma makes a popular 18–125mm zoom for digital cameras that is priced roughly the same as the 18–70mm kit lens but offers a little more telephoto reach. Many other vendors also make 18–200mm zooms, at a considerably lower price. Some dealers want to provide an extra-low kit price and package the A100 with Sigma's budget-priced 18–50mm zoom.

A third scenario might be that you had some definite ideas about what lens you wanted with your A100, so you chose something else from the Sony line or from third-party vendors. In any of these cases, if you have the A100 and just one lens, you're ripe for an add-on.

Kit lens advantages

If you bought your A100 with the 18–70mm kit lens, you have a lens that's extremely versatile and suitable for a wide variety of picture-taking situations. Here are some of the advantages of the kit lens:

✦ **Low cost.** For about $200, this lens is a very good value and is solidly constructed.

✦ **Nice 3.8X zoom range.** When you factor in the 1.5X lens multiplier factor (more on that later), this lens corresponds to a 27–105mm zoom on a full-frame film camera. At the wide end, that 27mm provides a moderately wide field of view, certainly enough for everyday shooting. The 105mm telephoto position falls smack into the range considered excellent for portraits and some types of close-in sports activities.

✦ **Adequate aperture speed.** The f/3.5 maximum aperture at the wide-angle position and f/5.6 at the telephoto end are about one-half to a full f-stop slower than what you'd expect from a prime (non-zoom) lens at the equivalent focal length. However, faster lenses cost a lot more, and the kit lens's speed is, at least, adequate.

✦ **Good image quality.** Even at its low price, the kit lens includes aspheric elements and extra low-dispersion glass to produce images that are easily sharp enough for most applications. If you read the user evaluations in the online photography forums, you know that owners of the kit lens have been very pleased with its image quality.

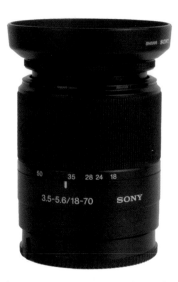

4.1 The SAL-1870 18–70mm f/3.5–f/5.6 zoom lens.

✦ **Compact size.** At 8.3 ounces and roughly 2.5 × 3.2 inches in size, this is a compact optic that makes a good "walking around" lens you can take with you when you plan to leave all your other gear at home.

✦ **Fast, relatively close focusing.** The autofocus mechanism of the 18–70mm lens is fast and quiet, and gets you down as close as 14 inches, so you can use it as a semi-macro lens in a pinch.

If you can afford only one lens for your A100, this is one to consider. If you have a bit more money, the 18–200mm lens is an excellent alternative. Unless you shoot many ultra-wide-angle photos, or you need to reach out with a longer telephoto, the kit lens or 18–200mm lens can handle most of the picture-taking situations you're likely to encounter. You generally don't need both, because their focal lengths have much duplication.

Add-on lens advantages

After you've used your A100 for awhile, you'll certainly discover that there are at least a few pictures you can't take with your existing set of lenses. It's time to consider buying an add-on lens. Here are some of the key reasons for making a switch:

✦ **Longer view.** A longer telephoto lens can do several things for you that a shorter lens cannot. A telephoto reaches out and brings distant objects closer to the camera; it's especially valuable when *sneaker zoom* (moving closer or farther away) won't work. A long lens has less depth of field, so you can more easily throw a distracting

background or foreground out of focus for a creative effect. Telephoto lenses have the opposite perspective distortion found in wide-angle lenses: subjects, such as faces, appear to be broader and flattened. So, you can improve the appearance of a narrow face simply by using a longer zoom setting. That same distortion is great when you want to reduce the apparent distance between distant objects — the same effect used in Hollywood to make it appear that the hero is darting in and out between oncoming cars when they are actually separated by 30 feet or more. With the A100, a 50mm lens has something of a telephoto effect, because of the crop factor produced by the smaller sensor, and longer lenses extend out to 600mm or much more.

✦ **Wider view.** When your back is against a wall — literally — you need a lens with a wider perspective. A lens with a shorter focal length lets you take interior photos without going outside to shoot through a window, or asking the owner of a 21st-century vegetable cart to move so you can photograph that 16th-century cathedral. You can emphasize the foreground in a landscape picture while embracing a much wider field of view. Move in close with a wide-angle lens to use the perspective distortion that results as a creative element. For the A100, wide-angle lenses generally fall into the 10–24mm range, and include both fish-eye (distorted, curved view) and rectilinear (nondistorted, mostly) perspectives.

4.2 Telephoto lenses bring you up close.

4.3 A much wider view of the shot in figure 4.2 is possible with the perspective of a wide-angle lens.

✦ **Macro focusing.** Macro lenses let you focus as close as an inch or two from the front of the lens, offering a different perspective on familiar objects. You can find these lenses available both as *prime* (fixed focal length) lenses (such as the popular SAL-100M28–100mm f/2.8 macro lens from Sony) as well as macro-zoom lenses from other vendors. The available range of focal lengths is important, because sometimes you want to get as close as possible to capture a particular viewpoint (for example, to emphasize the stamens in a delicate flower) or back off a few feet to avoid intimidating your subject (perhaps a hyperactive hummingbird).

4.4 Macro lenses provide extra magnification, as in this shot of a flower.

✦ **Sharper image.** Some lenses, such as fixed-focal-length prime lenses, are sharper, overall, than others. Inexpensive zoom lenses are often noticeably less sharp than the discriminating photographer might prefer. In addition, lenses rarely have the same sharpness at all apertures and zoom settings. A wide-angle lens, for example, might have lots of barrel distortion and fuzzy corners at its widest setting, and if you shoot many photos at that focal length, a different optic might serve you better. Lenses also fall down in sharpness when you ask them to do things they weren't designed for, such as taking macro photos with a zoom best-suited for sports photography, or shooting at maximum aperture under low-light conditions.

✦ **Faster aperture.** Your third-party 300mm f/4.5 lens may be sharp enough and have the perfect focal length for the sports photography you're planning to do. But you find that it's not fast enough to let you use a high enough shutter speed. What you may really need is the expensive but sublime Sony SAL-300F28G, a 300mm f/2.8 lens, optimized for shooting wide open. The difference between a shot grabbed at 1/500 second at f/2.8 and the same image captured at 1/180 second at f/4.5 can be significant in terms of action-stopping. In addition, your f/2.8 lens might be sharpest when stopped down to f/5.6. You might have to use f/8 to get similar sharpness with the f/4.5 optic.

Choosing Between Zoom or Fixed-Focal-Length Lenses

It wasn't that long ago when serious photographers worked almost exclusively with fixed-focal-length/prime lenses rather than zooms. Many zoom lenses were big, heavy, and not very sharp. The most expensive zooms were sharp, but they were still big and heavy. Today, you can buy a 28–300mm lens for the A100 from a third-party vendor that is about 3 inches long and weighs less than a pound.

Some of the early zoom lenses had a nasty habit of shifting focus as you zoomed in or out. They were used primarily for applications where it wasn't always practical to change lenses rapidly (such as sports or spot news), or when the zoom capability itself was needed for a special look, such as the ever-popular zoom-during exposure effect.

Today, optical science has made great strides, and there are lots of zoom lenses available that even the most snobbish photographer can endorse. They're small, light, fast, and sharp. For example, Sony's SAL-1680Z Carl Zeiss Vario-Sonnar T* DT 16–80mm f/3.5–f/4.5 zoom is an impressive optic with remarkable quality. Many A100 users favor this lens as a "walking around" optic over the kit lens, because of its image quality and marginally larger focal length range.

Prime lens considerations

Use a prime lens when you must have the ultimate in sharpness or speed at a particular focal length. For example, at around $1,400, Sony's SAL-35F14G lens, a 35mm f/1.4 optic, is unmatched at low-light photography. Prime lenses are a good choice when you have freedom of movement and can get closer to or back up a little from your subject to fill the frame appropriately.

Assessing Lens Compatibility

Sony brought with it a healthy stable of lens choices from the Konica Minolta product line. At the time I write this, there are 18 official Sony Alpha lenses, ranging from 11–18mm super-wide zooms to 500mm telephotos. However, you can use many earlier lenses from Konica Minolta and third-party vendors using the KM mounting system. You can frequently find bargain, second-hand lenses of this sort. Sony's Web page for the Alpha offers a downloadable list of all compatible Konica Minolta lenses.

Applying the Lens Crop Factor to Your Pictures

Here's a overview: You know that because your A100's sensor is smaller than the 24mm × 36mm standard film frame, lenses at a particular focal length produce what appear to be magnified images, but are, in fact, just cropped versions of the original image. The A100 provides a 1.5X crop factor (often erroneously called a *multiplier factor* even though nothing is being multiplied).

It's important to recognize that the cropping factor is not a focal-length multiplier, because the true focal length of the lens (along with its depth of field) remains the same. Your 200mm f/3.5 lens isn't really converted to a 300mm f/3.5 optic. It's still a 200mm lens, but you're cropping out the center portion in the camera rather than in Photoshop.

Although this so-called multiplier factor can be very cool for those who need fast, cheap telephoto lenses, it makes getting a true wide-angle view that much more difficult.

Of course, because a smaller portion of the lens coverage area is used, the smaller sensor crops out the edges and corners of the image; with some lens designs, the edges and corners are where aberrations and other defects reside. On the other hand, stretching an extremely short wide-angle lens (10–15mm) to fill the A100's sensor can reintroduce those very distortions that the crop factor in longer lenses reduces.

4.5 The A100's view is just a cropped version of the traditional 35mm film frame.

Using a Wide-Angle Lens

A wide-angle lens or wide-angle zoom setting is useful for several picture-taking situations, which I outlined briefly earlier in this chapter. Here's a concise listing of the top reasons for using a wide-angle lens:

✦ **In close quarters.** Frequently, you don't have much room to maneuver indoors if you want to shoot an entire room. Architectural photographers shooting outdoors might find that the perfect position to photograph a building might, unfortunately, be inside the lobby of the building across the street. Perhaps you want to photograph a celebrity surrounded by a crowd, and backing up an extra 5 feet means you have a wall of bodies between your camera and your subject.

✦ **To increase the field of view for distant shots.** You're looking at a stunning panorama and want to capture as much of it as possible. Shoot with a wide-angle lens to grab the broadest possible view.

✦ **To increase depth of field.** Wide-angle lenses offer more depth of field at a given aperture than a telephoto lens. Of course, the fields of view and perspective differs sharply, but if lots of depth of field is your goal, a wide-angle lens is your best bet.

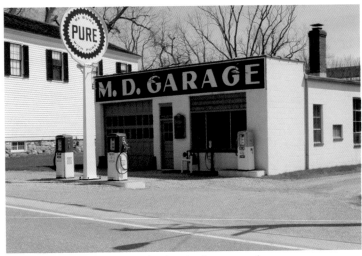

4.6 Wide-angle lenses emphasize the foreground.

✦ **To emphasize the foreground.**
Using a wide angle on that land-
scape also tends to emphasize the
foreground details while moving
the distant scenery farther back
from the camera. You can crop out
the foreground, or use it as a pic-
ture element. For example if you're
photographing a vista that includes
a lake, you might want to use the
wide angle to emphasize the
broad, unbroken expanse of water
nearest the camera.

✦ **To provide an interesting angle.**
Get down low and shoot up. Get
up high and shoot down. Wide-
angle lenses can emphasize the
unusual perspective of either
angle, providing additional creative
opportunities.

✦ **To distort the foreground.** Wide-
angle lenses provide a special kind
of perspective distortion to objects
that are closest to the camera, and
you can use this look to create
unique photos.

4.7 Wide-angle perspective distortion can
provide an interesting effect.

When you work with a wide-angle lens, there are several things to keep in mind:

✦ **Watch your horizontal and vertical lines.** Because things like the horizon or the lines of buildings in your photograph are emphasized, you want to keep the plane of the camera parallel to the plane of your subject; avoid tilting or rotating the camera if you want those lines to appear straight in your photo. Architecture can be especially problematic, because tilting the camera back to take in the top of a building invariably produces that peculiar tipping-over look.

✦ **Avoid unwanted perspective distortion.** Wide-angle lenses exaggerate the relative size of objects that are close to the camera. Although you might want to use this effect for creative purposes, you may also want to avoid it when shooting subjects, like people, that don't benefit from the distortion.

✦ **Be aware of lens defects.** Many lenses produce barrel or pincushion distortion, and perhaps have other problems, such as *chromatic aberration (*color fringes) or even *vignetting (*corner darkening), at the edges. You want to keep this in mind when composing your photos so that important picture information doesn't reside in problematic areas.

4.8 If you tilt the camera back, the structure appears to be tipping over.

✦ **Watch flash coverage.** Electronic flash units might not cover the full wide-angle frame in their default modes. You may need to use a diffuser or wide-angle accessory over your flash, or set the flash unit for its wide-angle mode to avoid dark corners. The lens hood on some lenses may cause a shadow in flash pictures when used with the A100's built-in Speedlight at the wide-angle positions of the kit lens and other lenses. Sometimes, simply removing the lens hood or zooming in slightly solves the problem.

✦ **Don't forget sneaker-zoom.** If the widest zoom setting isn't wide enough, look behind you. Unless you're standing at the edge of a cliff, you just might be able to back up a few steps and take in the entire view. Zoom lenses are so common these days, it's easy to forget that your feet can be brought into play.

✦ **Slower shutter speeds are possible.** You know that telephoto lenses require higher shutter speeds because their longer focal lengths tend to magnify camera shake. You'll find wide-angle lenses more forgiving because they have a wider field of view. You may be able to hand-hold your A100 at 1/30 second or slower when shooting with a wide-angle lens. That can be a special boon when taking photos in low-light conditions indoors, and a bonus on top of Sony's Super SteadyShot capabilities.

Using a Telephoto Lens

Many A100 users fall into one of two camps: the wide-angle people and the telephoto folks. Although these photographers are smart enough to use a full range of focal lengths creatively, they tend to favor the odd viewpoints that wide-angle lenses produce, or treasure the up-close, in-your-face perspective of telephoto lenses. If you're an innate telephoto shooter, here are some top reasons to explore one of these creative avenues:

✦ **To isolate your subject.** Telephoto lenses reduce the amount of depth of field and make it easy to apply selective focus to isolate your subjects.

✦ **To get close to the action.** Except for a few indoor sports like basketball, it's often difficult to get close to the action in other kinds of contests. A telephoto of decent focal length brings you right into the huddle, into the middle of the action around the goal, or up to the edge of the scrum.

✦ **To capture wildlife.** Whether you're photographing a hummingbird hovering 12 feet from your camera, or trying to capture a timid fawn 50 yards away, a telephoto lens can bring you closer without scaring off your photographic prey.

4.9 Get close without alarming your wild subject.

✦ **To take flattering portraits.**
Human beings tend to photograph
in a more flattering way with a
telephoto lens. A wide-angle might
make noses look huge and ears
tiny when you fill the frame with a
face, but that same magnification
looks more natural with a
50–85mm lens or zoom setting on
an A100.

✦ **To shoot close-ups.** An ordinary
50mm macro lens gets you up
close to that tiny object you want
to photograph — perhaps even too
close, so that the camera or lens
itself casts a shadow on your

subject. A longer telephoto macro
lens, such as Sony's 100mm f/2.8
or long lenses from third parties,
lets you back up and still shoot
close-ups.

✦ **To decrease distance.** Sometimes
you simply can't get any closer.
That erupting volcano makes a
tempting target, but you'd rather
stay where you are. Perhaps you
want to capture craters on the
moon, or photograph a house on
the other side of the river. Slip a
long lens on your A100, and you're
in business.

4.10 A telephoto macro lens throws the background out of focus, turning a white wall into a seamless background so your kitchen table becomes a close-up photography studio.

Telephoto lenses involve some special considerations of their own; some of them are the flip side of the concerns pertinent to using wide-angle lenses. Here's a summary:

✦ **Shutter speeds.** Longer lenses tend to magnify camera/photographer shakiness. The rule of thumb of using the reciprocal of the focal length (for example, 1/500 second with a 500mm lens) is a good starting point (without factoring in Super SteadyShot), but it doesn't take into account the actual steadiness of the photographer, the weight distribution of the camera/lens combination, and how much the image will be enlarged. When sharpness is very important, use a higher shutter speed, a tripod, or a monopod. Switch on Super SteadyShot in all cases to multiply your hand-held steadiness by two to three shutter speed steps.

✦ **Depth of field.** Telephoto and telezoom lenses have less depth of field at a given aperture as you increase focal length. Some have called this a myth, because when you enlarge a wide angle shot and crop it so the subject is the same size as in the telephoto picture, depth of field is actually the same. But who does such a crazy thing? The reduced depth of field of telephoto lenses might be a good thing or a bad thing, depending on whether you're using selective focus as a creative element in your photo. Use your depth-of-field (DOF) preview button, if necessary, and be prepared to use a smaller f-stop to provide the range of sharpness you need.

✦ **Haze/fog.** When you're photographing distant objects, a long lens shoots through a lot more atmosphere, which generally is muddied up with extra haze and fog. That dirt or moisture in the atmosphere can reduce contrast and mute colors, so you should be prepared to boost contrast and color saturation if necessary.

✦ **Flare.** Both wide-angle and telephoto lenses are furnished with lens hoods for a good reason: to reduce flare from bright light sources at the periphery of the picture area, or completely outside it. Because telephoto lenses often create images that are lower in contrast in the first place, you want to be especially careful to use a lens hood to prevent further effects on your image (or shade the front of the lens with your hand).

✦ **Flash coverage.** Edge-to-edge flash coverage isn't the problem with telephoto lenses; distance is. A long lens may make a subject that's 50 feet away look as if it's right next to you, but your camera's flash isn't fooled. You need extra power for distant flash shots, probably more than is provided by your A100's built-in flash. Sports photography, in particular, often calls for a more muscular external flash unit like the Sony HVL-F56AM digital camera flash.

✦ **Compression.** Telephoto lenses have their own kind of perspective distortion. They tend to compress the apparent distance between objects. Fence posts that extend down the west side of your spread's lower 40 might look as if they're only a few feet apart through a 1000mm lens. Similarly, human faces can look more flat (not flattering) when photographed with a very long lens. You can use this effect creatively if you like, but you should always be aware of it when using a telephoto.

4.11 Columns separated by 16 feet appear to be right next to each other in a telephoto shot.

Using a Macro Lens

Macro lenses are used to take what are called *close-ups*, although the term may be a misnomer. What you're really looking for when you shoot with a macro lens is not to get close, but to magnify the apparent size of the subject in the final image. The distance doesn't matter as much as the magnification.

When you use a macro lens, there are two things to keep in mind:

✦ **Magnification offered.** With conventional lenses, the specification touted is the close-focusing distance; that is, can you get down to 12 inches, six inches, or two inches from the subject. With macro lenses, the magnification is more important, because these optics are offered in a variety of focal lengths and, even as zoom lenses by vendors other than Sony. You want a lens that provides at least a half life-size image (1:2) magnification, and preferably one with life-size (1:1) magnification.

✦ **Minimum aperture and depth of field.** Depth of field is at a premium in macro photography, and you want to be able to stop down as far as possible (at least to f/32) to avoid a focused area that's too shallow. Of course, at such small apertures, you certainly lose sharpness to diffraction effects, but that's often an acceptable tradeoff.

Reducing Vibration

Those poor souls committed to several other vendors' product lines must make a decision every time they purchase a lens. Should I buy a VR/IS (vibration reduction/image stabilization) lens, or save a few hundred dollars and get the regular version of a lens? Sony is one of the few digital SLR camera vendors currently providing in-camera image stabilization. The others use special lenses with lens elements that shift internally in response to the motion of the lens during handheld photography, countering the shakiness the camera and photographer produces, and magnified, especially, by telephoto lenses.

In whichever form, anti-vibration technology provides you with camera steadiness that's the equivalent of at least two to three stops; this can be invaluable under dim lighting conditions, or when you're hand-holding a long lens for, say, wildlife photography. Perhaps that shot of an elusive polka-dotted field snipe calls for a shutter speed of 1/1000 second at f/5.6 with your third-party 80–400mm

4.12 Depth of field is at a premium in macro photographs as shown in this image of a two-inch tall woven figure.

zoom lens. If you switch on Super SteadyShot, go ahead and use 1/250 second at f/11 and you get virtually the same results.

Or, maybe you're shooting a high-school play without a tripod or monopod, and you'd really, really like to use 1/15 second at f/4. Assuming the actors aren't flitting around the stage at high speed, your Super SteadyShot feature should do the job.

Here are some things to keep in mind when using Super SteadyShot:

✦ **VR doesn't stop action.** Unfortunately, no vibration reduction (VR) technology is a panacea to replace the action-stopping capabilities of a higher shutter speed. VR applies only to camera shake. You still need a fast shutter speed to freeze action. VR works great in low light, when you're using long lenses, and for macro photography. It's not so great for action photography.

✦ **VR slows you down.** The process of adjusting the sensor properly to compensate for camera shake takes time, just as autofocus does, so you might find that VR adds to the lag between when you press the shutter and when the picture is actually taken. That's one reason why VR may not be a good choice for sports photography, especially when panning with the action. But, try it — you might like it.

Extending the Range of Any Lens with a Teleconverter

Sony, as well as third parties such as Kenko and Tamron, offer teleconverter attachments, which fit between your prime or zoom lens and your A100's camera body and provide additional magnification to boost the lens's effective focal length. These are available from Sony in 1.4X, and 2X boosts, as well as those magnifications plus 1.7X and 3X from the third-party vendors.

For about $100 to $400, you can transform your 200mm lens into a 280mm telephoto (with a 1.4X converter) or into a 600mm monster (with a 3X module). Remember that with the A100's 1.5 crop factor, your new 280mm lens has an actual field of view equivalent of a 420mm lens on a 35mm camera, and the 600mm monster is the equivalent of a 900mm lens. However, there is no free lunch. Here are some things to consider:

✦ **You lose an f-stop — or three.** Teleconverters all cost you some light as they work their magic. It may be as little as half an f-stop with Sony's 1.4X converter, to three full stops with a 3X converter. Transforming your 400mm f/6.3 lens into a 1200mm f/18 optic might not seem like such a great idea when you view the dim image in your finder and realize that you can use this lens only outdoors at ISO 1600. This light loss is one reason why the more moderate 1.4X converter is the most popular.

✦ **You may lose autofocus capabilities.** The A100's autofocus system doesn't function as well under very low light levels; it usually requires f/5.6's worth of light, or better. Most teleconverter vendors call this to your attention by recommending their higher magnification converters (especially the 3X models) for autofocus use only with lenses having a maximum aperture of at least f/2.8. That requirement excludes a lot of zoom lenses, unless you're willing to focus manually.

✦ **You lose sharpness.** In the best of circumstances, you lose a little sharpness when working with a teleconverter. Part of that loss of sharpness comes from the additional optics in the light path, and part of it might be due to the tendency to use a larger, less-sharp f-stop to compensate for the light loss. In the worst case, you might find that simply shooting with no converter at all and enlarging the resulting image might provide results that are equal or better. A converter with moderate magnification, especially one of the pricey Sony models, produces the best results.

Working with Light

Every artist should learn how to work with his or her medium of choice, and for a photographer, light is the basic tool used to build images. Both the quantity and quality of the light you work with has an effect on every other aspect of your photography. It's both the alpha (to slip in a sneaky reference) as well as the omega of your creative options.

For example, the amount of light available to make an exposure controls whether you can take a picture at all, whether you have enough flexibility in shutter speed choice to freeze action, or whether you can use a longer slice of time to blur movement in creative ways. The amount of light also affects whether you can use various apertures to apply selective focus techniques.

The distribution of light is also important. It affects the tonal values and contrast of your photo. A single, glaring light source can force a harsh look. Softer lighting produces a diffuse effect that can be flattering and romantic. The color of the light determines the hues you see.

In many ways, photography (derived from Greek words meaning *light writing*) depends as much on how you use light as it does on your selection of a composition or a lens. Great books have been written on working with lighting; for this field guide, I concentrate on some of the nuts and bolts of using the lighting tools available for the Sony Alpha A100 digital SLR.

Light falls into two categories: continuous light sources, such as daylight, incandescent and fluorescent light; and electronic flash. Both forms are important.

Alpha A100 Flash Basics

Electronic flash illumination is produced by accumulating an electrical charge in a device such as a capacitor, and then directing that charge through a glass *flash tube* containing a gas that absorbs the electricity and emits a bright flash of photons. If the full charge is sent through the flash tube, the process takes about 1/1000 second and produces enough light to properly illuminate a subject ten feet away at f/5.6 at ISO 200.

Exposure is calculated in this way because light diminishes with the distance (actually, the square of the distance). An object that is four feet from the flash receives four times as much illumination as one that is twice as far at eight feet. Photographers call this the *inverse square* law.

Through its exposure sensing system, the Alpha A100 is able to determine (via a pre-flash that you probably won't even notice) whether sufficient light is reflected from the subject; it changes the exposure accordingly. If the subject is more than ten feet away, the camera could use a larger f-stop, such as f/4, and if the subject is closer, the camera could use a smaller f-stop, such as f/8.

In practice, the Alpha A100's Speedlight, activated by elevating it from its stowed position on top of the camera, varies the amount of light issued by the flash tube to reduce the illumination reaching subjects that are closer to the camera. The flash does this by dumping some of the electrical energy before it reaches the flash tube, in effect making the duration of the flash shorter. The basic intensity is the same; the flash is just briefer.

No matter what the duration of the flash is, it generally occurs only when the Alpha A100's shutter is fully open. As with most SLR cameras, the Alpha A100's mechanical focal plane shutter consists of two curtains that follow each other across the sensor frame. First, the *front curtain* opens, exposing the leading edge of the sensor. When it reaches the other side of the sensor, the *rear curtain* begins its travel to start covering up the sensor. The full sensor is exposed when the flash is tripped. If the flash goes off too soon or too late, you see the shadow of the front or rear curtains as they moved across the frame.

With the Sony Alpha A100, the sensor is completely exposed for all shutter speeds from 30 seconds (or longer) to 1/160 second if you're not using Super SteadyShot. If you do have the anti-shake feature turned on, the additional time required to manipulate the sensor at exposure limits the maximum flash speed to 1/125 second. This is a good reason to turn Super SteadyShot off when using flash. The brief burst of the flash is likely to counter any camera shake at those shutter speeds, as long as the flash is the primary source of illumination.

The maximum top shutter speed that you can use with electronic flash is called the camera's *sync speed.* Under some circumstances, you can use external Sony flash units at higher than the nominal sync speed (called *high-speed sync*), using electronic trickery to make the flash last longer than the shortest interval when the shutter is completely open. Such techniques reduce the effective power of the flash and are useful chiefly for close-up photography.

What does all this mean in the field? These basics produce some corollaries that affect your shooting:

✦ Because the flash occurs for a brief time only when the shutter is completely open, the actual shutter speed has no effect on the flash's action-stopping power. A 1/100 second flash freezes action with the camera shutter speed at 1/2 second in exactly the same manner as at 1/160 second if it is the only source of illumination.

✦ If the shutter is open long enough to produce an image from the non-flash (available) light in a scene (that is, effectively, the flash is not the only source of illumination for the photo), you get a second exposure in addition to the flash exposure. If your subject is moving, this second exposure appears as a blurry ghost image adjacent to the sharp flash image. You must always take into account the fact that you're taking two exposures, not one, when shooting with flash.

✦ Photos taken with the automatic flash squelching in operation have an effective exposure speed that's much shorter than 1/1000 second — as brief as about 1/50000 second at the lowest power used for very close subjects. You can use this quality to stop very fast action.

5.1 The brief duration of an electronic flash can freeze the quickest action.

✦ After an exposure has been made, it takes a short time for the flash to recharge to full power, usually one to three seconds with the Alpha's built-in flash. If your photo didn't require the full capacity of the flash, you may be able to take another picture more quickly.

✦ Because of the effects of the inverse square law, electronic flash produces a correct exposure only at one distance. Objects that are farther away or closer to the flash will be under- or overexposed. For example, if you're photographing a person standing eight feet away, someone positioned four feet behind your main subject will receive about one f-stop less exposure; a bystander eight feet farther receives two fewer f-stops' worth of light. Someone in the foreground four feet from the camera will be overexposed by two full stops. You can think of this phenomenon as *depth of light,* although the distribution is the opposite of depth of field: on a foot-by-foot basis, there's more behind the main subject than in front of it.

Flash modes

Set the basic flash modes for your Sony Alpha by rotating the Function dial to the Flash position and pressing the Function button. When the Flash mode dialog box appears choose one of the following:

✦ **Autoflash.** If you've flipped the flash up and are using Auto, P, or one of the Scene modes, it fires under low light conditions, or when your subject is backlit. This is the default behavior for the built-in flash. This mode is not available when you use A, S, or M shooting modes. If you would prefer that the flash always fire, you can use the Flash Default setting in Recording menu 2 to change from Autoflash to Fill Flash.

✦ **Fill Flash.** The electronic flash, if flipped up, always fires in Auto, P, or one of the Scene modes. This mode is useful when you're photographing backlight subjects or subjects with dark shadows and want to use the flash to brighten dark areas only, while allowing the available light to provide most of the exposure.

✦ **Rear-curtain sync.** The flash is delayed until just before the shutter closes (see the next section for more information).

✦ **Wireless.** Use this mode when using an off-camera flash (either the HVL-F56AM or HVL-F36AM) in wireless mode.

Flash sync modes

Flash exposure calculation works with any of the Alpha A100's *sync modes,* which control how and when the electronic flash is triggered. These include:

✦ **Front-curtain sync.** In this mode, which is the default, the flash fires at the beginning of the exposure when the first curtain has reached the opposite side of the sensor and the sensor is completely exposed. The sharp flash exposure is fixed at that instant. Then, if the shutter speed's exposure is long enough to allow an image to register by existing light as well as the flash, and if your subject is moving, you end up with a streak that's in front of the subject, in the direction of the movement.

✦ **Rear-curtain sync.** In this optional mode, the flash doesn't fire until the end of the exposure. The ghost image is registered first and terminates with a sharp image produced by the flash at your subject's end

position, providing a ghost streak behind the subject, similar to the streaks you see in comic books and movies about superheroes. If you must have ghosts (or want them for creative effect), rear-curtain sync is more realistic.

✦ **High Speed sync (HSS).** If you're using a Sony HVL-F56AM or HVLF36AM external flash, you can go ahead and set the camera for shutter speeds higher than 1/160 or 1/125 second (depending on whether you're using Super SteadyShot or not). The external flash shifts into HSS mode, and fires repeatedly, producing the effect of a longer flash duration, albeit at a reduced power rating. (There's no setting to make on the camera.)

5.2 Front sync can produce ghosts that appear ahead of the direction of movement.

5.3 Rear-curtain sync creates more realistic trailing ghost images.

Using Wireless Mode

To use wireless mode, follow these instructions:

1. **Remove the protective shoe cover and attach the external flash to the Alpha's accessory shoe on top of the camera, and then turn on both the camera and the flash.**

2. **Rotate the Function dial to the Flash position and press the Function button.** When the Flash mode dialog box appears, choose WL (wireless) flash.

3. **Remove the external flash from the accessory shoe, and elevate the flip-up flash built into the Alpha.**

4. **Test to see if the external flash and camera are properly linked for wireless operation.** Press the AEL button on the camera. A test burst fires.

5. **Position the external flash as you want it for your photos.**

6. **Take your pictures.** The internal flash triggers the external flash wirelessly.

Several different channels are available to let you avoid interference between your wireless flash unit and one being used by another photographer. Consult the instructions for your flash to see how to change to a different channel. The information about the channel in use is automatically transferred to the A100 when you attach the flash unit to the camera.

Flash exposure modes

Your A100 determines the correct exposure by emitting a pre-flash just prior to the actual exposure, and then measuring the amount of light reflected from the subject. The pre-flash occurs almost simultaneously with the main flash, so you probably won't even notice it. The Alpha has two exposure modes:

✦ **ADI Flash.** Advanced Distance Integration is the basic through-the-lens (TTL) flash exposure system for the Alpha and is the default setting under Flash Control in Recording menu 2. It operates in conjunction with lenses that include a *distance encoder*. (All newer lenses do; they are marked as a "D-type" lens in their model name.) The distance encoder supplies specific distance information that the camera uses for calculating flash exposure. In use, the ADI flash system uses information supplied by the lens's autofocus system (which tells the camera the focal length of the lens and the distance of the main subject) with the measured light reflected during the preflash, and attempts to balance the flash illumination with the ambient light to produce the best exposure. If you are not using a D-type lens, the A100 reverts to pre-flash TTL, as described next.

✦ **Preflash TTL.** In this mode, a pre-flash is also triggered just prior to exposure, but only the amount of light reflected is used in calculating exposure. You can switch to this mode in Recording menu 2 under some specific conditions where you can eliminate the value of the distance information, such as when you use a wide-angle panel or diffuser on an external flash unit, when you attach a neutral density filter to the lens, or when you use a close-up lens attachment.

Flash exposure compensation

If you want to tweak the exposure set for you by your flash, you can use the A100's flash exposure compensation system. To make this adjustment, rotate the Function dial to the Flash position and press the Function button. When the Flash compensation dialog box pops up, press the down key on the Controller to select exposure compensation, and then use the left/right keys to dial in plus or minus 2EV of adjustment, which is applied only to the flash exposure.

This feature is especially useful when you're trying to use fill flash to brighten up shadows and your Alpha A100 provides either too much or too little fill.

Red-eye prevention

Because the built-in flash is located relatively close to the axis of the lens, it's fairly easy for the burst to reflect off the corneas of subjects looking directly at the camera, producing the infamous red-eye effect in people, or yellow or greenish glowing eyes in animals like dogs and cats. The effect is particularly pronounced under dim lighting conditions, when the subject's pupils open wide to admit more light. Unfortunately, that happens to be the time when it's more likely for you to use flash, too.

The only complete cure-all for red-eye is to use an external flash unit that's located sufficiently off-axis so the illumination doesn't reflect back from the eyes into the lens. However, the A100's red-eye reduction feature offers some relief. It causes low-level bursts of light to be emitted just prior to the actual exposure. If the subjects are looking at the camera, their pupils contract, reducing the likelihood of red-eye. The preflash can also be distracting or annoying. You can turn it on or off in Recording menu 2, using the Red Eye option. The default setting is Off. You can change the option to On to activate red-eye reduction.

Many image editors can eliminate red-eye for you completely using an automated tool. Adobe Photoshop Elements 5.0 even has an option in its Photo Downloader module to eliminate red-eye as the photos are transferred from your camera or memory card to your computer.

Using Other External Flash

As you work with your A100, you may find yourself constrained by the limitations of the built-in flash. There's a lot to like about the internal flash. It's always there when you need it, requires no extra batteries, and is well-integrated with the A100's exposure system. The built-in flash is more or less a no-brainer accessory.

Unfortunately, the internal flash has relatively limited output, so your effective range may be only seven feet at ISO 100. Its location is so close to the lens that it tends to

exacerbate red-eye problems, even with the (often) ineffectual red-eye preflash in use. The flash's position also means it's not very useful when shooting close-up photos or some wide-angle shots. The lens or its lens hood can cast a visible shadow on your subject. There's no way to re-aim the A100's internal flash to bounce it off the ceiling, walls, or reflectors. Finally, the internal flash wastes a lot of light, because it keeps the same coverage area whether you're using a wide-angle or telephoto lens. The internal unit also soaks up camera battery power, reducing the number of shots you can take per charge.

5.4 The Sony HVL-F56AM is handy, powerful, and easy to use.

An external flash unit, particularly one designed especially for the A100 such as the Sony HVL-F56AM or HVLF36AM, solves many of these problems. You can also use many earlier flash units produced for Minolta and Konica Minolta-branded film and dSLRs and retain many of the automated features. Third parties, such as Metz, also offer dedicated flash units that work well with the Alpha.

The higher output of external flash units gives you a more flexible range of f-stops for flash exposures, because the units provide three or four times as much illumination (or even more) as the built-in flash. Even mounted in the camera's accessory shoe, an external flash is much farther away from the lens, reducing red-eye problems. You can also swivel it up or down or from side to side to change its coverage while it's mounted on the accessory shoe. You can remove the flash from the camera (if you use a connecting cable or set it for wireless mode) and point it any way you like for bounce flash or close-ups. You can adjust flash coverage so it's narrower or wider to better suit the focal length of the lens you are using.

You can connect an external flash designed to work with the Alpha and its predecessors by sliding it into the accessory shoe. Dedicated Sony flash units are able to communicate with the camera using the special contact points built into the camera's flash shoe. Non-dedicated units from other vendors, or older flash units, can connect to the camera for the flash-triggering function only; you must set exposure manually or by using the non-dedicated flash's internal auto-exposure system.

Unfortunately, the A100 doesn't have a flash connector compatible with non-dedicated flash units. You have to turn to a third-party accessory vendor to purchase an accessory shoe-to-hot shoe/PC adapter. These devices slide into the accessory shoe and provide a standard hot shoe connector (for mounting an external flash) plus a PC/X connector that you can use to connect many flash units and studio flash units that use PC-type cables.

 Note *In reference to the cables (PC-type cables), PC does not stand for personal computer; it represents Prontor-Compur, two old-time shutter manufacturers who cooked up the connection.*

Things get even more complicated if the external flash you are using has a triggering voltage of more than about six volts. In that case, you need yet another attachment, a voltage isolator such as the Wein Safe Sync adapter, which is available as a hot shoe connector or an in-line device that snaps onto your PC cable. Unless you've got your heart set on using studio flash units with your A100, this is a lot of trouble to go through for a direct connection.

5.5 The Wein Safe Sync isolates your strobe's triggering voltage.

You can also trigger an external flash with your camera's built-in flash by equipping the supplementary flash with a light-sensing slave unit (some have them built-in). The slave sensor detects the A100's internal flash, which sets off the external unit. You may need to disable the preflash to avoid tripping overly sensitive slave units.

Conquering Continuous Lighting

The other form of light you may work with is continuous lighting, either in the form of available light that's already on the scene (including daylight), or add-on lamps, lighting fixtures, or reflectors that you supply expressly for photographic purposes.

Continuous lighting has some advantages over electronic flash. You always know what lighting effect you're going to get. Daylight and lamps of all types are their own modeling lights. Any such light automatically shows how it affects your scene and how it interacts with other continuous lighting in use. It's easier to measure exposure with daylight/incandescent/fluorescent-style lighting. Daylight tends to fill a scene completely, but artificial lights suffer from the same light fall-off due to the inverse square law characteristics as flash (as described earlier in this chapter); however, it's usually easier to increase your depth of light by providing broader, more diffuse lighting from multiple sources. Continuous lighting syncs with any shutter speed for any exposure.

On the other hand, continuous lighting doesn't have the built-in, action-stopping capabilities of electronic flash, nor is it always as intense. In the studio, even with Super SteadyShot activated to counter camera shake, you might have to mount your A100 on a tripod to get sufficient exposure at a high enough shutter speed to freeze subject movement. Under the same studio conditions, an electronic flash allows you to handhold the camera — usually a better option when you're photographing people or pets, as long as the ambient light in the scene is not strong enough to record a secondary ghost image on the sensor.

Types of continuous lighting

Fortunately for photographers, continuous lighting is much less complicated and confusing than flash. The main thing you want to be concerned about is the color of the light, which is referred to as *color temperature* and *white balance*. Both refer to the same phenomenon: the tendency of various types of illumination to change the apparent overall color of the light used to make the exposure.

As I mentioned at the beginning of this section, there are three types of continuous lighting: daylight, incandescent/tungsten light, and fluorescent light. There are also some oddball light sources, such as sodium vapor illumination, that share some of the unusual lighting renditions of fluorescent lighting, even though the process used to generate the light is different.

✦ **Daylight.** This is the light the sun produces, even on cloudy days when the sun isn't visible. Sunlight can be harsh when it's direct and softer when it's diffused by the clouds, filtered by shade, or illuminates a subject indirectly as it bounces off walls, other objects, or even reflectors you might use. Strictly speaking, moonlight is sunlight, too, but it's rarely intense enough for photographing anything other than the moon, unless you use a tripod and very long shutter speeds.

✦ **Incandescent/tungsten light.** This kind of continuous light is produced by a heated filament inside (usually) a glass bulb that contains a vacuum. The tungsten filament is, in a sense, burning like the sun itself. Unlike the sun, the filament tends to burn out during our lifetimes and the bulb must be replaced. Incandescent illumination is often called tungsten light because tungsten filaments are used in the most common variety of bulb.

✦ **Fluorescent light.** Fluorescent light is produced through an electro-chemical process in a tube full of gas, rather than through a burning filament (which is why the bulbs don't get as hot). The type of light produced varies depending on the phosphor coatings and type of gas in the tube. So, the illumination produced by fluorescent bulbs can vary widely in its characteristics, as you'll learn later in this section.

Color temperature

Continuous light sources that produce illumination from heat, such as daylight or incandescent/tungsten illumination, produce illumination of a particular color; this color can be characterized by its color temperature (or, in digital camera terminology, white balance). Electronic flash, another type of light that is produced by a burst of heat, also has a characteristic color temperature. Fluorescent light doesn't have a true color temperature, but its white balance can be accounted for nonetheless.

Scientists derive color temperature from a mythical object called a *black body*, which is a substance that absorbs all the radiant energy that strikes it and reflects none at all. A black body not only absorbs light perfectly, but it also emits it perfectly when heated. At a particular physical temperature, this black body always emits light of the same wavelength or color. That makes it possible to define color temperature in terms of actual temperature on the Kelvin (K) scale that scientists use. Incandescent light, for example, typically has a color temperature of 3200K to 3400K ("degrees" is not used). Daylight may be 5500K to 6000K.

Photographers refer to these color temperatures using terms such as "warm/reddish" or "cold/bluish," but the actual physical temperatures they describe are actually the reverse. As the black body is heated, it first glows with a dull reddish light, as you might see in iron that is being heated. As the temperature increases to around 3400K, the light becomes yellowish, and then around

5500K or higher, blue. People tend to associate reddish hues with warmth and blue with cold; so that's why you see indoor illumination called warm, and bright daylight called cold, even though the color temperature of incandescent light (3400K) is lower than that of daylight (5500K). If you can remember that "cold" lighting is called that because it reminds us of the color of ice and snow, and not because of its actual temperature, you can keep the concept straight.

Coping with white balance

In the digital camera world, white balance adjustments are how the different color temperatures of light are compensated for. All light sources, including electronic flash, can vary in the color balance of their illumination. Each individual source has its own particular color, popularly (but inaccurately) called *white balance*. This color can be partially – but only partially – specified using the scale called color temperature described in the previous section.

Digital camera sensors can't automatically adjust to the different colors of light the way your eyes do. So, you must let the sensor know what type of lighting it is looking at by specifying a color temperature. The Alpha A100's electronics can make some pretty good guesses at the type of lighting being used, and its color temperature, simply by examining and measuring the light in the scene. But when the camera's white balance setting is on Auto, you might not always get the results you want. That's why the A100 has an array of manual white balance settings, and the ability to measure and set white balance from a neutral area of your scene. You can select from daylight, incandescent light, and so forth. You can also fine-tune the white balance to a little warmer or cooler, as needed for particular situations.

 The various manual white-balance settings are addressed in Chapter 2.

Color Rendering Index

All light sources can also be graded using a system called *color rendering index*, or CRI, which measures how well a particular light source represents standard colors compared to another light source, using a scale from 0 (really bad) to 100 (perfect). For example, daylight and incandescent lights are assigned a CRI of 100. Daylight fluorescents may have a CRI of about 79, which is not great, but acceptable compared to other sources such as white deluxe mercury vapor lights (CRI 45) or low pressure sodium lamps (CRI 0-18). You won't generally use CRI in photography, except when checking, say, a fluorescent lamp you intend to use, to see how close its CRI is to ideal. (Warm white fluorescents may have a CRI of 55; a deluxe cool white fluorescent, a CRI of 86.)

Things get a little complicated when you introduce fluorescent lights into the mix, because such lights don't produce illumination from heat but, rather from a chemical/ electrical reaction. So, fluorescent light can't be pegged precisely to the color temperature scale. Also, such lights do not necessarily produce proportionate amounts of all the colors of light in the spectrum, and the color balance of fluorescents varies among different types and vendors.

5.6 An image exposed under daylight with the white balance set to Tungsten appears too bluish (top); with the white balance set to Daylight, the scene appears normal (bottom).

That's why fluorescents and other alternative technologies such as sodium-vapor illumination can produce ghastly looking human skin tones. Their spectra can be lacking in the reddish tones we associate with healthy skin and emphasize the blues and greens popular in horror movies and TV procedural investigation crime shows.

The Alpha A100 does a fairly good job of compensating for the most common types of fluorescent tubes, but when colors are critical, it's best to use incandescent light, flash, or daylight.

If you shoot RAW, you can adjust the white balance when the image is imported into your image editor. If you're an old-school photographer, you can use color-correction filters on your lenses, including the special filters such as the FL-D created for particular types of fluorescent lights. If you're not satisfied with the automatic white balance settings you're getting, you can select a manual setting.

 See Chapter 2 for instructions on setting a manual white balance.

Photo Subjects

If you want to become a better photographer with your Sony Alpha DSLR-A100, the best thing you can do to improve your skills is to go out and shoot pictures of as many different subjects as you can. Tackling interesting new types of photography stretches your skills and helps spark creative ideas. Indeed, as you use your camera more, you'll discover two things:

✦ **The more you shoot, the better a photographer you become.** The Sony Alpha DSLR-A100 has so many advanced features compared to the film or digital camera you might have used before that you'll find yourself growing into these capabilities as you become more proficient. You'll actually discover new kinds of photos you can shoot with the features now at your fingertips. Regardless of the end results, all of them help you learn how to improve your results and enhance your skills.

✦ **You'll constantly find new types of photography that excite you.** Perhaps photography became a serious pursuit for you when you decided to learn how to take great portraits or candid pictures of your kids or grandchildren. Then, the first time one of these youngsters stepped onto a soccer field or Little League diamond, you discovered how much fun sports photography can be. During quiet moments at home, you found out that close-up photography of flowers can be engaging and rewarding. There are dozens of different photographic arenas where you can apply your growing skills.

The first time you try a different kind of photography, you may find the new subject matter intimidating. You may want to have an "old hand" at your side who can point out the pitfalls and help spark your creativity. That's where this chapter comes into play. Each section provides a consistent formula for exploring a common shooting situation. You'll find tips for choosing a lens, selecting the right ISO setting, and composing the picture. You can turn to any photo subject, and follow the guidelines to get good pictures right off the bat.

The Basics of Composition

The very best photos are carefully planned and executed. Having good execution means more than having proper exposure and sharp images, especially because some very good pictures are deliberately under- or overexposed and include an element of blur in their design. Beyond the technical aspects, good images have good composition – a pleasing selection and arrangement of the photo's subject matter within the frame.

Here are some questions to ask yourself as you compose your picture:

✦ **What do I want to say?** Will this photo make a statement? Should it tell something about the subject? Is the intent to create a mood? Know what kind of message you want to convey and who your audience is.

✦ **What's my main subject?** A picture of six cute puppies may not be as effective as one that focuses on a single puppy surrounded by its littermates. Even if the picture is packed with interesting things, select one as the subject of the photo.

✦ **Where's the center of interest?** Find one place in the picture that naturally draws the eye and becomes a starting place for the exploration of the rest of the image. Da Vinci's *The Last Supper* included several groupings of diners, but viewers always look first at the gentleman seated in the center.

✦ **Would this picture look better with a vertical or horizontal orientation?** Trees may look best in vertical compositions; landscapes often lend themselves to horizontal layouts. Choose the right orientation now, and avoid having to waste pixels when you crop later on.

✦ **What's the right shooting distance and angle?** Where you stand and your perspective may form an important element of your composition. For example, getting down on the floor with a crawling baby provides a much more interesting viewpoint than a shot taken 10 feet away from eye level.

✦ **Where will my subject be when I *take* the picture?** Action photography, especially, may force you to think quickly. Your composition can be affected not just by where your main subject is now, but also by where it will be at the time the picture is taken.

6.1 There's no mistake about what's the center of interest in this photograph.

6.2 Choose a vertical or horizontal orientation appropriate for your subject matter.

✦ **How will the background affect the photo?** Objects in the background may become part of the composition — even if you don't want them to. Play close attention to what's visible behind your subjects.

✦ **How should the subjects in the photo be arranged?** This is the essence of composition: arranging the elements of the photograph in a pleasing way. Sometimes you can move picture elements, or ask them to relocate. Other times you'll need to change position to arrive at the best composition.

✦ **How should the eye move within the composition?** Viewers don't stare at a photograph; their eyes wander around the frame to explore other objects in the picture. You can use lines and curves to draw the eye from one part of the picture to another, and balance the number and size of elements to lead the viewer on an interesting visual journey.

6.3 An interesting fountain — but the background, even out of focus, is too distracting.

The Rule of Thirds

Photographers often consciously or unconsciously follow a guideline called the Rule of Thirds, which is a way of dividing a picture horizontally and vertically into thirds, as shown in figure 6.4. The best place to position important subject matter is often at one of the points located one-third of the way from the top, bottom, and sides of the frame.

Other times, you'll want to break the Rule of Thirds, which, despite its name, is actually just a guideline. For example, you can ignore it when your main subject matter is too large to fit comfortably at one of the imaginary intersection points. Or you may decide that centering the subject would help illustrate a concept, such as being "surrounded," or that placing the subject at one side of the picture implies motion, either into or out of the frame. Perhaps you want to show symmetry in a photograph that uses the subject matter in a geometric pattern. Following the Rule of Thirds usually places emphasis on one intersection over another; breaking the rule can create a more neutral (although static) composition.

6.4 The classrooms pictured, and the imaginary "horizon," in this photo are placed one third of the way down from the top of the frame, and the main structures are roughly one-third the distance from either side.

Other compositional tips

Here are some more compositional rules of thumb you can use to improve your pictures:

✦ **If subjects aren't facing the camera, try to arrange it so they're looking into the frame rather than out of it.** This rule doesn't apply only to people or animals. An automobile, a tree swaying in the wind, or a bouncing ball all look more natural if they're oriented toward the frame.

✦ **Use curves, lines, and shapes to guide the viewer.** Fences, a gracefully curving seashore, meandering roads, railroad tracks, a receding line of trees, or the architectural curves of a tall building all can lead the eye through the composition. Curved lines are gentle; straight lines and rigid geometric shapes are more forceful.

✦ **Look for patterns that add interest.** A group portrait of three people will be more interesting if the subjects are posed in a triangular or diamond shape, rather than in a straight line.

✦ **Balance your compositions.** Place something of interest on each half (left and right, top and bottom). For example, if you have a group of people on one side of the frame, you'll need a tree or a building or some other balancing subject matter on the other to keep the picture from looking lopsided.

6.5 Lines and curves lead the eye through the composition.

✦ **Frame your images.** Use doorways, windows, arches, the space between buildings, or the enveloping branches of trees as a "border" for your compositions. Usually, these frames will be in the foreground, which creates a feeling of depth, but if you're creative, you can find ways to use background objects to frame a composition.

✦ **Avoid mergers.** Mergers are those unintentional combinations of unrelated portions of an image, such as the classic tree-growing-out-of-the-top-of-the-subject's-head shot.

Abstract Photography

Abstract photography is your chance to make—rather than take—a picture. When you shoot abstract images, your goal is not to present a realistic representation of a person or object but, rather, to find interest in shapes, colors, and textures. One definition of abstract art says that the artistic content of such images depends on the internal form rather than the pictorial representation. That's another way of saying that the subject of the photo is no longer the subject!

6.6 Abstract images can be found in nature.

You can let your imagination run wild when you're experimenting with abstract photography. An image doesn't have to "look" like

anything familiar. Some people will tell you that if it's possible to tell what an abstract subject really is, then the image isn't abstract enough. A droplet of splashing water can become an oddly malleable shape; a cluster of clouds in the sky can represent fantasy creatures as easily as it can represent random patterns. When you choose to photograph an abstract shape, you're giving your vision a tangible form.

Inspiration

French photographer Arnaud Claass once said, "In painting, the curve is a hill; in photography, the hill is a curve." In other words, while painters attempt to use abstraction to create an imaginative image of a subject, photographers use abstract techniques to deconstruct an existing image down to its component parts. Both approaches create art that doesn't look precisely like the original

subject, but that evokes feelings related to the subject matter in some way.

You can find abstract images in nature by isolating or enhancing parts of natural objects such as plants, clouds, rocks, and bodies of water. Many wonderful abstracts have been created by photographing the interiors of minerals that have been sliced open, or capturing the surfaces of rocks polished over eons by ocean waves.

You can also create abstract compositions by arranging objects in interesting ways, and then photographing them in non-representational ways. A collection of seashells that you've stacked, lit from behind, and then photographed from a few inches away can be the basis for interesting abstract images that resemble the original shells only superficially and on close examination of the picture. Familiar objects photographed in unfamiliar ways can become high art.

6.7 Interesting details in this weathered plank form an abstract composition.

Abstract photography practice

6.8 A close-up view and some contrast and saturation adjustments turns this collection of pasta into an abstract image.

Table 6.1
Taking Abstract Pictures

Setup	**Practice Picture:** For figure 6.8, I placed a pile of rotini pasta on a sheet of paper, set it on a tabletop with a high-intensity desk lamp on either side. I mounted the Alpha A100 on a sturdy tripod, and captured the spirals from overhead.
	On Your Own: You can obtain some of the best abstract images from close-up views of everyday objects. A tripod lets you experiment with different angles, then lock down the camera when you find a view you like. Desk lamps make it simple to play with various lighting effects that can add to the abstract quality of your image.

Lighting	**Practice Picture:** I used direct lighting to enhance the contrast and create shadows that showed the texture of the pasta, which was already slightly pitted and cracked even though it came straight from the box.
	On Your Own: While hard light accentuates texture, you can also bounce light from reflectors to diffuse it and create a softer look. Experiment with colored reflectors or colored pieces of plastic held in front of the light source to add interesting color casts.
Lens	**Practice Picture:** SAL-50M28 50mm f/2.8 macro lens. A macro lens is essential for getting close enough to capture detail without distortion. You could also use a macro-zoom lens that focuses close enough or extension tubes or a close-up lens attachment that would let you focus closer than normally would be possible.
	On Your Own: Although close-focusing is a must for this kind of picture, a focal length of 50–60mm or perhaps a little wider is just as important. A longer lens, such as the SAL-100M28 100mm f/2.8 macro lens, even if it can produce the same magnification, tends to flatten the image, reducing the three-dimensional quality.
Camera Settings	**Practice Picture:** RAWt, processed using Adobe Camera Raw to adjust white balance (tungsten), increase saturation extensively, and boost both sharpness and contrast. Aperture Priority AE mode.
	On Your Own: Aperture Priority AE mode lets you choose a small aperture and let the camera select a slow shutter speed. Extra saturation, sharpness, and contrast increase the abstract appearance at the expense of realism. You can also boost these values when converting the RAW image and processing it in your image editor.
Exposure	**Practice Picture:** ISO 200, f/22, 1/8 second.
	On Your Own: A small lens aperture increases the depth of field so that the entire image is sharp. The long exposure means that the Alpha A100's ISO 200 sensitivity is sufficient. If you're patient, you can go as low as ISO 100 to improve quality slightly.
Accessories	A tripod lets you lock down the camera after you've found an angle you like; it also makes it possible to stop down to a small f-stop without worrying that the long shutter speeds that result will cause image blur.

Abstract photography tips

✦ **Go abstract in post-processing.** Many mundane conventional photographs can be transformed into abstract prize-winners by skillful manipulation in an image editor. Filter plug-ins can enhance edges, add textures, change color values, and perform other magic after-the-fact.

✦ **Freezing and blending time.** A high shutter speed can freeze a moment that isn't ordinarily easy to view, such as when a rock strikes the surface of a pond to produce concentric waves. Slow shutter speeds can merge a series of moments into one abstract image.

✦ **Use color and form to create abstract looks.** Exaggerated colors and shapes produce a nonrealistic look that has an abstract quality. Colored gels over your light sources can create an otherworldly look. An unusual angle can change a familiar shape into an abstract one.

✦ **Crop and rotate.** Try flipping an image vertically to create an unfamiliar look. When the light source seems to come from below, rather than above as you'd expect, your eyes see a subject in a new way. Or rotate the image to produce a new perspective. Then crop tightly to zoom in on a particular part of the image that has abstract qualities of its own.

Animal Photography

It's an apparent contradiction: Everybody likes interesting pictures of animals, but nobody likes photographs of caged animals in zoos. Most of us can't afford photo safaris to exotic locations to capture charging rhinos and prowling lions, but we can find interesting wildlife at zoos. The solution is to photograph animals *as if* you were on a safari and they were in their natural habitat. No one will be fooled into thinking you took a trip to the African grasslands, but if you do a good job, even the most jaded viewer will enjoy your animal photographs as much as if they were snapped in the wild.

6.9 Catching the expressions on animal faces, such as this bovine staring intently at the camera, adds a touch of personality to your animal photos.

Tips for Zoos

Veteran visitors to zoos know that their photo safaris will be more successful if they plan ahead of time.

✦ **Go early.** The animals are more active early in the morning. By the time the sun is high in the sky and the real crowds arrive, many of the animals will be ready for a nap. Phone ahead to find out when feeding times are, so you can capture the big cats gobbling up their lunch.

✦ **Use a tripod.** That long lens calls for either a high shutter speed or the steadiness a tripod can provide. A monopod can serve as a substitute, but you'll find that a lightweight tripod won't be that difficult to carry around, even in the largest zoos, for the few hours you'll be there.

✦ **Open wide.** If you must shoot through bars or a fence, use a longer lens and open your aperture all the way to throw the obstruction out of focus. Selective focus will also let you disguise the walls or fake rocks in the background that advertise that your animal is *not* in the wild. Use the Alpha A100's depth-of-field preview button to confirm that your depth-of-field trick is working.

✦ **Get down to their level, or below.** Think like prey—or predator. Animals don't spend a lot of time looking at what's above them, and overhead is not a great angle for photographing wildlife, either. If you have a choice of angles, get low.

✦ **Avoid the shooting-through-glass problem entirely.** Wait awhile or come back when it's cooler, and most zoo animals will leave their glass cages and venture outdoors. If you are forced to shoot through glass (some zoos are using glass "bars" even for outdoor exhibits), focus manually and throw the background out of focus, shoot at an angle, and, if you can get away with it, use a monopod to allow slightly longer exposures at low ISO settings (in the ISO 100–200 range if there is sufficient illumination).

Zoo animals are better cared for and less mangy than the in-the-wild variety, so you're likely to get more attractive-looking creatures to photograph. Modern zoos go to great lengths to duplicate the animals' natural habitats, and you'll find a minimum of bars and other barriers that inhibit your photography. It's likely you can get up close and personal with quite a few interesting fauna, with no danger to you or them.

However, do not overlook your own pets or those of friends and family. They are perfect models. You can also visit parks and grab photos of that Frisbee-catching dog or that frog lurking in the pond.

Inspiration

6.10 It's best to photograph zoo animals early in the day when they are the most active.

Zoo and animal photography practice

6.11 A close-up photo best portrays this feline's personality.

Table 6.2
Taking Pictures of Animals

Setup	**Practice Picture:** This family cat pictured in figure 6.11 was patient enough to pose for a picture as long as she was held by her owner.
	On Your Own: Patience is its own reward when photographing animals. Catch them when they're not sound asleep or simply sitting and observing the world around them. At zoos, plan on spending the morning shooting animals, and then wander around photographing flowers and plant life during the hottest hours of the day. Then return to shooting the animals in the late afternoon and evening when they become active again. Find a creature you like, spend enough time to learn its habits, and the payoff will be a picture that far surpasses the snapshots the other zoo visitors will get.
Lighting	**Practice Picture:** Bright sunlight showed off the texture of this cat's fur and highlighted her whiskers.
	On Your Own: You'll be working with the available light most of the time. Unless you can get closer than about 15 feet to the animal, Fill Flash won't do you much good.
Lens	**Practice Picture:** SAL-1870 18–70mm f/3.5–5.6 zoom lens at 50mm.
	On Your Own: If you're shooting wild animals, you might have trouble getting this close. In that case, a long lens will let you shoot close-up photographs of animals that are 40 to 50 feet away. You probably won't need a wide-angle lens much at zoos, so pack your longest lens.
Camera Settings	**Practice Picture:** RAW capture. Shutter Priority AE. Saturation and sharpness enhanced in post-processing with Adobe Camera Raw.
	On Your Own: Use Super SteadyShot. Even with a tripod, you'd need to use a relatively high shutter speed. I've found that 400–500mm lenses are almost impossible to handhold without using Super SteadyShot, even with 1/1000- or 1/2000-second shutter speeds.
Exposure	**Practice Picture:** ISO 200, f/8, 1/1000 second.
	On Your Own: You'll want to use selective focus to eliminate elements such as the background, or, at zoos, the cage or enclosures, so an aperture like f/8 is a good choice. Use a high shutter speed to freeze any movement of the animal, and to eliminate residual camera shake not countered by Super SteadyShot.
Accessories	Bring along a tripod or monopod if you're using a really long lens.

Animal photography tips

✦ **Long telephotos capture animals.** If wildlife is your photo prey, a long telephoto lens is your best friend. Even tree frogs will be happier if you keep your distance while you shoot.

✦ **Get close.** You'll probably have to use a telephoto lens to get close to most animals, but a headshot of a yawning tiger is a lot more interesting than a long shot of the beast pacing around in his enclosure.

✦ **Don't annoy the animals.** Just as chimps won't say "cheese!" and smile, tigers won't turn your way just because you jump up and down and yell. If there are monkeys about, you probably *don't* want to attract their attention (don't ask why). Instead, just watch patiently until your animal poses in an interesting way on its own.

✦ **Favor outdoor locations.** Many zoo exhibits of larger animals have both an indoor and outdoor component. The animals may come inside to feed or at night, and choose to spend other time outdoors in good weather. You want photographs of them outside, not inside.

Architectural Photography

Professional architectural photography is specialized and involves complex guidelines and sophisticated equipment. There are no such strictures on the kind of informal amateur architecture you can do just for fun with your Sony Alpha A100 and a few lenses. Whether you're taking some snapshots of existing homes you'd like to offer as suggestions to your architect, or looking to document historic structures, taking photos of interior and exterior architecture is fun and easy.

Architectural photos can be used for documentation, too, to provide a record of construction progress, or show how a building has changed through the years. Some of the most dramatic architectural photos are taken at night, using long time exposures or techniques such as painting with light (using a light source such as a flash to illuminate a subject multiple times during a long exposure).

Of course, even informal architectural photography requires a wide-angle lens with a minimum of the barrel distortion that causes straight lines near the edges of the image to bend outward. You'll find prime lenses in the 14–35mm range most useful. Thanks to the Alpha A100's 1.5X crop factor, those fixed-focal-length lenses provide the equivalent at the short end of the scale of the 20–21mm wide-angle lenses you might have used if you migrated from a full frame/film camera. The 28–35mm focal lengths offer a more or less "normal" lens field of view when cropped by the camera's sensor. Zoom lenses, including the SAL-1118 DT 11-18mm f/5.5–5.6 Super Wide Zoom Lens, can be useful for less critical work.

6.12 A wide-angle lens lets you take in an entire structure from a variety of vantage points.

Inspiration

The best architectural photographs involve a bit of planning, even if that's nothing more than walking around the site to choose the best location for the shot. Or you might want to take some test shots and come back at a specific time, say, to photograph an urban building on Sunday morning when automobile and foot traffic is light. A particular structure might look best at sunset.

6.13 The landscaping surrounding this barn converted into a residence is an important part of the overall composition.

However, the biggest challenge you'll need to plan for will be illumination. The existing lighting can be dim, uneven, or harsh. You may encounter mixed illumination — daylight streaming in windows to blend with incandescent room illumination — or lighting that is tinted. You can counter some of these problems by mounting your Alpha A100 on a tripod and using a long exposure. Perhaps you can add lighting, supplementing existing light with reflectors or lights mounted on stands. "Painting with light," by manually tripping an electronic flash aimed at different areas of an outdoor structure several times during a long exposure, can work, too.

Architectural photography practice

6.14 Photography of architecture after dark lends itself to long exposures.

Table 6.3
Taking Architectural Exteriors

Setup	**Practice Picture:** I loved the dramatic look of the spotlighting at the Rock and Roll Hall of Fame as shown in figure 6.14, and set up my camera on a tripod almost underneath the overhanging structure. **On Your Own:** Find a shooting spot that shows a building at its best, with a clean background and uncluttered foreground. Look for surrounding trees or other structures that can serve as a frame. You can look at articles in "home" magazines for ideas for the most flattering way to shoot a particular type of building. If you plan to shoot at night using light painting, study the existing illumination before you set up.

Lighting

Practice Picture: I used a 30-second exposure to capture all the details with the available lighting. This particular subject could also have lent itself to a "painting with light" technique (a method for using multiple flashes of light during a long exposure, and explained in detail later in this chapter, but I decided to go with the existing illumination).

On Your Own: At night, time exposures can yield good pictures of many exteriors with existing light. During the day, the lighting varies more. To avoid harsh shadows that can obscure important details, you may want to wait for slight cloud cover to soften the harsh daylight. If you've found a particular spot that's ideal and you have the luxury of time, you can choose the time of day that provides the best lighting.

Lens

Practice Picture: SAL-1870 18–70mm f/3.5–5.6 zoom lens set to 18mm. In tighter quarters, a lens with more wide-angle reach, such as the SAL-1118 DT 11–18mm f/5.5–5.6 Super Wide zoom lens may be more suitable.

On Your Own: Your lens choice depends on whether you can get far enough away to avoid tilting the camera to take in the top of the structure. As a last resort, you can use a fisheye lens like the SAL16F28 16mm f/2.8 fisheye lens and straighten out the curves in your image editor.

Camera Settings

Practice Picture: RAW capture. White balance set to Tungsten, manual exposure with a custom curve and saturation enhanced, and sharpening added in post-processing with Adobe Camera Raw.

On Your Own: When not shooting time exposures, you can usually use shutter-priority and Super SteadyShot to specify a speed that will nullify camera shake, and let the camera choose the appropriate aperture.

Exposure

Practice Picture: ISO 100, f/16, 30 seconds.

On Your Own: Time exposures are more or less a trial-and-error process, but in daylight your camera's autoexposure system will work well. Use center-weighted or spot metering to ensure that the exposure will be made for the building itself and not any bright surroundings such as sky or snow. Using the Alpha A100's automatic bracketing feature will let you take several consecutive pictures at slightly different exposures, so you can choose the one that most accurately portrays the building.

Accessories

A tripod was a must for this time exposure, and it can also be helpful if you plan to return from time to time to take additional shots from the sample angle. Record where you placed the tripod legs by removing the camera after the shot and taking a picture of the tripod and its position. Flash can sometimes be used in daylight to fill in shadows — but be careful of reflections off windows. That applies double for painting-with-light exposures, as described later in this chapter.

Architectural photography tips

✦ **Shoot wide.** Exterior architecture often requires a wide-angle lens, while interiors almost always call for a wide setting to capture most rooms or spaces. Unless you're shooting inside a domed stadium, cathedral, or other large open space, you'll find yourself with a back to the wall sooner or later. Wide angles also help you include foreground details, such as landscaping, that are frequently an important part of an architectural shot.

✦ **Try painting with light.** During a two-minute or longer exposure, have an assistant equipped with an external flash walk around the front of the building, pressing the "open flash" button at intervals to illuminate the dark areas, pointing the flash from an angle to avoid having the flash reflect off windows into the camera lens. (You can also do this yourself if you are fleet of foot.) Keep the body between the camera and the flash and keep moving so the human won't show up in the photo. Orange gels over the flash can help provide the same color balance as the existing lighting at night.

✦ **Watch out for lens distortion.** Some lenses produce lines that are slightly curved when they're supposed to be straight. Although you may not notice this distortion most of the time, architectural design often depends on straight lines and any warps introduced by your lens become readily apparent.

✦ **Avoid perspective distortion.** To avoid that "tipping over" look that results when the camera is tilted back, locate a viewpoint that's about half the height of the structure you want to photograph. It might be a neighboring building or a bluff overlooking the site, or some other elevation. Shoot the picture from that position, using the widest lens setting you have available, keeping the back of the camera parallel with the structure.

✦ **Ask permission.** The laws in most states don't require getting permission to shoot and use photographs of buildings that are clearly visible from public areas. However, many property owners will become nervous as soon as you set up a tripod and start shooting, so it's always a good idea to ask first, and, perhaps, offer them a free print if they seem reluctant.

Event Photography

Events are activities of limited duration where there are a lot of people and lots of things going on. They include county fairs, parades, festivals such as Mardi Gras, musical concerts, as well as weddings and other celebrations. They may last a few hours, a full day, or as much as a week. Your company's annual picnic at a local amusement park, a traveling art exhibit, a building dedication, or a tailgate party before a big football game all qualify as interesting events.

You'll find lots of photo opportunities at these events, usually with a lot of color, and all involving groups and individuals having fun. If you want your creativity sparked by a variety of situations, attending an event as a spectator or participant is a good place to start.

It sometimes helps to think of an event as an unfolding story that you can capture in photographs. Take photos that embody the theme of the event, including overall photographs that show the venue and its setting. Grab shots of the broad scope, the number of people in attendance, and the environment where the event takes place. Then zero in on little details, such as individuals enjoying moments, booths at an amusement part, a dignitary giving a speech, or an awards ceremony. Tell a story that transports the viewer to the event itself.

Planning can help you get the best shots. You can scout parade routes in advance, or recall what sort of lighting was used at the last rock concert you attended at a particular site. Events such as Renaissance fairs, festivals, or Civil War re-enactments usually have a schedule of events you can work

6.15 Classic car shows, air shows, and other events are perfect opportunities to collect photographs of things you just don't see every day, such as this classic World War II aircraft.

from (although you may need to request one in advance or visit the organizer's Web site). A program lets you spot scheduling conflicts, and separate the "must-see" events from those you'll catch if you have time.

Inspiration

6.16 Civil War re-enactments are events filled with authentic costumes, battles, and displays of historical artifacts.

Public events not only serve as photo opportunities but also give you a chance to document your life and time in a way that will be interesting for years to come. For example, popular-music concerts today are quite different from those staged during the late 1960s. Customs at weddings change over the years. Clothing, such as the outfits that were common in discos 25 years ago, can seem exotic or retro today. Give some consideration to photos that are interesting today, as well as those you take for posterity.

When attending an event, pack light to increase your mobility, but be sure to take along a wide-angle lens to capture overall scenes and medium shots in close quarters, and at least a short telephoto for more-intimate photos. At concerts, a longer telephoto works best to shoot the action onstage and probably a monopod to steady your hand for longer exposures in low light. If flash is permitted, a higher powered unit like one of the Sony external dedicated flash units to extend your shooting range is a good idea.

Event photography practice

6.17 A blues musician concentrates on his solo in this live concert shot.

Table 6.4
Taking Event Pictures

Setup	**Practice Picture:** The concert shown in figure 6.17 was held in a club that held about 400 people, all tightly packed around the stage or dancing nearby. I got permission to climb past the barriers at the front of the stage so I could shoot the band from about 10 feet away.
	On Your Own: Shooting low at a concert provides an interesting perspective and usually gives you a plain background so you can isolate one musician. However, up front and below the band at a concert is not always the best place to shoot, especially if you want to include more than one band member in the shot. See if you can get onstage in the wings or shoot from a few rows back where the angle won't be quite so drastic.
Lighting	**Practice Picture:** This picture was taken using only the stage lighting provided at the concert — in this case a dramatic spotlight. Usually, the existing light provides illumination that suits the mood of the performance. However, it's likely to be very contrasty with not much fill-in illumination in the murky shadows.
	On Your Own: Lighting at concerts can vary dramatically during the course of the performance. There may be big, bright lights used for energetic portions, and more subdued illumination, often with a blue or other hue color cast. If flash is allowed and dozens of delirious fans are snapping away, you can use the Alpha A100's built-in electronic flash using the Fill Flash setting to brighten shadows. Using the flash at the full setting will overpower the existing light and give your photo a harsh, snapshot-like look.
Lens	**Practice Picture:** SAL-85F14Z Carl Zeiss Planar T* 85mm f/1.4 telephoto lens at f/5.6.
	On Your Own: Although zoom lenses are great for events with bright lighting so you can change the focal length quickly, at concerts use fast prime lenses for their low-light capabilities.
Camera Settings	**Practice Picture:** Aperture Priority AE mode. The white balance was set to tungsten. By controlling the aperture, I was able to control the depth of field so that the guitarist's face is in sharp focus.
	On Your Own: To control the depth of field, switch to Aperture Priority AE mode and set the white balance to the type of light in the scene. If the light is low, switch to Shutter Priority AE mode.

Continued

Table 6.4 *(continued)*

Exposure	**Practice Picture:** ISO 800, f/5.6, 1/125 second.
	On Your Own: Concerts usually call for higher ISO ratings, and the Alpha A100 provides decent results at ISO 800. You might need ISO 1600 in very low light or when you're using a longer lens and want a higher shutter speed. Remember that Super SteadyShot compensates only for camera movement and not subject movement. Don't fear using lower shutter speeds to allow musicians' hands to blur slightly. Experiment with different shutter speeds to get different looks. For other kinds of events, particularly those taking place outdoors in bright sunlight, choose ISO 100 for the best results.
Accessories	A monopod is almost a must to steady your camera for exposures that are longer than 1/100 second — or even for faster shutter speeds with longer lenses, despite the shake-nullifying effects of Super SteadyShot. A little extra support in low light situations never hurts.

Event photography tips

✦ **Get there early.** Although security is tight at major rock concerts (even if you have a backstage pass), shows at smaller venues with less-well-known bands can be more photographer-friendly, particularly if you arrive early and are able to chat as equipment is unloaded and being set up. (Don't get in the way!) At other kinds of events, getting there early lets you scout the area and capture some interesting photos of floats or exhibits as they're prepped.

✦ **Concerts and other events look best photographed from a variety of angles.** Don't spend the whole concert performance planted in front of the stage, right at street-level for a parade, or around the barbeque grill at a tailgate party. Roam around. Shoot from higher vantage points and from down low. Use both wide-angle and telephoto lenses.

✦ **Ask for permission before photographing adults or children who aren't performing.** Sometimes a gesture or a nod is all you need to do to gain the confidence of an adult. It's always best to explicitly ask for permission from a parent or guardian before photographing a child.

✦ **For outdoor events, plan for changing light conditions.** Bright sunlight at high noon calls for positioning yourself to avoid glare and squinting visitors. Late afternoon through sunset is a great time for more-dramatic photos. Night pictures can be interesting, too, if you've brought along a tripod or monopod, or if you can use a flash.

Fill Flash Photography

Using electronic flash to fill in dark shadows is an easy way to improve the lighting of scenes with excessive contrast. Even photographs taken in broad daylight can often benefit from an extra squirt of light that balances the highlights with the darker portions of the image. Indoors, in studio environments, fill flash lets you control the balance of light, or, in lighting parlance, the *lighting ratio.* Figure 6.18 shows a series of images in which fill flash was applied to create lighting ratios of 4:1, 3:1, and 1:1 (left to right).

It's easy to forget to use flash as a source of shadow-filling light. Although the electronic flash built into your Sony Alpha A100 can provide the main illumination for a photograph, you probably know that direct flash isn't the best way to light a scene in a natural and attractive way. Using the existing light, or, perhaps some off-camera flash is usually the way to go if you want the best rendition of your subject.

However, you can set your Alpha A100's flash in Fill Flash mode to provide just a touch of illumination that fills in the shadows without that washed-out "flash photo" look. You can also apply some fill-in light with an off-camera flash unit, such as the Sony external flash units.

6.18 Fill flash brightens the shadows to reduce the harshness of the lighting in this portrait photo.

Inspiration

6.19 Flash can fill *any* shadow, not just those found in harsh, direct sunlight. Here, an off-camera flash provided a spotlight effect on a flamingo that was lurking in the shade of some foliage.

One cause of blown highlights (over-exposed light areas in photographs that have no detail) is the camera's valiant attempt to preserve information in the darkest shadows, even when the dynamic range of the image is beyond the capabilities of the sensor. If the correct exposure for the shadows is 1/250 second at f/4, and the highlights are calling for 1/250 second at f/16, something has to give. Depending on the exposure mode your Sony Alpha A100 is set for and which of the matrix metering zones are used to calculate exposure, you may end up with properly exposed highlights and dingy dark shadows, or full, open shadows and blown highlights.

Fiddling with metering modes and zones or applying custom tonal curves can help, but it is time consuming. Your best bet may be to simply alter the balance of the light in your photo. Use fill flash to brighten those shadows, and allow the camera to expose for the highlights.

The simplest way to do this is to set your Alpha A100 to Shutter Priority mode, set the flash mode to Fill Flash, and set the shutter speed to 1/160 second (the highest speed usable with electronic flash and Super SteadyShot turned off), flip up the camera's built-in flash and let the fill flash automatically calculate the right amount of electronic flash to apply. You can also get the same effect with Sony dedicated Speedlights.

Fill flash photography practice

6.20 A bit of electronic flash fill-in softens shadows dramatically.

Table 6.5
Using Fill Flash

Setup	**Practice Picture:** I spotted the alligator shown in figure 6.20 on a child's ride at a county fair, and noticed that he was looking at me out of the corner of one eye. The angle needed to capture that perspective provided a great background of clouds, but the side of the backlit figure facing me was cloaked in shadow.
	On Your Own: When shooting in harsh daylight, first try to change your position so that dark shadows aren't a prominent part of your photo. Then, don't hesitate to add some flash to reduce the contrast of the scene.
Lighting	**Practice Picture:** I used the Alpha A100's built-in flash to supplement the daylight.
	On Your Own: An external flash may be a better choice, because you can aim the flash more easily, use a diffuser, and cut the power level appropriately more easily using the controls on the back of the flash.

Continued

Table 6.5 *(continued)*

Lens	**Practice Picture:** SAL-1870 18–70mm f/3.5–5.6 zoom lens set to 18mm.
	On Your Own: Choose a lens suitable for your shot, but remember that longer focal lengths move you farther away from your subject, reducing the effectiveness of the flash in filling in the shadows.
Camera Settings	**Practice Picture:** RAW capture. Aperture Priority exposure.
	On Your Own: Even though your camera can handle daylight/fill flash exposure calculation, don't be afraid to make your settings manually after reviewing a couple pictures. That will let you zero in on the best fill flash/available light balance.
Exposure	**Practice Picture:** ISO 100, f/22, 1/160 second.
	On Your Own: Don't forget that even though you are shooting outdoors, your flash will sync at no more than 1/160 second. You may have to use a low ISO setting or a neutral density filter to allow shooting with such a "slow" shutter speed outdoors.
Accessories	If your electronic flash has a diffuser, consider using it to soften the fill light even more. Or, have a handkerchief handy to drape over your camera's built-in flash, diffusing the light and cutting its intensity at the same time.

Filter Effects Photography

Filter attachments that can be added to lenses (front, back, or inside the lens itself) have been around for decades. There are many effects you can apply effectively using a glass add-on attached to your favorite optics, and more that you can achieve only with a physical filter.

Some filters split up your image in interesting ways, like the Hoya Multivision series, available in three-face (three segment), five-face, and six-face versions. You can find similar filters from other vendors if you want to create effects like the one shown in figure 6.21.

6.21 A multi-image filter produced this effect.

There are image-splitting filters available with each face colored differently, say, red, green, and blue, and those that rotate so you can manipulate how your image is divided. You might prefer a star filter to add twinkles to the specular highlights in your images, or to attach a polarizer to reduce reflections and darken the sky.

Inspiration

6.22 "Clear spot" and blur filters can focus attention on the subject matter in the center of your image.

Filters let you visualize your photo as it's taken, so you can apply your creativity to an image at the moment of capture, rather than at some later time. Indeed, one key advantage of applying filters in your camera rather than in an image editor is that you can see the effect as you're taking the photo, and make adjustments then to your exposure, focus, or even shooting position to get the exact effect you want. For example, one popular kind of filter blurs the outer edges of an image using various techniques. A "clear spot" filter has a physical hole in the glass so that the center is sharp, while the rest of the image is affected by the blurring filter itself. Another way of achieving a similar look is to use a plain glass, UV, or skylight filter that has been smeared with petroleum jelly with a clean spot left in the center. The effects you get with such filters are variable and can vary within the image frame, making them much more organic and less artificial-looking than if you'd used a Photoshop blur filter.

Filters help you from a technical standpoint, too. There's no easy way to remove glare in an image editor, but a polarizer can perform the chore efficiently — and you can see the effect right in your viewfinder as you rotate the filter mounted to the front of your lens. One frequent problem in landscape photos is trying to balance an excessively bright sky with the less brightly lit foreground. There are split neutral density filters that can darken only the upper half of your image while allowing a normal exposure in the lower half (or vice versa).

Filter effects photography practice

6.23 A split neutral density filter balanced the sky with the foreground in this sunset image.

Table 6.6
Taking Filter Effects Pictures

Setup	**Practice Picture:** It was dusk, and I wanted to photograph the flock of sea birds on the shore, but exposing for them would wash out the sky, while properly exposing the sunset would render the birds as dark silhouettes. I broke out my split neutral density filter and captured the image shown in figure 6.23. **On Your Own:** It is easy to forget that you are carrying a filter that can solve a problem or add a special effect. If you train yourself to think about using these useful add-ons, you'll discover applications for them everywhere you look.
Lighting	**Practice Picture:** The sunlight alone provided the illumination for this photo. I resisted the temptation to use the Sony's built-in flash as fill, because the bluish flash would have given an artificial look to the warm hues in this scene. **On Your Own:** Some kinds of filters work best with particular kinds of light. For example, polarizers work best in sunlight coming from specific angles, which can vary depending on how high in the sky the sun is.
Lens	**Practice Picture:** I used a SAL-1870 18–70mm f/3.5–5.6 zoom lens set to 24mm. **On Your Own:** You can use a variety of lenses for filter effects, but some kinds of filters aren't suited for extreme wide angles, because their added thickness can cause vignetting, or darkening of the corners.
Camera Settings	**Practice Picture:** RAW format, processed using Adobe Camera Raw to adjust white balance, increase saturation, and boost both sharpness and contrast. Aperture Priority mode. **On Your Own:** While automatic exposure is best, you may have to switch to manual if your A100 is unable to properly compensate for the effects of your filter.
Exposure	**Practice Picture:** ISO 400, f/16, 1/200 second. **On Your Own:** You might need to increase the ISO setting of your camera if the filter removes a significant amount of light, producing a longer than normal exposure.
Accessories	If you want to use many different filters economically, consider an investment in the Cokin Filter System, available from any photo retailer.

Filter effects photography tips

✦ **Step up/step down.** It's unlikely that all your lenses will use the same size filter. You can use the same filter on several lenses if you purchase an appropriate step-up ring, which allows you to mount a larger filter on a lens with a smaller diameter thread, or a step-down ring, which adapts a smaller filter to a lens with a larger thread diameter (this works best with telephoto lenses—stepping down can cause vignetting with lenses that have normal or wide-angle focal lengths).

✦ **Get with the system.** The Cokin Filter System consists of a mount adapter that you can attach to several different lenses with appropriate adapters, and which accept any of dozens of available square filters. Because you're not paying for a mounting system with each filter you buy, Cokin can save you money in the long run.

✦ **Cover all the angles with polarizers.** Polarizing filters work best when the camera is pointed 90 degrees away from the direction of the light source. The polarizing effect is reduced when a lesser angle is involved. So, with the sun relatively near the horizon, you'd want it located at your left or right. If the sun is directly overhead, you'll find maximum polarization in front of you, at the horizon. Wide-angle lenses can be problematic, because their field of view is so large that some of the image may be 90 degrees from the direction of the sunlight, while other portions are almost facing the sun, producing an uneven polarizing effect.

Fireworks and Light Trail Photography

Every type of photography requires light to make an exposure, but did you know that it's easy to make light itself your subject? You probably know that if your camera moves during a long exposure (which can range from 1/30 second to several seconds or minutes), everything in the photo becomes streaky—especially any light sources within the frame.

If the points of light are the only thing bright enough to register, what you end up with is a photo that captures light trails. These trails show the path the light takes as the camera shakes or, in the case of non-stationary illumination, the movement of the light itself. Figure 6.24 shows an example of a fixed light source and a moving camera.

6.24 I pointed the camera at an interesting neon advertising sign in the window of a closed pizza shop, then panned the camera during a one-second exposure to produce these abstract light trails.

Alternatively, you can lock down the camera on a tripod and leave the shutter open long enough to capture moving lights at night, such as the headlights or taillights of moving automobiles, a rotating Ferris wheel, or fireworks displays. There is more about time exposures later in this chapter.

Inspiration

6.25 The camera was mounted on a tripod and the shutter opened for several seconds to produce the light trails left by this rotating county fair ride.

Use your imagination to come up with different ways of recording light trails. Here are a few ideas to get you started:

✦ Outdoors, on a very dark night, set up the camera on a tripod and open the shutter for a 30-second time exposure. A helper positioned within the camera's field of view can use a penlight pointed at the camera to write or draw an image with light. As long as no light spills over onto the person wielding the penlight, only the light trail shows up in the picture. Place a transparent piece of colored plastic in front of the penlight to change the color of the light trail, even during the exposure.

Tip *If your helper wants to inscribe actual words in midair, remember to have him or her use script letters and write backward! Or, you can simply reverse the image using your image editor.*

✦ Tie a penlight on a piece of long cord, suspend it from an overhead tree branch, and place the Alpha A100 on the ground, pointing upward. Start the penlight swinging back and forth, pendulum-fashion in a figure-eight or other pattern. Then open the shutter for a few seconds. The camera records a regular pattern. Carefully pass pieces of colored plastic in front of the lens during the exposure to create multicolored streaks.

✦ Find a darker location on a busy street, mount the camera on the tripod, and shoot long exposures to capture the streaking headlights and taillights of the automobiles. Experiment with various exposures, starting with about one second to 20 seconds to create different effects.

Light trails photography practice

6.26 A long exposure captured the multibursts that erupted during the finale of a Fourth of July fireworks extravaganza.

Table 6.7
Taking Pictures of Fireworks

Setup	**Practice Picture:** In order to capture the image in figure 6.26, I got to the fireworks show early so I could pick out a prime location on a small hill slightly elevated above the crowd and at the edge of a stand of trees where I could set up a tripod without obstructing the view of the crowds seated in the vicinity.
	On Your Own: A position close to where the fireworks are set off will let you point the camera up at the sky's canopy and capture all the streaks and flares with ease. On the other hand, a more distant location will let you photograph fireworks against a city's skyline. Both positions are excellent, but you won't have time to use both for one fireworks show. Choose one for a particular display, and then try out the other strategy at the next show.
Lighting	**Practice Picture:** The fireworks provide all the light you need.
	On Your Own: This is one type of photography that doesn't require making many lighting decisions.
Lens	**Practice Picture:** SAL-18200 18–200mm f/3.5–6.3 zoom lens set to 28mm.
	On Your Own: A wide-angle lens is usually required to catch the area of the sky that's exploding with light and color. You can even use a fisheye lens to interesting effect. If you're farther away from the display, you may need a telephoto lens to capture only the fireworks.
Camera Settings	**Practice Picture:** RAW capture. Manual exposure, with both shutter speed and aperture set by hand. Saturation was enhanced when the RAW image was imported.
	On Your Own: Depth of field and action stopping are not considerations. Don't be tempted to use noise reduction to decrease noise in the long exposures; the extra time the reduction step takes will cause you to miss some shots.
Exposure	**Practice Picture:** ISO 200, f/11, 30 seconds.
	On Your Own: Don't try to rely on any autoexposure mode. Your best bet is to try a few manual exposure settings and adjust as necessary.
Accessories	A steady tripod is a must. You also should have a penlight, so you can locate the control buttons in the dark! Carry an umbrella so your camera won't be drenched if it rains unexpectedly. You can use the Alpha A100's optional remote control to trip the shutter or to produce a bulb-type exposure that continues until you press the remote-control button a second time.

Fireworks and light trails photography tips

✦ **Use a tripod.** Fireworks and light trails usually require a second or two of exposure, and it's impossible to handhold a camera completely still for that long.

✦ **Don't use a tripod.** Break the rules! You can get some interesting light trails by handholding the camera and deliberately moving it during the exposure. Remember to turn Super SteadyShot off, or your camera will go crazy trying to correct for the movement!

✦ **Don't worry about digital noise.** It's almost unavoidable at longer exposures and won't be evident in your light trails or fireworks shots after you start playing with the brightness and contrast of your shots in your image editor.

✦ **Review the first couple fireworks shots you take on your LCD to see if the bursts are being captured as you like.** Decrease the f-stop if the colored streaks appear to be too washed out, or increase the exposure if the display appears too dark. Experiment with different exposure times to capture more or fewer streaks in one picture.

✦ **Track the skyrockets in flight so you can time the start of your exposure for the moment just before they reach the top of their arc and explode, and then trip the shutter.** An exposure of one to four seconds captures single displays. You can use longer exposures if you want to image a series of bursts in one shot.

Flower and Plant Photography

For many, flowers and plant-life are the only living things that are as much fun to photograph as people. Like people, each blossom has its own personality. Flowers come in endless varieties, and their infinite variety of textures and shapes can be photographed from any number of angles. If you like colors, flowers and fruits provide hues that are so unique that many of our colors — from rose to lilac to peach to orange — are named for them.

Best of all, flowers and plants are the most patient subjects imaginable. They sit for hours without flinching or moving, other than to follow the track of the sun across the sky. You can adjust them into "poses," change their backgrounds, and even trim off a few stray fronds without hearing a single complaint. You can photograph them in any season, including indoors in the dead of winter. Floral photographs are universal, too, as flowers are loved in every country of the world.

Flower photography is a good opportunity to show off your macro photography skills (see the Macro Photography section later in this chapter). You can get close to the blooms, as in figure 6.27 and figure 6.28, or *very* close, as was the case in figure 6.29, which was taken with the Alpha A100 on a tripod using a 50mm macro lens mounted on extension tubes to increase the magnification.

6.27 The translucent petals of flowers seem to glow with their own light when backlit.

Because of their popularity, you won't have to look far for subject matter. Your own garden may provide fodder, but if you're looking for more-exotic plants, there are bound to be public gardens, greenhouses, and herbariums you can visit for your photo shoots.

Photography is so likely to be part of the experience at some venues that you'll find maps leading you to the most popular exhibits, along with tips on the best vantage points for taking pictures. Take a few overall photos to show the garden's environment, and then get closer for floral "portraits" of your favorites.

Inspiration

Flower photography is an excellent opportunity to apply your creative and compositional skills. Use color, shape, lines, and texture to create both abstract and concrete images. Experiment with selective focus and lighting (just move to another angle, and the lighting changes!). It's always fun to find

plants and flowers that look like people or other objects when you want to add a little mystery or humor to your photographs.

When shooting flowers, you can capture individual blossoms, or photograph groups of them together. As every professional or amateur flower arranger knows, floral groups of different types of plant-life can be put together creatively in bouquets to form one-of-a-kind compositions.

6.28 A careful choice of lighting and angle isolates these blooms.

If you have a macro lens, you can isolate an individual part of a flower to explore the mysteries of how these small-scale miracles are constructed. It's possible to spend an entire career doing nothing but photographing flowers, and many photographers do. Surely, you'll find many hours of enjoyment tackling this most interesting subject on your own.

Flower and plant photography practice

6.29 Break a few rules—shoot from the side and allow the blooms to go partially out of focus—to create an unusual image.

Table 6.8
Taking Flower and Plant Pictures

Setup	**Practice Picture:** I wanted to show a bug's-eye view of some flowers, rather than the usual human viewpoint from above. So, I moved the camera down to shoot *through* the blooms to get the photo shown in figure 6.29.
	On Your Own: It's tempting to shoot down on flowers from a lofty perch above them, to better capture those sumptuous blooms. That's why you may enjoy the unusual results you'll get from looking at the plant's world from its own level. Or shoot up to include the contrasting blue sky in the photo. You can photograph single blossoms, bouquets, or an entire field full of wildflowers.

Lighting

Practice Picture: I took this shot in full midday bright sunlight, which produced vivid colors and high contrast.

On Your Own: Although overcast conditions can be suitable for floral photos, this soft lighting tends to mask the color and texture of flowers. Full sunlight brings out the brightest colors and most detail, but it also leads to dark shadows. Use reflectors or fill flash to more brightly illuminate individual blossoms and make the color pop out.

Lens

Practice Picture: SAL-50M28 50mm f/2.8 macro lens with auto extension tubes.

On Your Own: Macro lenses are ideal for flower photography. Shorter macros like the 50mm f/2.8 lens I used exaggerate the proportions of parts of the flower that are closest to the lens. A longer macro, like the SAL-100M28 100mm f/2.8 macro lens, lets you step back from the blossoms and helps throw the background or (in this case the foreground) out of focus. If you don't own a macro lens, a close-focusing telephoto in the 100mm range will also work. To photograph large groups of plants or an entire field of blossoms, use a 24–25mm lens or zoom setting.

Camera Settings

Practice Picture: Aperture Priority AE. I set the white balance to Auto, and used manual focus to prevent the camera from locking in on foreground flowers. I boosted saturation in post-processing using Adobe Camera Raw.

On Your Own: Usually you'll want to control the aperture yourself, either to limit depth of field for selective focus effects, or to increase the depth of field to allow several flowers to remain in sharp focus.

Exposure

Practice Picture: ISO 100, f/4, 1/1600 second.

On Your Own: An ISO 100 setting is ideal for outdoor lighting conditions when you want to use a large aperture to use selective focus. For more generous depth of field, use an f/8 or f/11 aperture, and boost the ISO setting to ISO 200–400 if necessary.

Accessories

Contemplative shots, such as macro photos of flowers, are often best made with a tripod, which lets you position the camera precisely and fine-tune focus manually if you need to.

Flower and plant photography tips

✦ **Try natural backlighting.** Get behind the flower with the sun shining through to capture details of the back-illuminated blossom. The translucent petals and leaves will seem to glow with a life of their own.

✦ **Use manual focus.** Play with manual focus and large apertures to throw various parts of the flower in and out of focus, creating a dramatic and romantic look.

✦ **Boost saturation.** Pump up the richness of the colors by boosting saturation in post-processing. You can use a polarizing filter to create even greater saturation in the flowers and sky.

Infrared Photography

Infrared (IR) photography is a great way to explore new ways of looking at familiar subjects; only illumination in the *near infrared* portion of the spectrum is used to make exposures. In this mode, the Alpha A100 records subjects in a range of tones that represent how much IR light they reflect. Plant life and foliage reflect IR light well, so trees and grass appear almost white in photos, as you can see in figure 6.30. The sky itself doesn't reflect much IR light to the camera, but the water vapor in clouds does, so you end up with fluffy white clouds on an eerie dark sky.

IR photography looks best when it provides a black-and-white view of the world, too. Your shots will initially have a reddish cast to them, which you can vanquish by converting the image to grayscale, or by isolating the red channel in your image editor.

6.30 In IR photos, foliage and clouds appear white, but objects that don't reflect IR well, such as the sky, are darker than they normally appear.

Can the Alpha A100 Cut It with IR?

You need to use long exposures in the several second range because the Sony Alpha A100's response to IR illumination has been reduced in order to improve picture quality. In one respect, that's a good thing. Too much IR light can degrade your image, so camera vendors tend to be more rigorous in filtering it out in their higher-end cameras. A tripod is mandatory.

There's not a lot of extra equipment involved in IR photography. All you really need is an IR filter, such as a Hoya R72 or Wratten #89B, and a tripod for the long exposures that are required. You'll be shooting blind, by the way, because an IR filter is virtually opaque to visible light — so that tripod is really a good idea to help you use a fixed viewpoint.

look to an otherwise mundane photograph. Because objects often reflect more or less IR light than we anticipate based on our perceptions of the visible light that reaches our eyes, everyday objects take on strange tonal values, with some things darker than we would expect and other things lighter. IR is even good for architecture, as you can see in figure 6.31.

Inspiration

When looking for subjects for infrared photography, start with traditional landscapes. Scenery is kind enough to hold still for the long exposures that IR photography requires with the Alpha A100. You can set your camera up on a tripod, focus and frame the image, and then attach your IR filter.

But don't avoid exploring other types of subjects. IR portraits can be interesting, if a little weird, because of the ghostly white rendition of human skin. (Teenagers with complexion problems might find the look especially cool!) Indoor pictures by firelight can also be interesting. You're not capturing the image by the heat of the fire, of course: that's far infrared illumination. But hot subjects like fires emit enough near infrared to allow some intriguing photos by firelight or candlelight.

IR photography can be used as a photojournalism tool. The grainy look, black-and-white tones, and motion blur all add an arty

6.31 IR photos don't have to be limited to landscapes. You can shoot architecture in IR to provide an especially dramatic effect.

Infrared photography practice

6.32 Dusk at a lake during late fall is a time of solitude and vivid colors that makes for beautiful scenic landscapes.

Table 6.9
Taking Infrared Pictures

Setup	**Practice Picture:** It was a great day for IR photography when I arrived at this lakeside vista. There were lots of fluffy clouds in the sky, and the trees were gloriously decked out in their fall finery. Although IR photography won't capture the colors of autumn, I decided to shoot a "color" infrared photo anyway, as you can see in figure 6.32.
	On Your Own: Outdoors: look for scenic locations with lots of greenery to provide a dramatic look to the foliage.
Lighting	**Practice Picture:** Daylight was all the illumination I needed for this shot.
	On Your Own: Brightly lit days are best for outdoor IR photography, but you'll find that the infrared illumination does cut through haze quite well, giving you some surprising results on foggy days, too.

Lens	**Practice Picture:** SAL-1870 18–70mm f/3.5–5.6 zoom lens at the 25mm zoom setting.
	On Your Own: Use a wide-angle lens to take in a broad view, especially if you want to take several photos in different directions without bothering to remove the IR filter. I've found that simply pointing the camera in the direction you want and snapping off a shot works a surprisingly high percentage of the time.
Camera Settings	**Practice Picture:** RAW capture. Manual exposure. I set white balance manually using the Alpha A100's custom white balance capability.
	On Your Own: Instead of pointing the camera at a neutral gray or white subject to capture the white balance, use the grass or trees to let the camera measure the white balance from your high-IR-reflecting subjects. Manual exposure lets you tweak the shutter speed and f-stop after reviewing a few (dim, but viewable) preliminary shots on your LCD. Store the white balance settings you measure for reuse the next time you shoot IR under similar conditions.
Exposure	**Practice Picture:** ISO 200, f/5.6, 4 seconds.
	On Your Own: Use a high enough ISO setting to let you keep shutter speeds within the range of a few seconds — unless you want to use longer exposures and see what blur from cloud movement looks like.
Accessories	A tripod is essential. If you want a "color" infrared photo, you'll also need an image editor to fine-tune the photo.

Infrared photography tips

✦ **Swap your channels.** To get a color IR shot from your basic infrared photo, use Photoshop's Channel Mixer to set the Red Channel's Red value slider to 0 percent and its Blue value slider to 100 percent. Then switch to the Blue channel and set the Red slider to 100 percent and the Blue slider to 0 percent. It's that simple, and what I did for figures 6.34 and 6.35.

✦ **Bracket exposures.** IR photos can look quite different when you bracket one-half to one full stop.

✦ **Take advantage of the long exposures.** Select subjects that have movement, such as rivers, streams and waterfalls, or moving cars and people. The intentional blur can become an interesting picture element.

Landscape and Nature Photography

Like floral photography, landscape and nature photography provides you with a universe of photo subjects, there for the taking, courtesy of Mother Nature. This kind of photography provides a dual joy: the thrill of the hunt as you track down suitable scenic locations to shoot — whether remote or close to home — and then the challenge of using your creativity to capture the scene in a new and interesting way.

Landscapes are an ever-changing subject, too. The same scene can be photographed in summer, winter, fall, or spring, and look different each time. Indeed, a series of these photos of a favorite vista in different seasons makes an interesting and rewarding project.

6.33 Winter landscapes have a chilly appeal of their own.

Inspiration

6.34 Lakes and rivers can be approached from many different angles, allowing you to carefully construct your compositions.

Nature photography can take many forms. You can photograph a landscape as it really is, capturing a view exactly as you saw it in a moment in time. Or you can look for an unusual view or perspective that adds a fantasy-world quality. The three basic styles of landscape photography actually have names: *representational* (realistic scenery with no manipulation), *impressionistic* (using photographic techniques such as filters or special exposures that provide a less realistic impression of the landscape), and *abstract* (with the landscape reduced to its essential components so the photo may not resemble the original scene at all).

Animals are a part of nature photography, too. You can photograph creatures like tree frogs or insects up close, or grab shots of more timid animals from a distance with a telephoto lens. Look for wildlife to populate your landscape, too, or shoot a scene with only the trees, plants, rocks, sky, and bodies of water to fill the view. Choose the time of day or season of the year. You may be working with the raw materials nature provides you, but your options are almost endless.

Scouting Locations

As you enjoy landscape and nature photography, you'll discover some tricks for finding good scenes to shoot.

✦ **If you're in an unfamiliar area, check with the staff of a camping or sporting goods store or a fishing tackle shop.** Stop in and buy a map or make another small purchase, and then quiz these local experts to discover where the best hiking trails or fishing spots are. You'll find lots of wildlife and great scenic views along these trails.

✦ **Buy a local newspaper and find out what time the sun or moon rises or sets, and when to expect high or low tide.** All these times of day offer their own landscapes and nature photographic charm. Dusk and dawn make particularly good times for landscape and nature photography because the light is warm and the lower angle of the sun brings out the texture of the scenery.

✦ **Don't get lost!** Carry a compass so you'll always know where you are when scouting locations. Plus, you can use the compass with subposition tables you can find locally to determine exactly where the sun or moon will be at sunset or sunrise. If the sun will set behind a particular mountain, you can use that information to choose your position.

✦ **Include weather in your plans.** Rainy or cloudy weather may put a damper on your photography, or it can form the basis for some interesting, moody shots. Some kinds of creatures can be more easily tracked when the weather is moist or there is snow on the ground. The National Weather Service or local weather forecasters can let you know in advance whether to expect clear skies, clouds, wind, or other conditions.

Landscape and nature photography practice

6.35 Landscapes don't have to be shot in landscape orientation, as this image of a curving shoreline, with a lighthouse off in the distance, shows.

Table 6.10
Taking Landscape and Nature Pictures

Setup	**Practice Picture:** The shoreline shown in figure 6.35 is actually the east side of a breakwall leading out to a lighthouse. There's a crowded public beach on the west side, but I wandered over to this quiet vista to take the picture. **On Your Own:** You don't need to find a remote location to find unspoiled wilderness. Even sites close to home can make attractive scenic photos if you're careful to crop out the signs of civilization.
Lighting	**Practice Picture:** It was late afternoon and the sun was beginning to descend in the sky, casting interesting shadows on this side of the breakwall. **On Your Own:** You won't have much control over the available illumination when shooting scenics. Your best bet is to choose your time and place, and take your shots when the light is best for the kind of photographs you want to take.
Lens	**Practice Picture:** SAL-18200 18–200mm f/3.5–6.3 zoom lens set to 20mm. **On Your Own:** Use a long telephoto to reach out and grab scenes containing easily spooked wildlife. Use a wide-angle lens to take in a broader view for scenics, but keep in mind that the foreground will be emphasized. If you're far enough from your chosen scene, a telephoto lens will capture more of the distant landscape, and less of the foreground.
Camera Settings	**Practice Picture:** RAW capture. Shutter Priority AE, with saturation set to enhanced. Although I could have boosted saturation during conversion from RAW, often it's easier to make your basic settings at the time you shoot. **On Your Own:** Shutter Priority mode lets you set a high enough shutter speed to freeze your landscape and the motion of things that move, such as waves on the water. Super SteadyShot counters only camera shake.

Continued

Table 6.10 *(continued)*

Exposure	**Practice Picture:** ISO 200, f/11, 1/500 second. This combination gave me excellent picture quality at the lower ISO setting, plus a reasonable f-stop and motion-freezing shutter speed.

On Your Own: Later in the day, an ISO setting of 400 can allow a 1/250 second shutter speed. Any extra noise caused by the ISO boost shows up only in the distant trees and in shadow areas. |
| **Accessories** | Landscape photographers often use tripods to steady the camera and make it easy to fine-tune the composition. Use a quick-release plate so you can experiment with various angles and views and then lock down the camera on the tripod only when you've decided on a basic composition. A circular polarizer and an umbrella and raincoat might be handy accessories, too. |

Landscape and nature photography tips

✦ **Use a circular polarizer with caution.** A polarizer can remove reflections from water, cut through haze when you're photographing distant scenes, and boost color saturation. However, a polarizer may cause vignetting with extra-wide-angle lenses, will reduce the amount of light reaching your sensor (increasing exposure times), and may be unpredictable when applied to images with a great deal of sky area.

✦ **Bracket your exposures.** The same scene can look dramatically different when photographed with a half-stop to a full-stop (or more) extra exposure, or with a similar amount of underexposure. An ordinary dusk scene can turn into a dramatic silhouette.

✦ **Take along protective gear for inclement weather.** A sudden shower can drench you and your Sony Alpha A100. An unexpected gust of wind can spoil an exposure, or even tip over a tripod-mounted camera. An umbrella can protect you from precipitation or shield your camera from a stiff wind.

Macro Photography

Close-up, or *macro,* photography is another chance for you to cut loose and let your imagination run free. This type of picture-taking is closely related to floral photography and still-life photography, which also can involve shooting up close and personal. However, the emphasis here is on getting really, really close.

6.36 A needle and thread can become an interesting macro subject when photographed from an inch or two away.

Although you can have lots of fun shooting close-ups out in the field, macro photography is one of those rainy-day activities that you can do at home. You don't need to travel by plane to find something out of the ordinary to shoot. That weird crystal salt shaker you unearthed at a garage sale might be the perfect fodder for an imaginative close-up that captures its brilliance and texture. Grains of sand, spider webs, the interior workings of a finely crafted Swiss watch, and many other objects can make fascinating macro subjects. Or you can photograph something important to you, such as your coin or stamp collection.

Inspiration

Explore the world around you by discovering interesting subjects in common objects. When you've found subject matter that will give your imagination a workout, the next step is to make it big.

Indeed, the name of the game in macro photography is magnification, not focusing distance. If you want to fill the frame with a postage stamp, it matters little whether you're using a 50mm or 100mm macro prime lens, or a close-focusing zoom lens. Any of these should be able to fill that frame with the stamp, and for a relatively flat object of that sort, you probably won't be able to tell which lens or focal length was used to take the picture.

Your choice of lens, then, depends on how far away you want to be when you fill that frame. To shoot a postage stamp, you might like the Sony 50mm lens; the company's 100mm lens might be better when you're photographing a flower and want enough room to play with some lighting effects, as was the case for figure 6.37. If your passion is photographing poisonous spiders or skittish critters, perhaps a 200mm macro lens, available from third-party vendors, would be more suitable.

You don't have to purchase an expensive macro lens to enjoy close-up photography. If you're not ready to spring for an exotic lens, a lens you already own may focus close enough for some kinds of macro work. Any good prime lens can do the job. You can couple that optic with an inexpensive extension tube to extend its focus range down to a few inches from your subject.

Automatic extension tubes that preserve your Alpha A100's autofocus and exposure features can be purchased individually for as little as $50, in sizes ranging from about 12–36mm in length, or in sets of three. You can combine tubes to get longer extensions. A good, sharp lens and some extension tubes can get you in the macro game quickly.

Less ideal are close-up attachments that screw onto the front of a lens similarly to a filter, and provide additional magnification. Unless you buy one of the more expensive models ($50 or more, depending on the filter size your lens requires), you'll lose a little sharpness. You can use several close-up attachments at once to produce additional magnification at the cost of a little more resolution.

6.37 A close-up photo can help you discover new worlds in everyday objects, such as this rose.

Macro photography practice

6.38 Chess pieces and a glass chessboard made this atmospheric macro shot easy to achieve.

Table 6.11
Taking Macro Photos

Setup	**Practice Picture:** One of my long-term projects is finding new ways to photograph a glass chessboard and matching glass chess pieces shown in figure 6.38. I placed the chessboard on a piece of white poster board, supported by a quartet of half-liter water bottles so I could light it from underneath.
	On Your Own: Use poster board, fabric, or other backgrounds to isolate your macro subjects, and pose them on a tabletop or other flat surface.

Continued

Table 6.11 *(continued)*

Lighting	**Practice Picture:** I used a pair of high-intensity desk lamps located on either side of the chessboard, with a little light spilling underneath the board.
	On Your Own: You can use desk lamps to light small setups, with reflectors to fill in the shadows.
Lens	**Practice Picture:** SAL-100M28 100mm f/2.8 macro lens.
	On Your Own: Use a macro lens or close-focusing prime or zoom lens to provide the magnification you need. Or fit a 50mm or other prime lens with extension tubes to get in close.
Camera Settings	**Practice Picture:** RAW capture. Manual exposure. RAW capture allowed tweaking the white balance when the image was imported into an image editor, so I could change the white balance to a much bluer rendition that added an icy cool mood to this shot.
	On Your Own: Unless you're going for a special effect, you'll want to control the depth of field, so choose Aperture Priority AE mode and set the white balance to the type of light in the scene.
Exposure	**Practice Picture:** ISO 100, f/18, 8 seconds. To blur the background, while still allowing good focus on chessmen arranged two-deep, I used a relatively small f-stop. But, I focused slightly in front of the king, so the pieces would be in focus even if the background was not.
	On Your Own: The Alpha A100's depth-of-field preview button is your friend for visualizing how much is in focus before you take the shot. For maximum front-to-back sharpness, set a narrow aperture such as f/16 to f/22. To blur the background, choose a wider aperture such as f/8 to f/11. Use ISO 200 for maximum sharpness and the least amount of noise. You won't need higher ISOs when your camera is mounted on a tripod.
Accessories	Use a tripod for macro photography. Use the self-timer to trip the shutter without vibrating the camera.

Macro photography tips

✦ **Use manual focus and zero in on the exact plane you want to appear sharpest.**

✦ **Remember that long exposures take some time.** Just because you heard a click doesn't mean the picture is finished — you heard the shutter *opening*. Wait until the shutter closes again, or you can see the review image on the LCD before touching the camera.

✦ **Review your close-up photos right away.** Use the Alpha DSLR-A100's LCD to double-check for bad reflections or other defects. It takes a long time to set up a close-up photo, so you want to get it right now, rather than have to set up everything again later.

Night and Evening Photography

Photography during the evening and after dusk is a challenge because, after the sun goes down, there is much less light available to take the photo. Use add-on light sources, such as electronic flash, only as a last resort, because as soon as you add an auxiliary light, the scene immediately loses its nighttime charm.

Instead, the goal of most night and evening photography is to reproduce a scene much as it appears to the unaided eye, or, alternatively, with blur, streaking lights, or other effects added that enhance the mood or create an effect.

Because night photography is so challenging technically, you'll find it an excellent test of your skills, and an opportunity to create some arresting images.

6.39 It was still pitch dark outside when I got up just before dawn to shoot this military academy from a hill that overlooked its strategic position.

Inspiration

6.40 Just after sunset is another prime time to capture interesting evening photographs.

Correct exposure at night means boosting the amount of light that reaches your sensor. You can accomplish this several different ways, often in combinations. Here are some guidelines:

✦ **Use the widest possible aperture.** A fast prime lens, with a maximum aperture of f/1.8 to f/1.4, will let you shoot some brightly lit night scenes handheld using reasonably short shutter speeds.

✦ **Use the longest exposure time you can handhold.** For most people, 1/30 second is about the longest exposure they can use without a tripod with a wide-angle or normal lens. You can often bump that down to 1/8 second or longer with Super SteadyShot

active. Telephotos require 1/60 to 1/125 second, even with Super SteadyShot, making them less suitable for night photography without a tripod.

✦ **Use a tripod, monopod, or other handy support.** Brace your camera or fix it tight and you can take shake-free photos of several seconds to 30 seconds or longer.

✦ **Boost the ISO.** Increase the sensor's sensitivity to magnify the available light. Unfortunately, raising the ISO setting above 400 also magnifies the grainy effect known as *noise*. If you're not in a hurry, the Alpha A100's noise-reduction option can process the image to reduce the noise effects.

Night- and evening-photography practice

6.41 Photography of architecture after dark lends itself to painting-with-light techniques (which involves making a long exposure, supplemented with multiple flashes from an electronic flash unit (or several units) or even extra lighting supplied by flashlights or other portable incandescent lights).

Table 6.12
Night and Evening Photography

Setup	**Practice Picture:** Although this government building was fairly well lit, the left and right sides of the structure were cloaked in murky shadows. To get the photo shown in figure 6.41, I set my camera on a tripod and used the painting-with-light technique to illuminate it with several manually applied flashes during the long exposure. I was fortunate that it was a calm night, without any breezes that would cause the flags on the poles topping the building to unfurl and blur during the long exposure.
	On Your Own: Find a shooting spot that shows a building at its best, with a clean background and uncluttered foreground. Look for surrounding trees or other structures that can serve as a frame. You can look at articles in home magazines for ideas for the most flattering way to shoot a particular type of building. If you plan to shoot at night using the painting-with-light technique described here, study the existing illumination before you set up.

Continued

Table 6.12 *(continued)*

Lighting	**Practice Picture:** During a two-minute exposure, I had an assistant equipped with an external flash walk around the front of the building, pressing the open flash button on the electronic flash at intervals to illuminate the dark areas, pointing the flash from an angle to avoid having the flash reflect off windows into the camera lens. He kept his body between the camera and the flash and kept moving so he wouldn't show up in my photo. Orange gel over the flash gave the unit the same color balance as the existing lighting. **On Your Own:** At night, time exposures can yield good pictures of many exteriors with existing light. During the day, the lighting varies more. To avoid harsh shadows that can obscure important details, you might want to wait for a slight cloud cover to soften the harsh daylight. If you've found a particular spot that's ideal and have the luxury of time, you can choose the time of day that provides the best lighting.
Lens	**Practice Picture:** I used the SAL-1870 18–70mm f/3.5–5.6 zoom lens set to 28mm. **On Your Own:** Your lens choice depends on whether you can get far enough away to avoid tilting the camera to take in the top of the structure. In extreme cases, a wide-angle lens like the SAL-1118 DT 11–18mm f/5.5–5.6 super wide zoom lens might be necessary.
Camera Settings	**Practice Picture:** I used RAW capture, set the white balance to tungsten, used manual exposure with a custom curve, and added saturation enhancement and sharpening in post-processing with Adobe Camera Raw. **On Your Own:** When not shooting time exposures, you can often use Shutter Priority to specify a suitable speed and allow the Alpha to choose the aperture.
Exposure	**Practice Picture:** ISO 100, f/22, 120 seconds. **On Your Own:** Time exposures are usually trial-and-error. Use center-weighted or spot metering to ensure that the exposure is made for the building itself and not any surroundings. Using the Alpha's automatic bracketing feature lets you take several consecutive pictures at slightly different exposures, so you can choose the one that most accurately portrays the building.

Accessories A tripod was a must for this time exposure, but it can also be helpful to allow a repeatable perspective, in case you return from time to time to take additional shots from the same angle. Record where you placed the tripod legs by removing the camera after the shot and taking a picture of the tripod and its position. Although it's not exactly painting with light, you can sometimes use flash in daylight to fill in shadows—but be careful of reflections off windows. That applies double for painting-with-light exposures: Watch where your flash is pointed to avoid reflecting back to the camera.

Night and evening photography tips

✦ **If you absolutely *must* use flash, use a slow shutter speed.** Longer shutter speeds with flash enable existing light in a scene to supplement the flash illumination. With any luck, you'll get a good balance and reduce the direct flash look in your final image. You can try the A100's Night View/Night Portrait Scene mode to see if it provides the look you want.

✦ **Shoot in twilight.** This enables you to get a nighttime look that takes advantage of the remaining illumination from the setting sun.

✦ **When blur is unavoidable due to long exposure times, use it as a picture element.** Streaking light trails can enhance an otherwise staid night-scene photo.

✦ **If you have a choice, shoot on nights with a full moon.** The extra light from the moon can provide more detail without spoiling the night-scene look of your photo.

✦ **Bracket exposures.** Precise exposure at night is iffy under the best circumstances, so it's difficult to determine the "ideal" exposure. Instead of fretting over the perfect settings, try bracketing. A photo that's half a stop or more under- or overexposed can have a completely different look and can be of higher quality than if you produced the same result in an image editor.

Product Photography

Even if your job description doesn't include "product photographer," you still might be called on to take suitable pictures of wares hawked by your company, perhaps for catalogs, brochures, public relations news releases, or other typical product photograph applications.

Given the huge popularity of eBay and other online auction sites, it's likely that readers of this book will need good photos of items that will be put up for auction. Indeed, online auction sites such as eBay are great venues for those who want to clear out their attics, sell their older photographic gear so they can buy new lenses and accessories, or locate a rare or unusual item. Auction photos are probably the most common type of product photography being done by non-professional photographers today.

The first thing sellers discover is that good photos make it possible to sell products at higher prices because buyers, especially those who are purchasing from advertisements, Websites, or online auctions are more likely to pay a good price for something if they can see exactly what they're getting.

You can sell just about any product on eBay, with some notable exceptions for firearms, human body parts, and other excluded items. In addition to photo gear, you can find computers and accessories, clothing, videogames, books, automobiles, and other common items for sale. Because shipping large items can be expensive, the vast majority of the items sold on eBay are roughly the size of a proverbial breadbox or two. That means that much of what you've learned about close-up or flower photography, or even indoor portraiture, can be applied to online auction photos and product photos. The goals are the same: to capture a clear, well-lit image of a subject.

6.42 There's a separate eBay Motors auction site for motor vehicles, but the photo rules remain the same: Picture the product you're selling in an attractive setting, so buyers will want to own what you're offering.

If you're shooting a product photograph for publication in an ad, distribution with a public relations news release, for display in on a Web page, or for use in an online auction, you'll want the image to be sharp, clear, and show your product in an attractive way.

Inspiration

6.43 This massive wood carving is the typical product of the artisan who produced it.

Some product photography is outside the ordinary, as in the case of the wood carving of the Native American chief shown in figure 6.43. This artisan has a goal of erecting carvings of this type in all 50 States of the Union, and uses photographs of finished products such as this one to obtain commissions for additional work. Because the carving happened to be surrounded by scaffolding on three sides, I had to spend a great deal of time selecting angles and ended up getting down low in front of it and shooting through the scaffolding to get this shot.

Catalog work and some other kinds of mass production product photography tend to be less contemplative when you have many different items to photograph for multiple auctions. While you might spend half an hour setting up a conventional close-up photo to get it exactly right, when you have 15 or 20 different items to photograph for the next catalog, you'll want to be able to crank out good pictures very quickly. The key is to have a setup you can use over and over. After you have arranged the background and lights, you can drop one product into the setting, take a photo or two, and then replace it with a different product. Instead of spending 30 minutes per photo, you might want to be able to shoot ten or 20 pictures in 30 minutes.

For any type of product photography, if you want to work very fast, use a piece of fabric as a background, and find a location with good natural lighting so you can dispense with flash or lamps altogether. Mount your camera on a tripod so you can keep the same subject distance and angle for a series of similar-sized items, and consider using an IR remote control so you don't even have to take more than a glance through the viewfinder between shots. With some practice, you'll be cranking out auction photos as quickly as an experienced catalog photographer.

Product photography practice

6.44 Product-type photographs are often needed to illustrate brochures and presentations.

Table 6.13
Taking Product Photos

Setup	**Practice Picture:** To illustrate the concept of "good fortune," I photographed this pile of fortune cookies on a seamless background to produce the image shown in figure 6.44.
	On Your Own: If you shoot many product photos, you may want to set aside a corner as your permanent "studio" with background and lighting already in place. You'll find that a single setup can work with objects in a broad range of sizes.
Lighting	**Practice Picture:** Two flash units bounced off umbrellas provided relatively soft illumination, but the white umbrellas were still bright enough to provide specular highlights on the shiny surfaces of the cookies. I set up a dark screen to shield the background to produce an interesting shadow effect.
	On Your Own: Direct flash won't give good results for this kind of photography. It is too harsh and you may even find that the camera's lens or lens hood casts a shadow on the item being photographed.

Lens	**Practice Picture:** SAL-100M28 100mm f/2.8 macro lens.
	On Your Own: Use a macro lens or close-focusing prime or zoom lens to provide the magnification you need. You can also use a prime lens with extension tubes to photograph objects from a few inches to a few feet from the camera.
Camera Settings	**Practice Picture:** RAW capture. Aperture Priority AE with saturation set to Enhanced.
	On Your Own: As with other close-up photos, try to control the depth of field, so choose Aperture Priority AE mode and set the white balance to the type of light in the scene.
Exposure	**Practice Picture:** ISO 100, f/22, 1/160 second.
	On Your Own: Use an f-stop between f/11 and f/22 to maximize front-to-back sharpness. If the camera is mounted on a tripod, you can use longer shutter speeds as required, and stick with an ISO setting of 200 for maximum quality.
Accessories	Use reflectors to fill in the shadows.

Product photography tips

✦ **Crop tightly.** If you're trying to fill a 600-pixel-wide image with information for display on a Web page, crop tightly so you don't waste any space. You can crop in the camera, or later in your image editor. Fortunately, your Alpha A100 has pixels to spare — about 25 times more than you really need for a photo that will be seen online.

✦ **Use a plain background.** Although plain backgrounds are important for most kinds of close-up photography, they're even more important for product photos, which often must present the product being sold with no distractions.

✦ **Use higher-contrast lighting.** Soft lighting obscures details, and snappier lighting shows off the details in the product you're trying to sell. Save the diffused illumination for your glamour photography.

✦ **Boost saturation — within limits.** For some kinds of products, it's a good idea to dial in some extra saturation to make your image more vivid and appealing. However, if the true colors of your item are an important selling point (as with clothing or dinnerware), go for a more realistic rendition that doesn't mislead your buyers.

Panoramic Photography

No scenic photo is quite as breathtaking as a sweeping panorama. Horizons look more impressive, mountain ranges more majestic, and vistas more alluring when presented in extra-wide views. If you shoot scenic photography—from landscapes to seascapes—you'll want to experiment with panoramas. You can create them in your camera, or assemble them from multiple shots in your image editor.

Some of the charm of panoramas comes from the refreshing departure from the typical 3:2 aspect ratio that originated with 35mm still-photo film frames, and which lives on in the 3872 × 2592-pixel resolution of the Sony Alpha A100. Even common print sizes, such as 5 × 7, 8 × 10, or 11 × 14 inches provide a staid, squat, rectangular format. You can go far beyond that with your Sony Alpha A100, producing panoramas that stretch across your screen or print in just about any ultrawide view you choose.

6.45 This panorama was produced by taking an ordinary shot and cropping off the top and bottom to eliminate excess sky and foreground areas. It was shot in black-and-white to produce a sunset picture without the usual ruddy tones.

Inspiration

There are several different ways to create panoramas. The easiest method is to take a wide-angle photo of your vista, and then crop off the top and bottom portions of the image to create a view that's much wider than it is tall. If you go this route, you'll want to start with the sharpest possible original image. Mount your camera on a tripod, set sensitivity to ISO 100, and work with the sharpest suitable lens in your collection, set to its sharpest f-stop. The 10 megapixels of resolution in your Alpha should be plenty to allow you to crop off the upper and lower edges of the frame.

Another method for creating a panorama is to take several photos and merge them in your image editor. (Photoshop and Photoshop Elements have special tools for stitching photos together.) For the best results, mount your camera on a tripod and pan from one side to the other as you take several overlapping photos. (The term *pan* comes from panorama, by the way.) Ideally, the pivot point should be the center of the lens (there are special mounts with adjustments for this purpose), but for casual panoramas, mounting the camera using the Alpha A100's tripod socket works fine.

When choosing your panorama subjects, remember that you're not limited to scenic photographs. Almost any subject that can be captured with a wide-angle lens can be turned into fodder for a panorama. A super-wide panorama can show both the infield and action around the plate in a single photograph.

6.46 Panoramic photos are a creative way to express wide open spaces, as in this photo of a dairy farm's "spread."

Panorama photography practice

6.47 This panorama shows a river gorge in the summer.

Table 6.14
Taking Panorama Pictures

Setup	**Practice Picture:** A traditional wide-angle shot of this river gorge would have wasted a lot of space on the sky and water, so I decided to shoot with a wide-angle lens, and then trim the excess to arrive at the photo shown in figure 6.47.
	On Your Own: Look for scenes that you can crop to produce images that are much wider than they are tall. Mountains and other kinds of landscapes and skylines are especially appropriate.
Lighting	**Practice Picture:** The existing light provided by the midday sun was just fine for this panorama.
	On Your Own: As with conventional landscape photography, your control over lighting will generally be limited to choosing the best time of day or night to take the photo. Unless you're taking a picture on the spur of the moment, think about planning ahead and showing up at your site when the lighting is dramatic.
Lens	**Practice Picture:** SAL-1118 DT 11–18mm f/5.5–5.6 super wide zoom lens.
	On Your Own: If you don't need the extreme wide view required for the practice picture, you can choose a good moderate wide-angle zoom lens to capture your vista for panoramas created by cropping a single photo. If you're stitching pictures together, you may want to try a slightly wider zoom setting to reduce the number of images you need to collect. Avoid very wide angle lenses if you can because of the distortion they can produce.

Camera Settings	**Practice Picture:** RAW capture. Shutter Priority AE.
	On Your Own: Use Shutter Priority AE and select a high shutter speed to produce the sharpest possible image.
Exposure	**Practice Picture:** ISO 200, f/16, 1/200 second.
	On Your Own: Unless you're including foreground objects for framing, you can select a high shutter speed and let the camera go ahead and open the lens fairly wide, with no worries about the shallower depth of field.
Accessories	For dawn or dusk panorama shots, a tripod can help steady the camera during longer exposures.

Panorama photography tips

✦ **Use a tripod.** If you're shooting several photos to be stitched together later, use a tripod to help you keep all the shots in the same horizontal plane. Super SteadyShot will fix camera shake, but won't allow you to keep the camera in the precise position you need for overlapping photos.

✦ **Overlap.** Each photo in a series should overlap its neighbor by at least ten percent to make it easier to stitch the images together smoothly.

✦ **Watch the exposure.** Use the same exposure for each photograph in a panorama series. Use the Alpha A100's exposure-lock feature; otherwise your camera calculates a new exposure for each shot.

✦ **Save time with software.** If you don't have Photoshop or Photoshop Elements, do a Google search to find the latest photo-stitching software for your particular computer platform (Windows or Mac). Although you can stitch images together manually, the right software can save a lot of time.

✦ **Plan your composition.** If you're planning on cropping a single shot into a panorama, map out your composition carefully before you shoot, making sure there is no important subject matter in the upper and lower thirds of the frame.

✦ **Think sharp.** Because you're throwing away as many as half the available pixels when you crop a single shot into a panorama, the remaining image area must be extra sharp. Consider using a tripod even in broad daylight; use a low ISO setting, and work with your sharpest lens at its optimum f-stop.

Seasonal Photography

Everybody talks about the weather, and your Alpha A100 gives you the opportunity to do something about it. Instead of hunkering down indoors when skies are dark and cloudy, the air is cold, and precipitation is falling, you can go out and grab some interesting shots that reflect Mother Nature at work. Of course, bright sunny days are weather, too, but windy, overcast, snowy, or rainy conditions have the makings of some interesting photos.

You can use seasonal and weather pictures to create photographic art, as documentation for changing climates, or even as a tool for reporting damage to your insurance company following a major storm.

6.48 Fall is a great time for capturing colorful foliage, but your time window for the best colors may be only a week long.

Inspiration

6.49 Nothing says summer like a shot taken at the beach.

You don't have to hunt for seasonal and weather photos—they will seek you out, wherever you happen to be. The key is to be prepared so you're in no danger of you or your equipment getting wet, overly cold, or thrown about. Some larger camera shoulder bags have a built-in rain-coat so they can be used in inclement weather. The covering pulls out and makes it easy for sports photographers and others who have little choice about their working conditions to continue shooting even in the worst conditions.

You can make a water-resistant case for your Alpha out of a recloseable plastic bag. Cut a hole for the lens to peep through, and place a clear glass UV filter over the lens to protect it from moisture. You can activate most camera controls right through the plastic bag.

Lightning is among the most interesting seasonal phenomena to photograph. There are even storm chasers who drive around looking for storms so they can photograph bolts from the sky. All you need is to mount your camera on a tripod, switch to Manual, and choose a small f-stop and long exposure. Point the camera in a direction where you've seen lightning in the last few minutes, and wait for another flash to pop. Just be certain you're not out in the open and liable to lure a strike yourself!

The less adventurous might want to specialize in cloudy skies, instead. There are lots of different types of clouds, ranging from wispy to menacing, and all make good photo subjects. Indeed, you can shoot clouds and then use an image editor to drop them into cloudless skies in other photographs you've taken.

Seasonal photography practice

6.50 During summer, this particular lakeshore is a popular recreational boat-launching site. In winter, it's a deserted and lonely scene that lends itself to this backlit silhouetted image.

Table 6.15
Taking Seasonal Pictures

Setup	**Practice Picture:** I can't resist re-visiting locations where I've taken pictures at other times of year, and was pleased to see how this boat-launching beach was transformed into an icy scene by the cold grip of winter, as you can see in figure 6.50.
	On Your Own: Interesting weather conditions are definitely worth a little field trip looking for good shooting situations. Once the worst of a storm, snowfall or rain shower is over, venture out looking for interesting compositions.
Lighting	**Practice Picture:** It was late in the day, so the sun was low in the sky. The backlighting was perfect.
	On Your Own: Although you can work with the light on hand, if it's not actually raining or snowing, you can use reflectors to bounce light into areas that could use a little extra illumination. If you use Fill Flash in moderation, it can also help provide a little extra snap.

Lens	**Practice Picture:** SAL-1870 18–70mm f/3.5–5.6 zoom lens set to 24mm.
	On Your Own: Use the same lenses you'd work with for landscape photography; wide-angles for the big picture, and longer lenses and zooms to capture details. Close-up photos of ice or icicles can benefit from a macro lens, but many zoom lenses will get you down to the roughly 1–2 foot distance you'll need for photos of this type.
Camera Settings	**Practice Picture:** RAW capture. Aperture Priority AE. Saturation set to enhanced.
	On Your Own: Use Aperture Priority AE mode to control depth of field for close-ups. In dim light, switch to Shutter Priority so you can be certain that you're using a high enough shutter speed to prevent blur from camera shake.
Exposure	**Practice Picture:** ISO 400, f/11, 1/800 second.
	On Your Own: If the background is distracting use the widest aperture possible to blur the background. ISO 200 or 400 should be enough for good exposures, but on very stormy days or nearer to sunset you may have to jump up to ISO 800.
Accessories	Silver reflectors are useful for close-ups on overcast days even though lighting is already fairly diffuse. Bouncing a little extra light onto your subject from a silver reflector can add a little contrast.

Weather photography tips

✦ **Use a polarizer.** You might find a circular polarizer useful for cutting down on atmospheric haze and improving contrast. Polarizers always work best when the camera is pointed at right angles to the sun.

✦ **Try a filter.** Graduated gray or colored filters can darken the sky to improve the rendition of the foreground.

✦ **Use a tripod.** Bad weather often calls for a tripod or monopod to steady your camera.

✦ **Have patience.** When shooting lightning pictures, take a few with the shutter open long enough to capture two or three bursts in one photo, for a particularly dramatic effect.

Sports and Action Photography

The Sony Alpha DSLR-A100's fast response and rapid-fire three frames-per-second continuous shooting mode (with unlimited bursts if you're shooting in JPEG mode) capabilities make it a popular tool for capturing sports shots at football or baseball games, soccer and tennis matches, and even hockey and rugby. But action photography isn't limited to sports, of course. You encounter fast-moving action at amusement parks, while swimming at the beach, or while struggling to climb a mountain. Everything from skydiving to golf to auto racing all lend themselves to action photography.

Action photography is exciting because it captures a moment in time. The goal is to find exactly the right moment to take the photo. Your Alpha simplifies the process in several ways. You can leave it switched on and ready to go at all times, so you never lose a shot waiting for your camera to warm up. Also, after the camera is up to your eye and you see a picture you want to take, the autofocus and autoexposure systems work so quickly that you can depress the Shutter Release button and take a picture in an instant, without the interminable shutter lag that plagues so many point-and-shoot digital cameras. Finally, the Alpha A100's continuous shooting mode can fire off bursts of shots as quickly as thee frames per second, so even if your timing is slightly off, you can

6.51 A fast shutter speed froze this football action in its tracks.

still improve your chances of grabbing the precise instant. When deciding how to shoot action, don't worry about freezing all motion with a fast shutter speed. Sometimes the right amount of blur can enhance your photo by imparting a sense of movement. One way to do this is to *pan* the camera, or move it in the direction of the motion. When you pan, the camera follows the moving subject, so a given shutter speed offers more action-stopping capability. Turn Super SteadyShot off when panning.

Inspiration

You can take action pictures during the daytime, using fast shutter speeds to freeze action, or using slower speeds to allow a little blur (see figure 6.52) to provide a feeling of motion in your images. Or, you can shoot at night and let the action-stopping capabilities of electronic flash freeze your subjects in their tracks.

The dual challenges facing action photographers are knowing the right subject and knowing the right time. The other aspects are just technical details that are easy to master. However, you always need to understand enough about what is going on to anticipate where the most exciting action will take place and be ready to photograph that subject. Then you need to have the instincts to pull the trigger at exactly the right instant to capture that decisive moment.

6.52 The blur of the baseball at 85 mph gives a feeling of motion to this baseball action shot.

Sports and action photography practice

6.53 A long lens, a good choice of location, perfect timing, and a little help from the Alpha A100's continuous shooting mode combined to produce this shot of a pitcher attempting to pick off a runner at first base.

Table 6.16
Taking Sports and Action Pictures

Setup	**Practice Picture:** My seat next to the visitors' dugout for the professional baseball game shown in figure 6.53 provided the perfect vantage point for covering both the pitcher's mound and first base.
	On Your Own: Know where to stand or sit for the best action-shooting opportunities. At football games, that may be on the sidelines 10 yards in front of or behind the line of scrimmage. You can shoot soccer games from behind or next to the net. Basketball games look best from near the bench or behind the backboard. You may not have easy access to these positions at pro or college contests, but high school are games considerably more photographer-friendly. Until you find a favorite location or two, roam around and scout out the best shooting sites.

Lighting

Practice Picture: Daylight was just fine for lighting at this mid-afternoon baseball game.

On Your Own: Even outdoors, the illumination can be less than perfect, particularly on gloomy days or at dusk. When the outdoor light is really scarce, you can't do a lot except use a flash to fill in murky areas. Indoors, the light may be okay as is if you boost the ISO setting to ISO 800 or ISO 1600. More-ambitious sports photographers may want to experiment with multiple flash units to provide broad illumination over larger areas.

Lens

Practice Picture: Sigma 170–500mm f/5–6.3 APO aspherical autofocus telephoto zoom lens at 400mm. When you're far from the action, the longer the focal length you can muster, the better.

On Your Own: Your lens choice depends on the type of action you're shooting. Indoor sports may call for wide-angle or normal focal lengths. Outdoors, if you can get close to the action, a 70–200mm zoom lens like the SAL-70200G 70–200mm f/2.8 G-series telephoto zoom lens may cover all the bases. That particular optic may be too expensive at $2,400, but third-party vendors offer lenses with the equivalent focal length but slower apertures for a couple of thousand dollars less. If you're up in the stands or you want to capture an outfielder snaring a fly ball, a prime lens or zoom in the 300–500mm range may be required. You need a lens that's fairly fast if you want the Alpha A100's autofocus features to focus for you. A wide aperture also makes it easier to focus manually. However, most of your shots will be taken with the lens stopped down to produce sufficient depth of field.

Camera Settings

Practice Picture: JPEG Fine. Shutter Priority AE and continuous shooting mode.

On Your Own: The Alpha A100 stores JPEG Fine images more quickly than RAW format, so when shooting quickly and continuously, you gain some speed with very little quality loss by choosing Fine. Select Shutter Priority mode so you can choose the highest appropriate shutter speed when you want to stop action. Under reduced light levels, drop down to a slower shutter speed or boost the ISO setting.

Continued

Table 6.16 *(continued)*

Exposure	**Practice Picture:** ISO 400, f/11, 1/1000 second. At 400mm, the f/11 aperture allowed the people in the stands to blur, and 1/1000 second was plenty fast enough to freeze all the action except for the ball and the end of the bat.
	On Your Own: Image noise isn't a problem with the Alpha A100 at ISO 400, but good results are possible at ISO 800 if you need a smaller aperture or faster shutter speed. Keep in mind that you don't necessarily need to make an exposure at a very small aperture if focus is accurate; indeed, a larger f-stop can help isolate your subject. Nor do you need the fastest shutter speed possible. Most action can be stopped at 1/500 to 1/1000 second, and sometimes 1/250 second is enough (particularly if you pan to follow the action).
Accessories	Even with high shutter speeds, a tripod or monopod can help steady a long lens and produce sharper results. Compact tripods and monopods made of carbon fiber or magnesium are light in weight and easy to tote to sports events. Indoors, a flash may be useful.

Sports and action photography tips

✦ **Anticipate action.** Become sensitive to the rhythm of a sport and learn exactly when to be ready to press the Shutter Release button to capture the peak moment.

✦ **Be ready to use manual focus or focus lock.** Autofocus works great, particularly the Alpha A100's predictive-autofocus feature that tries to anticipate where your subject will be at the time the picture is taken. However, don't be afraid to turn off the autofocus feature, manually focus or lock focus on a position where you think action will be taking place, and then snap the picture when your subjects are in position. You may be able to get more accurate focus this way.

✦ **Take advantage of peak action.** Many sports involve action peaks that coincide with the most decisive moment. A pole-vaulter pauses at the top of a leap for a fraction of a second before tumbling over to the other side. A quarterback may pump-fake a pass, and then hesitate before unleashing the ball. A tennis player poised at the net for a smash is another moment of peak action. These moments all make great pictures.

✦ **Shoot oncoming action.** Movement that's headed directly toward the camera can be frozen at a slower shutter speed than movement that's across the field of view. If you don't have enough light to use the Alpha A100's highest 1/4000 second shutter speed, try photographing oncoming action to freeze the motion.

Still-life Photography

Still-life pictures have long been a favorite of artists and photographers looking for infinitely patient models that can become the basis for images that explore form and light to their fullest. The best thing about still-life photography is that, after you're finished, you don't need to buy your model lunch — your model can *be* lunch!

Shooting still-life photos is a perfect rainy-day activity. A quick visit to your collection of porcelain figurines, pewter soldiers, or artificial flowers can yield enough subject matter to keep you busy for hours. Or you might find the subject matter you need in the refrigerator.

The most labor-intensive part of photographing a still life is coming up with pleasing arrangements that lend themselves to creative compositions. Count on spending time positioning your objects, perhaps adding something to the arrangement, or removing an item that doesn't quite work. Setting up a still-life arrangement is the closest a photographer can come to sculpting or painting.

You may be attempting to create photographic art or illustrate a cookbook, but still-life photography is challenging under any circumstances. Although still-life images have traditionally involved settings on a table, with bowls of flowers or fruit, cornucopias, and perhaps a sprinkling of leaves, don't feel that you're limited to that kind of approach. You can skip the accoutrements, get in close, and concentrate on shape, texture, and color.

6.54 Edward Weston transformed peppers into muscular human figures in black-and-white; in color, the shape and texture of this pepper is just as interesting.

Inspiration

Still-life photography is like macro photography but a step or two farther from your subject. Your subject matter is likely to be a bit larger, sometimes covering an entire table. You probably won't need a macro lens to focus close enough. Yet the same principles of lighting and composition apply. Use auxiliary lighting such as flash or incandescent lights, maintain control with umbrellas or reflectors, and, after you've selected the best composition, lock your camera down on a tripod.

In fact, you can light many still-life setups as you would a portrait sitting:

✦ Use a main light to create shadows that provide your subject with shape and form.

✦ Illuminate the shadows with reflectors or fill lights.

✦ Consider lighting the background on its own to provide separation between your subject and its surroundings.

6.55 Dramatic lighting can make your still-life photograph more interesting.

Still-life photography practice

6.56 Simple setups such as this are easy and quick to create.

Table 6.17
Taking Still-Life Pictures

Setup	**Practice Picture:** I couldn't resist collecting a group of these colorful hot peppers and placing them on a piece of poster board that had been curved to form a seamless background, as you can see in figure 6.56.
	On Your Own: Some of the best still-life photos are the simplest. Use the natural beauty of food or a handcrafted object, and don't clutter up the picture with other props.
Lighting	**Practice Picture:** I used a pair of white umbrellas placed to the left and right of the camera, and turned them around to shoot through the fabric to create extra-soft lighting for the peppers.
	On Your Own: Many umbrellas are backed with black fabric (often removable) to reduce light loss. If your electronic flash is powerful enough, you can use the extra diffusion from shooting through the umbrellas to produce an even softer lighting arrangement. Add-ons called soft boxes produce even smoother broad lighting.
Lens	**Practice Picture:** SAL-50M28 50mm f/2.8 macro lens.
	On Your Own: A close-up macro lens has the advantage of extra sharpness and the capability to focus close, but you don't necessarily need such a lens for your still-life photography. Any zoom lens that focuses down to a foot or two is suitable for all but the tightest of compositions.
Camera Settings	**Practice Picture:** RAW capture. Aperture Priority AE with a custom white balance. Saturation set to enhanced.
	On Your Own: To control the depth of field, choose Aperture Priority AE mode and set the white balance to the type of light in the scene, either tungsten or flash.
Exposure	**Practice Picture:** ISO 100, f/22, 1/160 second.
	On Your Own: Close-up photos call for smaller f-stops and extra depth of field, and most still-life pictures are in that distance range.
Accessories	Umbrellas with external flash units are your best choice, but desk lamps and reflectors can also be used. A tripod is handy for locking down a composition and holding the camera steady if the exposure time is long.

Still-life photography tips

✦ **Use your imagination.** Seek out still-life subjects and backgrounds that you may not think of immediately. For example, an end table carefully arranged with lamp, television remote control, newspaper folded open to the crossword puzzle, and pencil could become an interesting still life, rather than a picture of some cluttered furniture.

✦ **Inject the element of surprise.** A little bit of the unexpected or a humorous touch can spice up a mundane still life. An arrangement of green peppers with one yellow pepper in the middle will attract attention. A cluster of stainless-steel nuts making a nest for a single walnut is a visual pun that can tickle the funny bone — especially if you can work a confused stuffed toy squirrel into the picture.

✦ **Small touches mean a lot.** Spritzing a little water on food can make it seem more appetizing. The difference between a suitable background and the perfect background can be significant. For example, a layout of a picnic basket and its contents on a checkered tablecloth may be interesting, but a background of an old slab of wood from a weathered picnic table resting on a few tufts of grass may be better.

✦ **Try different angles.** Even if you've meticulously set up your still life, you may find that another angle you hadn't considered looks even better. Don't ignore the possibility of happy accidents.

Sunset and Sunrise Photography

Sunsets and sunrises are classic photo subjects that are difficult to mess up. Their crisp compositions tolerate a wide range of exposures and tend to provide vivid colors in infinite variety; a picture taken from one position on one day might look entirely different from one taken at the same place the next day. Sunrises and sunsets are so beautiful they make even average photographers look brilliant.

6.57 About 20 minutes after sunrise, the sun had moved up behind the clouds, creating interesting patterns of color for this shot.

Inspiration

You can shoot unadorned sunrises and sunsets with nothing but the sky and horizon showing, or incorporate foreground subjects into the picture. Place the emphasis on the sky itself with a wide-angle lens, or zero in on the majesty of the setting sun with a telephoto.

Your choice of shooting a sunrise or a sunset depends primarily on whether you're willing to get up early and where the sun will be at the time you take the picture. For example, on the East Coast of the United States, the sun peeping over the ocean's edge must be captured in the early-morning hours. On the West Coast, sunsets over the Pacific are the norm. However, you can shoot the setting or rising sun with a lake, mountain range, or city skyline, too, simply by choosing your position.

Don't ignore the twilight hours just before sunset, and the moments just after sunrise. The skies are colorful and worth capturing at those times, too.

6.58 This ordinary beach took on a new silhouetted look at sunset.

Shooting Silhouettes

Because sunrises and sunsets, by definition, are backlit, they're the perfect opportunity to shoot silhouettes. You can outline things at the horizon, or create silhouettes from closer subjects, such as people or buildings. Here are some things to consider:

✦ **Make underexposure work for you.** Silhouettes are black outlines against a bright background, so you usually have to underexpose from what the Alpha A100 considers the ideal exposure. Use the exposure value compensation to reduce exposure by two stops.

✦ **Shoot sharp.** Silhouettes usually look best when the outlined subject is sharp. Watch your focus, using the focus lock button or manual focus if necessary to ensure sharp focus.

✦ **Use imaginative compositions.** It's too easy to just find an interesting shape and shoot it at sundown in silhouette mode. Use the dramatic lighting to enhance your composition. For example, one favorite wedding shot is the bride and groom in profile facing each other, jointly holding a half-filled wine glass. Shot at sunset as a silhouette, the shapes of their faces contrast beautifully with the non-silhouetted image of the transparent wine glass.

✦ **Use colored filters or enhanced saturation.** These techniques can make the sunset more brilliant, while retaining the dramatically dark outline of the silhouette.

Sunset and sunrise photography practice

6.59 Shapes along the horizon can be transformed into interesting and mysterious objects when silhouetted against a sunset or sunrise.

Table 6.18
Taking Sunset and Sunrise Pictures

Setup	**Practice Picture:** I spotted the scene in figure 6.59 while strolling along an overlook one fall afternoon. I decided the composition would work better as a sunset silhouette, so that's how I shot it.
	On Your Own: As with other kinds of landscape photography, the key to finding a good composition is to scout the area beforehand and then come back, if necessary, when lighting is ideal.
Lighting	**Practice Picture:** I maneuvered to find a spot where the sun would set behind the silhouetted trees and buildings in an interesting way.
	On Your Own: Sometimes, taking a few steps to the left or right can dramatically change the relationship and lighting provided by the setting or rising sun and objects in the foreground.

Continued

Table 6.18 *(continued)*

Lens	**Practice Picture:** SAL-18200 18–200mm f/3.5–6.3. zoom lens at 30mm.
	On Your Own: Wide-angle lenses are fine if you want to take in a large area of sky. A telephoto setting is a better choice to emphasize the sun and exclude more of the foreground.
Camera Settings	**Practice Picture:** RAW capture. Shutter Priority AE.
	On Your Own: Use a high shutter speed to minimize camera shake and a small f-stop to underexpose the foreground in a silhouette.
Exposure	**Practice Picture:** ISO 200, f/16, 1/800 second.
	On Your Own: Underexpose by one or two f-stops to create your silhouette effect.
Accessories	A star filter can add an interesting effect to the sun, but a small f-stop tends to produce a star-like effect anyway.

Sunset and sunrise photography tips

✦ **Keep in mind that sunrises and sunsets aren't created equal.** There are some subtle differences between sunrises and sunsets, which can be accentuated depending on the time of year. For example, with a sunrise after a cold night, you might encounter a lot of fog that forms in the cool air above a warmer ground. In some parts of the country, sunsets can be plagued by smog or haze that clears up by morning.

✦ **Experiment with filters.** Try split-gradients, star filters, colors, diffraction gratings, and other add-ons for some interesting variations.

Travel Photography

Travel, whether foreign or domestic, provides a perfect opportunity to cut loose and experiment with your digital camera. You can capture new and exotic locales, interesting people, and historic buildings or monuments—all while having the time of your life.

Unless you're traveling on business and your business isn't photography, you likely have lots of free time to photograph the places and events you're enjoying. And, while memories fade, your images will still be there to remind you of a special time.

6.60 The interesting and exotic can vary, depending on where you're from. When you arrive in a foreign country, *everything,* from monuments, houses of worship, clothing, to soda cans is likely to be strange and interesting.

Inspiration

In many ways, foreign-travel photography shares a lot of the attributes of the architecture, event, landscape, seascape, night, and street-life situations I already covered in this chapter. What makes it most exciting is the differences you find. Clothing and jewelry may differ sharply; common items such as soda cans, candy bars, or electric outlets may be interestingly odd. Even plant and animal life may not be what you're accustomed to.

Be sensitive to cultural differences. Some cultures frown upon photographic images of other human beings, and women wear clothing designed to hide their appearance. In some of these countries, photographing people can be a serious offense.

Although you want any people you photograph to appear natural, it's still a good idea to ask their permission first. In poorer countries, they may want a few coins in exchange. Emphasize that you want the picture to be natural, and that they should return to what they were doing before.

What to Take When You Travel

Experienced travelers pack light, taking only the minimal amount of clothing and other gear. Experienced photographers make certain that their short list of equipment and accessories includes everything they absolutely need for the trip. Some things you may overlook, but should include:

✦ **A cleaning kit.** Make sure you have a cleaning cloth and lens tissue for keeping your lens and camera spotless. You also want to have a blower for dusting off your sensor, and perhaps a few silica packets to absorb moisture. Be sure and use only your manufacturer's recommended procedures for cleaning your sensor!

✦ **A roll-up plastic rain poncho.** To keep you and your camera dry when unexpected weather strikes.

✦ **Plenty of memory cards.** Take enough to record an entire vacation, unless you also have a laptop or a portable hard drive/CD-burner with you to offload pictures from the flash memory. A good estimate is that you need at least a 512MB card each day if you shoot RAW files, or 256MB of memory space if you're shooting JPEG Fine.

6.61 Super SteadyShot enables you to take photos at night in brightly lit locations, including the Great White Way itself, as this shot of Broadway in New York City shows.

Don't forget to provide feedback, and indicate that you're glad they granted you the favor of their photograph. You may want to let them review the pictures you took on your camera's LCD.

While those living near big theme parks take them for granted, they aren't right next door for most of us living in the United States. They're often stopovers during vacation trips, or worth a trip on their own. Use your theme park visit as an opportunity to put your Sony Alpha to work.

Travel photography practice

6.62 Travel to a regional theme park provides lots of opportunities for photos.

Table 6.19
Taking Travel Pictures

Setup	**Practice Picture:** A summer theme park tour with stopovers at several large entertainment complexes provided lots of interesting photos, like the one shown in figure 6.62.
	On Your Own: Travel photos can involve modern sites like theme parks, or more traditional tourist attractions like monuments, famous buildings, battlefields, and ancient structures. When you shoot historical subjects, if you can compose your photo so that modern buildings and artifacts are hidden, the scene can look much as it did 400 to 500 years ago. Hunting for unspoiled treasures can be an enjoyable pastime on its own, and recording your find in pixels is just the culmination of the hunt.
Lighting	**Practice Picture:** Bright midday sun offered plenty of illumination for this action shot.
	On Your Own: When traveling through an area, you are rarely able to wait for the lighting to change, so you have to make do with what you've got. In bright sunlight, go for vivid lighting; at dusk, try to use the dramatic lighting; on overcast days, try for a moody look. In dark alleyways, use the diffuse light that is available.
Lens	**Practice Picture:** Sigma 170–500mm f/5–6.3 APO aspherical autofocus telephoto zoom lens at 500mm.
	On Your Own: Telephotos are good for distant views, but you'll also need wide-angle lenses for travel photos involving castles, cathedrals, and landscapes, providing you can get far enough back to avoid tilting the camera. If quarters are tight, crop your view and emphasize interesting details rather than the big picture.
Camera Settings	**Practice Picture:** RAW capture. Shutter Priority AE.
	On Your Own: Shutter Priority AE mode lets you select a shutter speed to eliminate camera shake, and you can set the white balance to the type of light in the scene.
Exposure	**Practice Picture:** ISO 400, f/11, 1/1000 second.
	On Your Own: Consider bracketing a stop or two on either side of the exposure recommended by your camera, because a slightly darker or lighter version can look quite different.
Accessories	You might not want to carry a tripod on a trip (but consider doing so anyway), though even a monopod might be overkill unless you're shooting a lot of interior photos (say, inside cathedrals or museums). If neither a tripod nor monopod appeals to you, consider taking along a beanbag you can use as a camera support just about anywhere you can find a solid surface.

Travel photography tips

✦ **Capture the cultural environ-ment.** Look for things that are unusual, and shoot lots of photos. Show people playing, relaxing, and working, because these behaviors may be different in foreign countries — or even in different parts of your own country.

✦ **Move in close.** You may be tempted to shoot the vistas, but close-up details provide lots of interest and add intimacy to your portrayal of a strange land and its people. You'll find that even a person's hands can tell you a lot about that person and what he's done, whether it's repairing computers or watches, or doing manual labor.

✦ **Mix it up.** Shoot both horizontal and vertical photos of people, buildings, and landscapes. Avoid getting locked into one mindset and having all your travel photos look exactly the same.

Water and Waterfalls Photography

Water and waterfalls are a type of outdoor or nature photography that fall into a category all their own. Water is always an enhancement to your landscape photos, and waterfalls have a charm all their own. One reason for their popularity is that once a fledgling photographer becomes comfortable with his or her camera, the one shot that is most often attempted is the time-honored "blurry waterfall" effect. It's a challenge to create a new look to what threatens to become a photographic cliché, using a time exposure to allow the cascading water to blend into a laminar flow while the surrounding trees, rocks, and other objects in the photo remain tack sharp.

One challenge is finding a suitable subject. Truly impressive waterfalls aren't all that common, and many of them are inaccessible, or located far from the road (which helps preserve their natural beauty, but makes enjoying them somewhat of an adventure). It's also necessary to hope that the view hasn't been marred by the encroachment of humans; nothing is more alarming to a nature photographer than finding a wonderful woodsy scene marked with graffiti carved into the trees next to a waterfall cascading into a pool filled with soda cans.

But the challenges only make photographing these natural wonders all that much more rewarding.

6.63 Colored filters, deliberate under exposure, and a bit of fine-tuning in an image editor produced this photo of a lake in late evening.

Inspiration

Of course, there's a lot more to photographing waterfalls than blurry streams of water. You can photograph them from above, below, or even shoot from behind the sheet of falling water. Waterfalls can be captured in mid-summer, look gorgeous in the fall when surrounded by trees in changing colors, and make fascinating subjects in winter. You can find opportunities in tiny waterfalls and interesting pictures in mammoth displays like Niagara Falls. Your goal is to find a new way of photographing a very popular subject.

Unusual angles are often the best approach. Lazy photographers park themselves in front of the falls and fire away, not realizing that clambering down the gully and taking a few shots from the side yields a much more interesting picture. If you're able to get behind the falls without risk of getting your camera damp, you can get some great pictures of the falls itself as well as the sunlight filtering through the water.

6.64 A slow, 2-second shutter speed allows the droplets of this waterfall to blur in an unusual way.

Water photography practice

6.65 A long time exposure with three colored filters alternated in front of the lens gave this waterfall a multihued look.

Table 6.20
Taking Waterfall Pictures

Setup	**Practice Picture:** I wanted to enhance the customary blurred water effect with a spot of color, so I used the Harris shutter (described in the sidebar) to produce the effect you can see in figure 6.65. **On Your Own:** You don't need special equipment to shoot interesting photos with blurry waterfalls cascading over a rough bed of rocks. All you need is a camera mounted on a tripod and a shutter speed that's long enough to allow the water to take on a filmy, laminar look.
Lighting	**Practice Picture:** Direct sunlight provided the illumination for this shot. **On Your Own:** If you're using a time exposure, cloudy days with diffuse lighting is even better, because the reduced illumination makes it easier to leave the shutter open for a longer period of time.
Lens	**Practice Picture:** I used a SAL-1870 18–70mm f/3.5–5.6 zoom lens at 30mm. Mounted on the front of the lens was a pair of 8X neutral density filters, which reduced the available illumination by three stops each, or six stops total. **On Your Own:** The lens you use depends on how close you can get to the waterfall. In most cases, you'll be using a medium-wide-angle or wide-angle zoom setting.
Camera Settings	**Practice Picture:** RAW format, processed using Adobe Camera Raw to adjust white balance (tungsten), increase saturation, and boost both sharpness and contrast. Manual exposure mode. **On Your Own:** If you're using heavy neutral density filters, it's likely that your Alpha's autofocus system won't work, and exposure metering will be inaccurate. Both manual focus and exposure are your best bet for this kind of photograph.
Exposure	**Practice Picture:** ISO 100, f/22, 4 seconds. **On Your Own:** Use your camera's lowest ISO sensitivity, your lens's smallest f-stop, and the longest exposure you can manage to blur the falling water.
Accessories	A tripod lets you lock down the camera and use long exposure without image blur. You can release the shutter using the Alpha's self-timer. An optional wired remote control is faster for releasing the shutter without jiggling the tripod.

Multicolored Waterfalls

One compelling effect is the multicolored waterflows you can obtain using an easy-to-build Harris shutter, named after Kodak whiz Bob Harris who created the technique many decades ago. The Harris shutter consists of a simple frame (you can make one out of cardboard) that fits in front of your lens, and a strip containing red, green, and blue filters (again you can make one yourself) that is dropped in front of the lens during an exposure of one second or less with the camera on a tripod. You can see an example in figure 6.65. The nonmoving rocks, which received a regular red/green/blue exposure, are colored normally, but the moving water has multicolored highlights, depending on which filter was in front of the lens as the water moved.

If you search the Internet for the "Harris shutter," you can find a dozen or more Web sites with instructions for building a frame that holds the red/green/blue strip as it passes in front of the lens. But you can just move the strip manually if you move quickly and are careful not to jar the camera.

Water and waterfall photography tips

✦ **Time after time.** If a particular body of water is located near your home base, consider visiting it during all four seasons of the year to show how one of these natural wonders changes with the weather. After you've taken the first in a planned series of photographs, remove your camera from the tripod and photograph the tripod itself so you can reproduce the positioning of your tripod the next time you visit.

✦ **Freezing time.** So many photographers are trying to reproduce a blurry waterfall effect that using a high shutter speed can give you an unusual picture without much effort on your part. Visit a falls after a dry spell when the water is dribbling, rather than gushing over, to improve your chances of freezing individual droplets.

✦ **Waterfalls make great backdrops.** Get some people in a few of the shots. Waterfalls make good backgrounds for environmental portraits. Shoot from an angle so the falls and surrounding rocks add interest to your portrait.

✦ **Add some wildlife.** Bodies of water can attract wildlife, such as deer, looking for liquid refreshment. Help yourself along by placing a block of salt near the edge of the water, and then hiding out of sight. (Photographers who are also hunters and have used blinds have an advantage here.) If you're patient, you may be able to capture a woodland creature as an accent to your image.

Downloading and Editing Pictures

Once you've taken a set of great photos, you need to transfer them to your computer, organize them for viewing or printing, and, if necessary, edit your shots to improve composition with cropping, fine-tune the color, or adjust the tones.

You can perform most of those functions using the software included with your Sony Alpha DSLR-A100, but you may want to go beyond the basics and learn to use other applications and utilities. In this chapter, I explain some of the things you may want to do, and the software available to do them. Because this is a field guide, I won't go into extensive detail on how to use any of these programs. After all, unless you take a laptop with you out into the field, you probably won't be using one of these applications until you're back at your home or office, safely nestled in front of your computer. This chapter isn't intended as a software tutorial; it's just a reference guide for key downloading and editing functions.

Transferring Photos

Downloading photos from your memory card or camera to your computer is easy. Sony includes two applications for transferring and manipulating your photos, Picture Motion Browser and Image Data Converter SR (which is explained in more detail later in this chapter). Your Macintosh operating system and Microsoft Windows also include tools for transferring pictures, and many third-party image cataloging/editing programs such as Adobe Photoshop Elements and ACDSee have their own pop-up programs for transferring photos.

There are several ways to copy or move photos from your camera to your computer:

✦ **Card reader.** The fastest and easiest way to physically transfer your photos is by using a card reader attached to a Universal Serial Bus (USB) or FireWire port on your computer. All you need to do is turn your camera off, remove the CompactFlash memory card (or CompactFlash adapter containing your Memory Stick Pro Duo card) and insert it in a CompactFlash slot in the card reader or directly into your computer, if your machine has a card reader built in. (Some laptop computers have a PC Card slot that accepts a CompactFlash card adapter.)

✦ **Direct connection.** You can also link your Alpha directly to your computer using the USB cable furnished with the camera. This method might *seem* more convenient, but it has several drawbacks. First, you have to find and connect the cable, which means you can only transfer pictures to your personal computer when you remember to take the cable along when visiting a friend or colleague. In addition, this kind of direct linkup typically offers slower transfers than using a card reader does, and uses more of your camera's power to boot. Even so, many photographers prefer this method.

To transfer using a direct connection, open the Compact Flash door on the camera and plug in the small end of the transfer cable that came with your camera. The other end connects to a USB port on your computer.

Whether you've made a direct link connection or removed your memory card and inserted into a card reader, what happens next is generally the same in either case. Your computer recognizes that a device containing photographs is available, and a dialog box appears offering to copy or move the photos to your computer's hard drive. One or more of the following dialog boxes may appear:

✦ **Windows AutoPlay.** When the Windows AutoPlay facility recognizes a camera or memory card, it displays a dialog box like the one shown in figure 7.1. You can choose to download your photos with the Microsoft Scanner and Camera Wizard if you like. The Wizard asks you questions about where you want the photos copied, and whether you want them erased in their original location after transfer. The AutoPlay dialog box also shows any other software you have installed that can download photos, so you can use one of those options instead. Macintosh OS X recognizes your camera or memory card and a similar dialog box appears.

7.1 The Windows AutoPlay Wizard can help you transfer your photos.

✦ **Sony Media Check Tool.** If you've installed the Sony Picture Motion Browser, a Windows-only program, Sony's own dialog box, shown in figure 7.2 appears. It enables you to specify a destination for your files. Click Import when you're ready to transfer your photos.

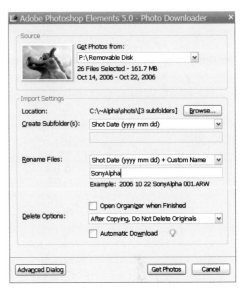

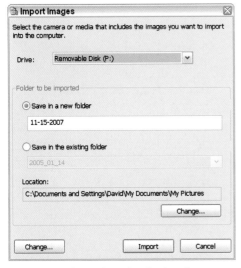

7.2 Sony's photo downloader has few options, but is automatic and easy to use.

7.3 Adobe Photoshop Elements' Photo Downloader has many options and features.

If you don't want to use any of these auto-mated tools, you can use Windows Explorer or the Mac desktop to open your camera or memory card as if it were just another disk drive, and drag and drop the files directly to a destination folder of your choice, just as you would copying or moving files from any other folder in your system.

✦ **A third-party downloader.** Many popular image-editing and photo-organizing packages include their own downloading module. Most of them have functions similar to the Adobe Photoshop Elements 5.0 Photo Downloader shown in figure 7.3. These more sophisticated tools often have features like automatic file renaming, in-stream red-eye removal, and other cool facilities. They also organize your photos into albums that you can use to sort and retrieve images, as well as perform some correction and edit-ing chores.

Sony's Software Offerings

Sony includes two basic, but serviceable, software utilities with the Alpha DSLR-A100. They are the Picture Motion Browser (for Windows only) and Image Data Converter SR (for both Windows and Mac operating systems). You install both from the single CD supplied with the camera. Picture Motion Browser is an importing utility that collects images into folders and offers some simple editing capabilities for making minor

fixes. Image Data Converter SR is useful for importing and manipulating RAW images.

My guess is that Sony anticipates that buyers of a sophisticated camera like the Alpha already have a preferred image-editing and RAW converter, or plan to buy one from a third party. The two bundled Sony utilities seem intended to provide basic functionality that you can use until you settle on a more fully featured package for key editing and converting functions.

Picture Motion Browser

This tool works with still images and video files produced by other Sony cameras and camcorders. It has a photo downloading utility, called Media Check Tool, which you can activate or deactivate in the Tools menu. Imported images are deposited into a folder within your My Pictures folder and are named after the import date. You can specify a different folder name if you want.

Imported images, as well as those in other folders you have "registered" with the browser, are displayed either in a folder view (see figure 7.4) or in an interesting calendar view that groups the photos by the date they were created.

When you double-click on a thumbnail image in the browser, it is displayed in an editing window (see figure 7.5) that includes tools for trimming, rotating, adjusting brightness and contrast, enhancing or reducing saturation, adjusting sharpness, manipulating tonal curves, and activating red-eye reduction. Picture Motion Browser can also display all the photos in a folder as a slide show.

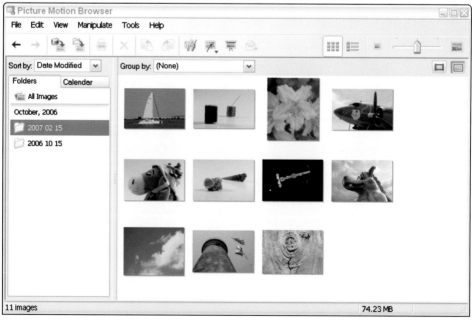

7.4 Picture Motion Browser makes a good basic image organizing tool.

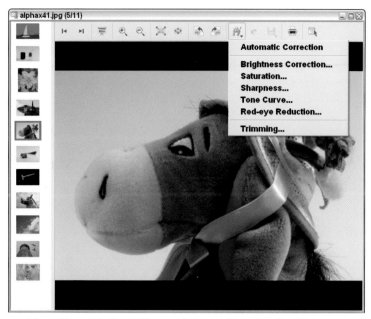

7.5 The editing window offers tools for making simple adjustments to your image.

Image Data Converter SR Version 1.1

This RAW converter has some nice features that you'll find useful. One main advantage that it has over third-party RAW converters is that Image Data Converter SR is 100-percent guaranteed to be compatible with your Sony Alpha DSLR-A100 RAW files. As Sony makes changes in its RAW file format as it introduces additional cameras, you can count on getting updates that will be compatible with all your Sony RAW files. You can also set up this utility to transfer converted files directly to another image editor, such as Adobe Photoshop or Photoshop Elements, for additional editing.

Image Data Converter SR (see figure 7.6) enables you to change any of the settings you could have made in the camera, plus tweak other settings, such as tonal curves, that you can't normally adjust when you take the photo. Making these changes after the picture is taken enables you to fine-tune your images, correct errors you might have made when you shot the photo, and fix things such as color balance that the camera might have set incorrectly.

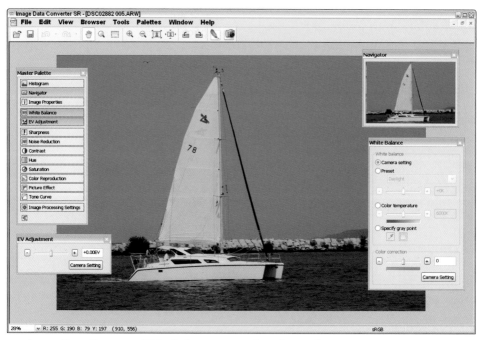

7.6 Image Data Converter SR includes an array of settings palettes.

This program includes a Master Palette that enables you to summon specific dialog boxes with sliders and other adjustments. For example, there are separate exposure value (EV) adjustment settings, contrast and saturation settings, and a three-channel histogram, which displays separate red, green, and blue histograms rather than the simple brightness (luminance) histogram shown in the camera.

The Image Properties dialog box (see figure 7.7) is especially helpful. It provides a complete listing of all the settings you applied when you originally took the photo, including lens, f-stop, shutter speed, ISO setting, metering mode, and so forth.

Image Properties	⊠
Item	**Value**
File name	DSC02882 005.ARW
File type	ARW Format
Date taken	10/22/2006 5:13 PM
Created	10/22/2006 5:13 PM
Image width	3872
Image height	2592
Orientation	Standard
Manufacturer name	SONY
Model name	DSLR-A100
Lens open F value	F5.6
Lens focal length	50.0 mm
Shutter speed	1/20 sec.
Diaphragm value	F5.6
Exposure correction va...	+0.0 EV
Exposure program	Program AE(Auto Exposure)
Photometry mode	Spot
ISO	400
White balance settings	Auto
White balance mode	Auto
Flash	Not used
Flash mode	No flash
Red-eye reduction	Off
Saturation	Standard
Contrast	Standard
Sharpness	Standard
Color space	sRGB
Scene capture type	Standard
Color reproduction	-
Scene selection	
Zone matching	Off
Color temperature	----
Magenta/Green compe...	0
Lens	DT 18-70mm F3.5-5.6
STEADY SHOT	Off
D-Range Optimizer	Off
Color / DEC	Standard

7.7 Image Data Converter SR includes an array of settings palettes.

Other software options

If you want more sophisticated software to perform image editing and RAW conversion, image editors and RAW file utilities are available from a wide range of suppliers and can cost you nothing (in the case of Irfan Skiljan's IrfanView) or be included in the cost of other software (as is the case with Adobe Camera Raw, which is included in the price of Photoshop and Photoshop Elements). Alternatively, you can pay $129 for a sophisticated utility such as Bibble Professional, or as much as $500 for a top-of-the-line program such as Phase One's Capture One Pro (C1 Pro).

Software to consider includes:

✦ **IrfanView.** You can download this freeware Windows-only program at www.irfanview.com. It can read many common RAW photo formats, including Sony's, and give you a quick way to view RAW files, just by dragging and dropping to the application's window. You can crop, rotate, or correct your image, and do cool things such as swapping the colors around (red for blue, blue for green, and so forth).

✦ **Phase One Capture One Pro (C1 Pro).** This premium-priced RAW converter program does everything, but reduced-function versions, Capture One dSLR and Capture One dSLR SE, exist for those of you who don't need such a flexible application. Available for both Windows and Mac OS X, C1 Pro offers special noise reduction controls, a quick develop option that provides speedy conversion from RAW to TIFF or JPEG formats, dual-image side-by-side views for comparison purposes, and helpful grids and guides that can be superimposed over an image. Learn more at www.phaseone.com.

✦ **Bibble Pro.** This utility offers instantaneous previews and real-time feedback as changes occur. That's important when you have to convert many images in a short time. With Bibble's batch processing capabilities, you can process large numbers of files using custom settings with no user intervention. You can even create a Web gallery from within Bibble. Bibble Pro now includes Noise Ninja's noise reduction features. Learn more at www.bibblelabs.com.

✦ **Photoshop CS2/Photoshop Elements.** Photoshop CS2 is the serious photographer's number one choice for image editing, and Elements is an excellent option for those who need most of Photoshop's power, but not all of its professional-level features. Both use the latest version of Adobe's Camera Raw plug-in, a RAW converter that makes it easy to adjust things such as color space profiles, color depth (either 8 bits or 16 bits per color channel), image resolution, white balance, exposure, shadows, brightness, sharpness, luminance, and noise reduction. Learn more at www.adobe.com.

✦ **Corel PhotoPaint.** This Windows-only image-editing program is included in the popular CorelDRAW Graphics suite. Various versions of the program are available for the PC and the Mac. It's a full-featured photo retouching and image-editing program that includes selection, retouching, and painting tools for manual image manipulations as well as convenient automated commands for a few common tasks, such as red-eye removal. PhotoPaint accepts Photoshop plug-ins to expand its assortment of filters and special effects. Learn more at www.corel.com.

✦ **Corel Paint Shop Pro.** This Windows software is a general-purpose image editor that has gained a reputation as the "poor person's Photoshop" because it provides a substantial portion of Photoshop's capabilities at a fraction of the cost. It includes a nifty set of wizard-like commands that automate common tasks, such as removing red eye and scratches, as well as filters and effects that can be expanded with other Photoshop plug-ins. Learn more at www.corel.com.

✦ **Macromedia Fireworks.** This Windows and Mac image-editing program (formerly from Macromedia, and now owned by Adobe) specializes in Web development and animation software like Dreamweaver and Flash. If you're using your Alpha DSLR-A100 images on Web pages, you'll like this program's capabilities in the Web graphics arena, such as those for banners, image maps, and rollover buttons. Learn more at www.macromedia.com.

✦ **Corel Painter.** Another Windows and Mac image editing-program from Corel, Corel Painter's strength is in mimicking natural media, such as charcoal, pastels, and various kinds of paint. Painter includes a basic assortment of tools that you can use to edit existing images, but the program is really designed for artists to use when they create original illustrations. As a photographer, you might prefer another image editor, but if you like to paint on top of your photographic images, nothing else really does the job as well as Painter. Learn more at www.corel.com.

✦ **Ulead PhotoImpact.** This general-purpose Windows-only photo editing program provides a huge assortment of brushes for painting, retouching, and cloning in addition to the usual selection of cropping and fill tools. If you find you frequently perform the same image manipulations on a number of files, you'll appreciate PhotoImpact's batch operations. Using this feature, you can select multiple image files and then apply any one of a long list of filters, enhancements, or auto-process commands to all the selected files. Learn more at www.ulead.com.

✦ **PictureCode Noise Ninja.** This program is among the best of a group of utilities that can process your Sony Alpha A100's images to reduce the noise that results from shooting at high ISO ratings and long exposures. It uses a sophisticated approach that can identify and recognize noise that presents itself at different frequencies, in various parts of your image, and in varying color channels. Unlike the Alpha A100's built-in noise reduction feature, Noise Ninja gives you control over how its algorithms are applied, using easy-to-operate sliders with real-time previews for feedback. There's also a "noise brush" you can apply to selectively modify the noise in those parts of the image where it's particularly troublesome. Learn more at www.picturecode.com.

Appendixes

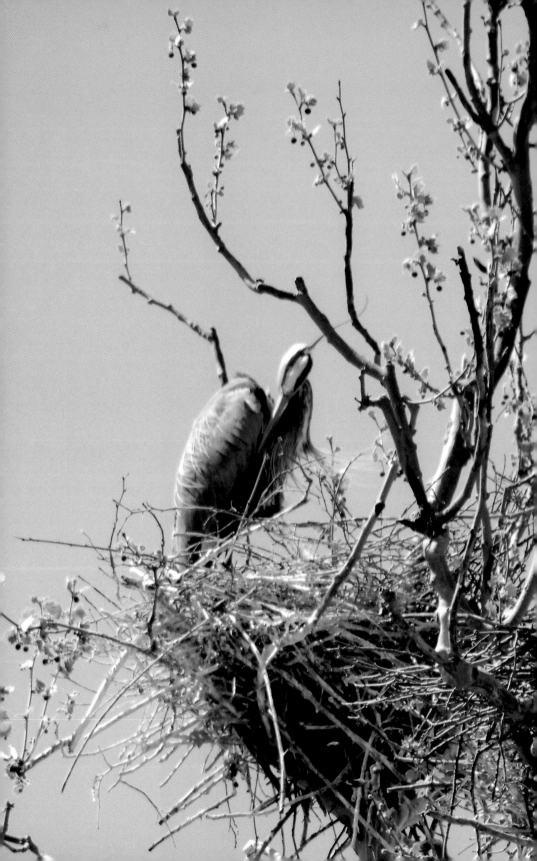

Troubleshooting

Don't panic! If your Sony Alpha A100 is not performing exactly as you expect, is doing something weird, or, worst of all, seems to have given up the ghost entirely, a quick fix may be at hand. If not, and you do have to send your camera in for servicing, tech support is ordinarily very speedy and efficient about fixing what's wrong and getting the camera back to its rightful owner. However, this appendix may help you avoid all that by providing some tips on how to apply some home remedies before you call tech support.

Troubleshooting Batteries

The lithium-ion battery furnished with the A100 should be good for hundreds of shots. But you're not getting nearly that many. What's up here? There are several factors at work:

✦ **The battery is not seasoned.** A new battery takes several charge/discharge cycles to achieve its optimum capacity. However, the difference really shouldn't be more than 10 to 20 percent once you've seasoned the battery. You can't expect it to suddenly last twice as long after you've recharged it a few times. However, if your Alpha is new, you can try using the battery completely and recharging it a few times to improve your battery life.

✦ **The built-in flash uses a lot of power.** The A100's built-in flash is quite powerful. If you want to optimize the life of the A100's internal battery, you need to minimize your flash use, or switch to an external flash like the two available from Sony or one of the dedicated flash units designed for the Alpha's Konica Minolta ancestors.

✦ **The LCD is used excessively.**
Early users of a great camera like the A100 often try out all the features and do a lot of *chimping* (admiring every shot on the LCD and exclaiming, "Oooh! Ooh!" in a chimp-like voice during picture review). The LCD alone uses up quite a bit of juice, and if you're exploring all the menus, experimenting with autofocus, and putting the camera through its paces, you may find that the battery doesn't last very long. Once you've familiarized yourself with the A100's operation and settled into reviewing photos only briefly after every few shots, you get battery life. Meanwhile, set the LCD display to a faster time-out under LCD backlight in Setup menu 3. You can choose a display time on playback as brief as two seconds, or turn the playback display off entirely.

✦ **Power-hungry features use up juice.** Consider that Super SteadyShot uses a lot of juice. So does the Eye Start autofocus, which activates the autofocus mechanism as soon as you bring the viewfinder to your eye. Even the amount of time the camera remains active before going to sleep can affect battery life. Consider turning off features you can live without and using Setup menu 3's Power save option to tell the camera to go to sleep after one minute (instead of the default three minutes) to save even more battery power.

Remember, you can recharge the A100's battery at any time, even after just a few shots, with no danger of the battery building a memory (a tendency to accept only as much of a charge as was previously applied over time) and losing capacity. So, go ahead and recharge just before heading out for a new shooting session.

Reviving Bad Memory Cards

Your Alpha A100 suddenly suggests that you format your memory card, even though it's full of pictures (or so you think). I once had this happen to me while shooting a concert. I'd only shot a few pictures on that card, so I went ahead and reformatted it in the camera. Although the format was apparently successful, the card remained unusable. I swapped out cards and continued shooting. I ended up having to insert the original card in a card reader, do a format from Windows, then re-insert it in my A100 and format it again to restore the card to life.

Sometimes bad things happen to good memory cards. If the card is formatted in your computer, your camera might fail to recognize it. Occasionally, I've found that a memory card used in one brand of camera fails if it's used in a different brand camera until I reformat it in Windows and then again in the camera. That's a weakness of the Compact Flash card: it works in so many different cameras that it's likely to be accidentally corrupted if you do a lot of swapping between camera brands. Chalk one up for using a Memory Stick Pro Duo in the A100 using a Compact Flash adapter. Of course, every once in awhile, a card goes completely bad and can't be salvaged.

If this happens to you and the photos are important, you might be able to retrieve them using a picture recovery utility. If not, you may be forced to reformat the card or, in the worst case, discard it (no pun intended).

The media used with your A100 – even the relatively fragile mini-hard disk drives – are quite reliable, so you might run into this problem only rarely.

Countering Noise

Although the A100 does a much better job of controlling noise than many other DSLRs, you may find that your pictures are filled with those multi-colored speckles called *noise*. Remember that using your camera's noise reduction features can slow down your shooting speed (while each image is processed to remove noise) and can cost you some sharpness as a bit of image detail is removed along with the noise. Here are some steps to take:

✦ **Make sure long exposure Noise Reduction is ON.** You'll find this option in Shooting menu 1. When activated, the A100 applies noise reduction for photos taken at shutter speeds of about one second or longer.

✦ **Turn in-camera noise reduction OFF, and use a third-party noise correction solution.** If you shoot RAW files, you can get excellent noise reduction from Adobe Camera RAW and other software applications, such as Noise Ninja or Neat Image. Photoshop also has a less-effective noise reduction feature that you can apply to JPEG or RAW images after conversion.

Performing CPR for a Dead Camera

If your camera goes completely dead, or won't allow you to take photos, it can be really annoying! However, there are several possible causes:

✦ **No memory card.** It's easy to miss the E error message that appears in the viewfinder if you turn the Alpha on with no memory card inserted. If your camera refuses to function, this is the first thing to check.

✦ **No battery.** Perhaps you took the battery out for charging and forgot to re-insert it. One tip-off that the battery is missing is that nothing happens when you bring the camera viewfinder to your eye.

✦ **Focus difficulty.** If you've set the A100 for Single Autofocus (AF-S) and the camera is unable to zero in on perfect focus (moving subjects or subjects with plain, featureless, no-contrast backgrounds, like the sky, cause this), it will refuse to shoot a picture. Change to Release Priority in Custom menu 1 when you absolutely must be able to take a picture, even if precise focus isn't achieved.

Diagnosing Spotty Photos

Even with the Alpha's anti-dust feature vibrating to shake off dust every time you turn the camera off, someday you might still notice a few spots on your photos. These can come from several sources and can usually be removed with a clone brush or other spotting tool in your favorite image editor. Some spots are intermittent, and sometimes they are the result of the superb sharpness of your A100 camera and its lenses. I've enlarged odd-looking spots at times to discover that they were actually just birds in flight, captured by the sensor.

At other times, the spots may appear in the same position in a series of photos. In such cases, your problem is either a dead/stuck pixel in your sensor or dust that's settled on the anti-aliasing filter that is mounted on top of the sensor even with the best efforts of anti-dust vibration. If the problem is a pixel that's permanently switched on or off, you see a black or a white pixel in your image, surrounded by a halo of other pixels. The pixels aren't actually defective themselves but are the result of your camera's interpolation/demosaicing algorithm, which applies information from each pixel to the surrounding photosites to come up with the final RGB (red, green, blue) image.

Dead/stuck pixels can be removed by a process called *pixel mapping*, which programs the A100 to ignore the defective pixels. Unfortunately, you have to send your camera back to Sony service for this remedy.

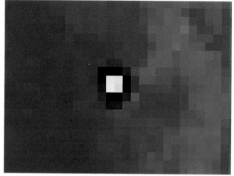

AA.1 A pixel that is permanently "stuck" looks like this at great magnification.

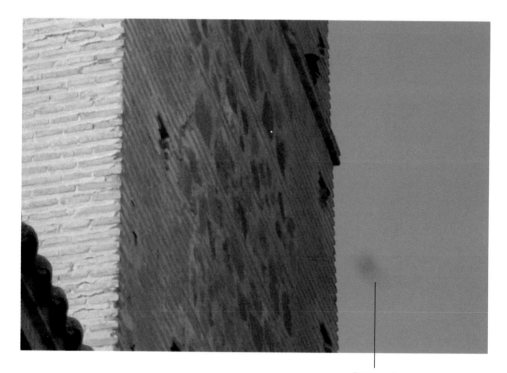

Dust spot

AA.2 Sensor dust spots frequently show up first in areas of solid color, such as the sky, and may be out of focus at intermediate f-stops.

If the artifact disappears when you're using larger f-stops, and reappears when you stop down, you're looking at dust on the sensor. You can fix this using one of the following methods, which you should try in the order listed. In all cases, the first step is to remove the lens and lock up the mirror out of the way, exposing the sensor to your ministrations. When the mirror is activated, just press the shutter release to raise it and open the shutter. Turn the A100 off to reverse the process. Always clean your sensor with a fully charged battery or when using the optional DC adapter. And *always* take special care when working around your sensor or mirror to avoid scratching, transfer of dust, and other potential problems.

> **Tip** *You can find Clean CCD setting, which locks up the mirror, in the Setup 3 menu.*

✦ **Blow it off.** Use a bulb blower such as an ear or nasal aspirator or a tool designed for the job, such as a Giottos Rocket. Don't touch the sensor with the blower, but instead, direct a few gusts at the sensor surface, with the lens mount pointed down so the dust can fall out of the mirror chamber. Do not use canned air, which can coat your sensor with an unhealthy layer of propellant.

✦ **Brush it off.** If blowing off the sensor doesn't work, use one of the special brushes designed for swiping sensors, available from a variety of sources, including Visible Dust (www.visibledust.com). Such brushes can be expensive. You can use a nylon-fiber cosmetic brush that has been thoroughly cleaned to remove sizing and contaminants. Blow some air through the brush to electrically charge it, and then pass over the sensor so it can pick up the dust that resides on the sensor's surface.

AA.3 A variety of tools are available to help you clean your Sony Alpha's sensor.

✦ **Swab it off.** If the first two methods fail, you need to wet-clean your sensor, using extra-pure methanol. Eclipse solution from Photographic Solutions (www.photosol.com) works best. You need a soft, lint-free swag, which you can purchase from Visible Dust, Photographic Solutions, or Copper Hill (www.copperhillimages.com). You can also make your own swabs using a cut-off rubber spatula wrapped in Pec*Pad cloths (also from Photographic Solutions). Put a drop or two of Eclipse on the swab, and gently wipe in one direction, flip the swab over, and wipe in the other direction. As I noted previously, be particularly careful when working around the sensor or mirror box area.

Glossary

additive primary colors The red, green, and blue hues that are used alone or in combination to create all other colors that you capture with a digital camera, view on a computer monitor, or work with in an image-editing program, such as Photoshop. See also *CMYK color model*.

AE lock A control on the Alpha A100 that lets you lock the current auto exposure setting prior to taking a picture, freeing you from having to hold the shutter release partially depressed, although you must depress and hold the shutter release partially to apply the feature.

ambient lighting Diffuse, non-directional lighting that doesn't appear to come from a specific source but, rather, bounces off walls, ceilings, and other objects in the scene when a picture is taken.

analog/digital converter The electronics built into a camera that convert the analog information captured by the sensor into digital bits that can be stored as an image bitmap. In the Sony Alpha, this step occurs in the Bionz image processor.

angle of view The area of a scene that a lens can capture, determined by the focal length of the lens. Lenses with a shorter focal length have a wider angle of view than lenses with a longer focal length.

anti-alias A process that smoothes the look of rough edges in images (called *jaggies* or *staircasing*) by adding partially transparent pixels along the boundaries of diagonal lines that are merged into a smoother line by our eyes. See also *jaggies*.

aperture-preferred A camera setting that enables you to specify the lens opening or f-stop that you want to use, with the camera selecting the required shutter speed automatically based on its light-meter reading. See also *shutter-preferred*.

artifact A type of noise in an image, or an unintentional image component, produced in error by a digital camera during processing, usually caused by the JPEG compression process in digital cameras.

aspect ratio The proportions of an image as printed, displayed on a monitor, or captured by a digital camera.

autofocus A camera setting that enables the A100 to choose the correct focus distance for you, usually based on the contrast of an image (the image will be at maximum contrast when it is in sharp focus) or a mechanism such as an infrared sensor that measures the actual distance to the subject. The Sony Alpha can be set for *single-shot autofocus,* or *AF-S* (the lens is not focused until the shutter release is partially depressed); *continuous autofocus,* or *AF-C* (the lens refocuses constantly as you frame and reframe the image); *automatic autofocus,* or *AF-A* (the A100 switches between AF-S and AF-C depending on whether the subject is moving or not); or *direct manual focus,* or *DMF* (the camera sets the focus, but you can fine-tune the setting).

averaging meter A light-measuring device that calculates exposure based on the overall brightness of the entire image area. Averaging tends to produce the best exposure when a scene is evenly lit or contains equal amounts of bright and dark areas that contain detail. The Alpha A100 uses much more sophisticated exposure measuring systems, which are based on center-weighting, spot-reading, or calculating exposure from a matrix of many different picture areas. See also *center-weighted meter* and *spot meter*.

backlighting A lighting effect produced when the main light source is located behind the subject. Backlighting can be used to create a silhouette effect, or to illuminate translucent objects. See also *frontlighting* and *sidelighting*.

barrel distortion A lens defect, usually found at wide angle focal lengths, that causes straight lines at the top or side edges of an image to bow outward into a barrel shape. See also *pincushion distortion*.

blooming An image distortion caused when a photosite in an image sensor has absorbed all the photons it can handle, so that additional photons reaching that pixel overflow to affect surrounding pixels, producing unwanted brightness and overexposure around the edges of objects.

blur To soften an image or part of an image by throwing it out of focus, or by allowing it to become soft due to subject or camera motion. Blur can also be applied in an image-editing program.

bokeh A buzzword used to describe the aesthetic qualities of the out-of-focus parts of an image, with some lenses producing "good" bokeh and others offering "bad" bokeh. *Boke* is a Japanese word for "blur," and the *h* was added to keep English speakers from rhyming it with *broke*. Out-of-focus points of light become discs, called the *circle of confusion.* Some lenses produce uniformly illuminated discs. Others, most notably mirror or catadioptic lenses, produce a disc that has a bright edge and a dark center, producing a "doughnut" effect, which is the worst from a bokeh standpoint. Lenses that generate a bright center that

fades to a darker edge are favored, because their bokeh allows the circle of confusion to blend more smoothly with the surroundings. The bokeh characteristics of a lens are most important when you're using selective focus (say, when shooting a portrait) to deemphasize the background, or when shallow depth-of-field is a given because you're working with a macro lens, with a long telephoto, or with a wide-open aperture. See also *circle of confusion*.

bounce lighting The light bounced off a reflector, including ceiling and walls, to provide a soft, natural-looking light.

bracketing Taking a series of photographs of the same subject at different settings, including exposure, color, and white balance, to help ensure that one setting will be the correct one.

buffer The digital camera's internal memory where an image is stored immediately after it is taken until it can be written to the camera's nonvolatile (semipermanent) memory or a memory card.

burst mode The digital camera's equivalent of the film camera's motor drive, the burst mode is used to take multiple shots within a short period of time.

calibration A process used to correct for the differences in the output of a printer or monitor when the output is compared to the original image. Once you've calibrated your scanner, monitor, and/or your image editor, the images you see on the screen more closely represent what you'll get from your printer, even though calibration is never perfect.

Camera Raw A plug-in included with Photoshop and Photoshop Elements that can manipulate the unprocessed images captured by digital cameras, such as the Alpha A100's RAW files.

camera shake The movement of the camera, aggravated by slower shutter speeds, which produces a blurred image. Sony's Super SteadyShot counters this movement by adjusting the position of the sensor during exposure.

CCD See *charge-coupled device (CCD)*.

center-weighted meter A light-measuring device that emphasizes the area in the middle of the frame when you're calculating the correct exposure for an image. See also *averaging meter* and *spot meter*.

charge-coupled device (CCD) A type of solid-state sensor that captures the image. It is used in scanners and some digital cameras. The Alpha A100 uses a CCD sensor.

chromatic aberration An image defect, often seen as green or purple fringing around the edges of an object, caused by a lens failing to focus all colors of a light source at the same point. See also *fringing*.

circle of confusion A term applied to the fuzzy discs produced when a point of light is out of focus. The circle of confusion is not a fixed size. The viewing distance and amount of enlargement of the image determine whether we see a particular spot on the image as a point or as a disc. See also *bokeh*.

close-up lens A lens add-on that enables you to take pictures at a distance that is less than the closest-focusing distance of the lens alone.

CMOS See *complementary metal-oxide semiconductor (CMOS)*.

CMYK color model A way of defining all possible colors in percentages of cyan, magenta, yellow, and frequently, black. (K represents black, to differentiate it from blue in the RGB color model.) Black is added to improve renditions of shadow detail. CMYK is commonly used for printing (both on press and with your inkjet or laser color printer).

color correction Changing the relative amounts of color in an image to produce a desired effect, typically a more accurate representation of those colors. Color correction can fix faulty color balance in the original image, or compensate for the deficiencies of the inks used to reproduce the image.

complementary metal-oxide semiconductor (CMOS) A method for manufacturing a type of solid-state sensor that captures the image that is used in scanners and digital cameras.

compression Reducing the size of a file by encoding, using fewer bits of information to represent the original. Some compression schemes, such as JPEG, operate by discarding some image information, while others, such as TIF, preserve all the detail in the original, discarding only redundant data.

continuous autofocus An automatic focusing setting (AF-C) in which the camera constantly refocuses the image as you frame the picture. This setting is often the best choice for moving subjects. See also *single autofocus*.

contrast The range between the lightest and darkest tones in an image. A high-contrast image is one in which the shades fall at the extremes of the range between white and black. In a low-contrast image, the tones are closer together.

dedicated flash An electronic flash unit, such as the HVL-F56AM Digital Camera Flash or HVL-F36AM Digital Camera Flash, designed to work with the automatic exposure features of a specific camera.

depth of field (DOF) A distance range in a photograph in which all included portions of an image are at least acceptably sharp. With the Alpha A100, you can see the available depth of field at the taking aperture by pressing the depth-of-field preview button, or estimating the range by viewing the depth-of-field scale found on many lenses.

diaphragm An adjustable component, similar to the iris in the human eye, which can open and close to provide specific-sized lens openings, or f-stops.

diffuse lighting Soft, low-contrast lighting.

digital processing chip A solid-state device, such as the Bionz image processor found in the Sony Alpha digital camera, that's in charge of applying the image algorithms to the raw picture data prior to storage on the memory card.

diopter A value used to represent the magnification power of a lens, calculated as the reciprocal of a lens's focal length (in meters). Diopters are most often used to represent the optical correction a viewfinder uses to adjust for limitations of the photographer's eyesight, and to describe the magnification of a close-up lens attachment.

D-Range Optimizer. An optional feature of the Alpha DSLR-A100 when using matrix metering mode and P, A, or S shooting modes, in which the camera examines shooting conditions and adjusts brightness and contrast to improve the dynamic range and tonal values of JPEG images.

equivalent focal length A digital camera's focal length, which must be translated into the corresponding values for a 35mm film camera if the sensor is smaller than 24mm × 36mm. This value can be calculated for lenses used with the Alpha A100 by multiplying by 1.5.

exchangeable image file format (Exif) A format that was developed to standardize the exchange of image data between hardware devices and software. A variation on JPEG, Exif is used by most digital cameras, and includes information such as the date and time a photo was taken, the camera settings, the resolution, the amount of compression, and other data.

Exif See *exchangeable image file format (Exif)*.

exposure The amount of light allowed to reach the film or sensor, determined by the intensity of the light, the amount admitted by the iris of the lens, and the length of time determined by the shutter speed.

exposure values (EV) EV settings are a way of adding or decreasing exposure without the need to reference f-stops or shutter speeds. For example, if you tell your camera to add +1EV, it will provide twice as much exposure, either by using a larger f-stop, a slower shutter speed, or both.

fill lighting In photography, it is the lighting used to illuminate shadows. Reflectors, additional incandescent lighting, or electronic flash can be used to brighten shadows. One common technique outdoors is to use the camera's flash as a fill.

filter In photography, it is a device that fits over the lens, changing the light in some way. In image editing, it is a feature that changes the pixels in an image to produce blurring, sharpening, and other special effects. Photoshop includes several interesting filter effects, including Lens Blur and Photo Filters.

flash sync The timing mechanism that ensures that an internal or external electronic flash fires at the correct time during the exposure cycle. A DSLR's flash sync speed is the highest shutter speed that can be used with flash, ordinarily 1/160 second (with Super SteadyShot turned off) or 1/125 second (with Super SteadyShot turned on) with the Alpha A100. See also *front-curtain sync* and *rear-curtain sync.*

focal length The distance between the film and the optical center of the lens when the lens is focused on infinity, usually measured in millimeters.

focus lock A camera feature that lets you freeze the automatic focus of the lens at a certain point, when the subject you want to capture is in sharp focus.

focus servo A digital camera's mechanism that adjusts the focus distance automatically. The focus servo can be set to single autofocus (AF-S), which focuses the lens only when the shutter release is partially depressed, and continuous autofocus (AF-C), which adjusts focus constantly as the camera is used. The automatic autofocus (AF-A) setting switches between the two, depending on whether the subject is moving or not.

focus tracking The capability of the automatic focus feature of a camera to change focus as the distance between the subject and the camera changes. One type of focus tracking is *predictive,* in which the mechanism anticipates the motion of the object being focused on, and adjusts the focus to suit.

fringing A chromatic aberration that produces fringes of color around the edges of subjects, caused by a lens's inability to focus the various wavelengths of light onto the same spot. Purple fringing is especially troublesome with backlit images. See also *chromatic aberration.*

front-curtain sync The default kind of electronic flash synchronization technique, originally associated with focal plane shutters, that consists of a traveling set of curtains, including a *front curtain* (which opens to reveal the film or sensor) and a *rear curtain* (which follows at a distance determined by the shutter speed to conceal the film or sensor at the conclusion of the exposure). For a flash picture to be taken, the entire sensor must be exposed at one time to the brief flash exposure, so the image is exposed after the front curtain has reached the other side of the focal plane, but before the rear curtain begins to move. Front-curtain sync causes the flash to fire at the beginning of this period when the shutter is completely open, in the instant that the first curtain of the focal plane shutter finishes its movement across the film or sensor plane. With slow shutter speeds, this feature can create a blur effect from the ambient light, appearing as patterns that follow a moving subject with the subject shown sharply frozen at the beginning of the blur trail. See also *rear-curtain sync.*

frontlighting The illumination that comes from the direction of the camera. See also *backlighting* and *sidelighting.*

f-stop The relative size of the lens aperture, which helps determine both exposure and depth of field. The larger the f-stop number, the smaller the aperture itself.

graduated filter A lens attachment with variable density or color from one edge to another. A graduated neutral density filter, for example, can be oriented so the neutral density portion is concentrated at the top of the lens's view with the less dense or clear portion at the bottom, thus reducing the amount of light from a very bright sky while not interfering with the exposure of the landscape in the foreground. Graduated filters can also be split into several color sections to provide a color gradient between portions of the image.

gray card A piece of cardboard or other material with a standardized 18-percent reflectance. Gray cards can be used as a reference for determining correct exposure or for setting white balance.

high contrast A wide range of density in a print, a negative, or another image.

highlights The brightest parts of an image containing detail.

histogram A kind of chart showing the relationship of tones in an image using a series of 256 vertical bars, one for each brightness level. A histogram chart, such as the one the Alpha A100 can display during picture review, typically looks like a curve with one or more slopes and peaks, depending on how many highlight, middle, and shadow tones are present in the image.

hot shoe A mount on top of a camera, also called the *accessory shoe*, used to hold an electronic flash, while providing an electrical connection between the flash and the camera.

hyperfocal distance A point of focus where everything from half that distance to infinity appears to be acceptably sharp. For example, if your lens has a hyperfocal distance of 4 feet, everything from 2 feet to infinity will appear sharp. The hyperfocal distance varies by the lens and the aperture in use. If you know you'll be making a grab shot without warning, sometimes it's useful to turn off your camera's automatic focus and set the lens to infinity, or, better yet, set the hyperfocal distance. Then, you can snap off a quick picture without having to wait for the lag that occurs with most digital cameras as their autofocus locks in.

image rotation A feature that senses whether a picture was taken in horizontal or vertical orientation. That information is embedded in the picture file so that the camera and compatible software applications can automatically display the image in the correct orientation.

image stabilization A technology, also called *anti-shake* or *vibration reduction*, which compensates for camera shake, usually by adjusting the position of the camera sensor (in the case of the Sony Alpha) or lens elements (in lenses produced by some other vendors) in response to movements of the camera.

incident light Illumination falling on a surface.

International Organization for Standardization (ISO) A governing body that provides standards used to represent film speed, or the equivalent sensitivity of a digital camera's sensor. Digital camera sensitivity is expressed in ISO settings.

interpolation A technique digital cameras, scanners, and image editors use to create new pixels required whenever you resize or change the resolution of an image based on the values of surrounding pixels. Devices such as scanners and digital cameras can also use interpolation to create pixels in addition to those actually captured, thereby increasing the apparent resolution or color information in an image.

ISO See *International Organization for Standardization (ISO)*.

jaggies The staircasing effect of lines that are not perfectly horizontal or vertical, caused by pixels that are too large to represent the line accurately. See also *anti-alias*.

JPEG A file lossy format (short for *Joint Photographic Experts Group*) that supports 24-bit color and reduces file sizes by selectively discarding image data. Digital cameras generally use JPEG compression to pack more images onto memory cards. You can select how much compression is used (and, therefore, how much information is thrown away) by selecting from among the Standard, Fine, Super Fine, or other quality settings your camera offers. See also *RAW*.

Kelvin (K) A unit of measure based on the absolute temperature scale in which absolute zero is zero. It is used to describe the color of continuous-spectrum light sources, and is applied when setting white balance. For example, daylight has a color temperature of about 5500K, and a tungsten lamp has a temperature of about 3400K.

lag time The interval between when the shutter is pressed and when the picture is actually taken. During that span, the camera may be automatically focusing and calculating exposure. With dSLRs such as the Alpha A100, lag time is generally very short; with non-dSLRs, the elapsed time easily can be 1 second or more.

latitude The range of camera exposures that produces acceptable images with a particular digital sensor or film.

lens flare A feature of conventional photography that is both a bane and a creative outlet. It is an effect produced by the reflection of light internally among elements of an optical lens. Bright light sources within or just outside the field of view cause lens flare. Flare can be reduced by the use of coatings on the lens elements or with the use of lens hoods. Photographers sometimes use the effect as a creative technique, and Photoshop includes a filter that lets you add lens flare at your whim.

lighting ratio The proportional relationship between the amount of light falling on the subject from the main light and other lights, expressed in a ratio, such as 3:1.

lossless compression An image-compression scheme, such as TIFF, that preserves all image detail. When the image is decompressed, it is identical to the original version.

lossy compression An image-compression scheme, such as JPEG, that creates smaller files by discarding image information, which can affect image quality.

macro lens A lens that provides continuous focusing from infinity to extreme close-ups, often to a reproduction ratio of 1:2 (half life-size) or 1:1 (life-size).

matrix metering A system of exposure calculation that looks at many different segments of an image to determine the brightest and darkest portions.

midtones Parts of an image with tones of an intermediate value, usually in the 25 percent to 75 percent range. Many image-editing features enable you to manipulate midtones independent of the highlights and shadows.

mirror lock-up The capability to retract the SLR's mirror to reduce vibration prior to taking the photo (with some cameras), or, with the Alpha A100, to allow access to the sensor for cleaning.

neutral color A color in which red, green, and blue are present in equal amounts, producing a gray.

neutral density filter A gray camera filter that reduces the amount of light entering the camera without affecting the colors.

noise In an image, it is pixels with randomly distributed color values. Noise in digital photographs tends to be the product of low-light conditions and long exposures, particularly when you've set your camera to a higher ISO rating than normal.

noise reduction A technology used to cut down on the amount of random information in a digital picture, usually caused by long exposures at increased sensitivity ratings.

normal lens A lens that makes the image in a photograph appear in a perspective that is like that of the original scene, typically with a field of view of roughly 45°.

overexposure A condition in which too much light reaches the film or sensor, producing a dense negative or a very bright/light print, slide, or digital image.

pincushion distortion A type of lens distortion, most often found at telephoto focal lengths, in which lines at the top and side edges of an image are bent inward, producing an effect that looks like a pincushion. See also *barrel distortion*.

polarizing filter A filter that forces light, which normally vibrates in all directions, to vibrate only in a single plane, reducing or removing the specular reflections from the surface of objects.

RAW An image file format that includes all the unprocessed information the camera captures. RAW files are very large compared to JPEG files and must be processed by a special program such as Capture or Adobe's Camera Raw filter after being downloaded from the camera. See also *JPEG*.

rear-curtain sync An optional kind of electronic flash synchronization technique, originally associated with focal plane shutters, which consists of a traveling set of curtains, including a *front curtain* (which opens to reveal the film or sensor) and a *rear curtain* (which follows at a distance determined by the shutter speed to conceal the film or sensor at the conclusion of the exposure). For a flash picture to be taken, the entire sensor must be exposed at one time to the brief flash exposure, so the image is exposed after the front curtain has reached the other side of the focal plane, but before the rear curtain begins to move. Rear-curtain sync causes the flash to fire at the end of the exposure, an instant before the second or rear curtain of the focal plane shutter begins to move. With slow shutter speeds, this feature can create a blur effect from the ambient light, appearing as patterns that follow a moving subject with the subject shown sharply frozen at the end of the blur trail. If you were shooting a photo of The Flash, the superhero would appear sharp, with a ghostly trail behind him. See also *front-curtain sync*.

red-eye An effect from flash photography that appears to make a person's eyes glow red, or an animal's eyes glow yellow or green. It's caused by light bouncing from the retina of the eye and is most pronounced in dim illumination (when the irises are wide open) and when the electronic flash is close to the lens and, therefore, prone to reflect directly back. A preflash from the camera's electronic flash unit can cause the pupils to contract, minimizing the effect. Image editors can fix red-eye by cloning other pixels over the offending red or orange ones.

RGB color model A color model that represents the three colors — red, green, and blue — used by devices such as scanners or monitors to reproduce color. Photoshop works in RGB mode by default, and even displays CMYK images by converting them to RGB.

saturation The purity of color; the amount by which a pure color is diluted with white or gray.

selective focus Choosing a lens opening that produces a shallow depth of field. Usually this is used to isolate a subject by causing most other elements in the scene to blur.

self-timer A mechanism that delays the opening of the shutter for some seconds after the release has been operated.

sensitivity A measure of the degree of response of a film or sensor to light, measured using the ISO setting.

shadow The darkest part of an image, represented on a digital image by pixels with low numeric values.

sharpening Increasing the apparent sharpness of an image by boosting the contrast between adjacent pixels that form an edge.

shutter In a conventional film camera, the shutter is a mechanism consisting of blades, a curtain, a plate, or some other movable cover that controls the time during which light reaches the film. Digital cameras can use a combination of a mechanical shutter (for slower shutter speeds) and an electronic shutter (for higher speeds).

shutter-preferred An exposure mode in which you set the shutter speed and the camera determines the appropriate f-stop. See also *aperture-preferred*.

sidelighting Applying illumination from the left or right sides of the camera. See also *backlighting* and *frontlighting*.

single autofocus An automatic focusing setting (AF-S) in which the camera locks in focus when you press the shutter release half way. This setting is usually the best choice for nonmoving subjects. See also *continuous autofocus*.

slave unit An accessory flash unit that supplements the main flash, usually triggered electronically when the slave senses the light output by the main unit or through radio waves.

slow sync An electronic flash synchronizing method that uses a slow shutter speed so that ambient light is recorded by the camera in addition to the electronic flash illumination. This enables the background to receive more exposure for a more realistic effect.

specular highlight Bright spots in an image caused by reflection from light sources.

spot meter An exposure system that concentrates on a small area in the image. See also *center-weighted meter* and *averaging meter*.

subtractive primary colors Cyan, magenta, and yellow, which are the printing inks that theoretically absorb all color and produce black. In practice, however, they generate a muddy brown, so black is added to preserve detail (especially in shadows). The combination of the three colors and black is referred to as CMYK. (K represents black, to differentiate it from blue in the RGB model.)

TIFF (Tagged Image File Format) A standard graphics file format that can be used to store grayscale and color images, plus selection masks. See also *JPEG and RAW*.

time exposure A picture taken by leaving the shutter open for a long period, usually more than 1 second. The camera is generally locked down with a tripod to prevent blur during the long exposure.

through the lens (TTL) A system of providing viewing and exposure calculation through the actual lens taking the picture.

tungsten light Light from ordinary room lamps and ceiling fixtures, as opposed to fluorescent illumination.

underexposure A condition in which too little light reaches the film or sensor, producing a thin negative, a dark slide, a muddy-looking print, or a dark digital image.

unsharp masking The process for increasing the contrast between adjacent pixels in an image, increasing sharpness, especially around edges.

vignetting The dark corners of an image, often produced by using a lens hood that is too small for the field of view, by using a lens that does not completely fill the image frame, or by generating it artificially using image-editing techniques.

white balance The adjustment of a digital camera to the color temperature of the light source. Interior illumination is relatively red; outdoor light is relatively blue. Digital cameras often set correct white balance automatically or let you do it through menus. Image editors can often do some color correction of images that were exposed using the wrong white balance setting.

Index

Continued